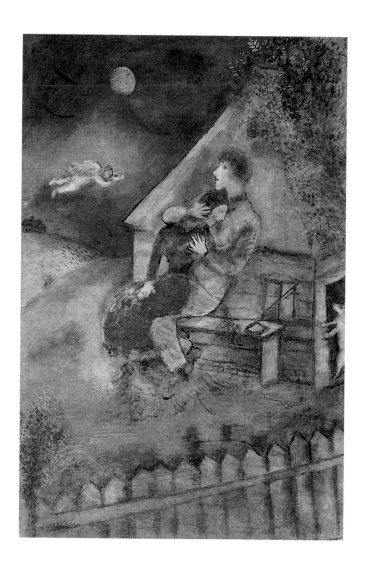

JEWISH ENCOUNTERS

Jonathan Rosen, General Editor

Jewish Encounters is a collaboration between Schocken and Nextbook, a project devoted to the promotion of Jewish literature, culture, and ideas.

JEWISH ENCOUNTERS

PUBLISHED

THE LIFE OF DAVID · Robert Pinsky

MAIMONIDES · Sherwin B. Nuland

BARNEY ROSS · Douglas Century

BETRAYING SPINOZA · Rebecca Goldstein

EMMA LAZARUS · Esther Schor

THE WICKED SON · David Mamet

MARC CHAGALL · Jonathan Wilson

FORTHCOMING

MOSES · Stephen J. Dubner

BIROBIJAN · Masha Gessen

JUDAH MACCABEE · Jeffrey Goldberg

YEHUDA HA'LEVI · Hillel Halkin

THE DAIRY RESTAURANT · Ben Katchor

DISRAELI · Adam Kirsch

THE JEWISH BODY · Melvin Konner

THE SONG OF SONGS · Elena Lappin

THE AMERICAN SONGBOOK · David Lehman

ABRAHAM CAHAN · Seth Lipsky

THE LUBAVITCHER REBBE · Jonathan Mahler

GLÜCKEL OF HAMELN · Daphne Merkin

THE ALTALENA · Michael B. Oren

THE HEBREW ALPHABET · Ilan Stavans

MARSHALL MEYER · Noga Tarnopolsky

MESSIANISM · Leon Wieseltier

JEWS AND POWER · Ruth R. Wisse

Marc Chagall

JONATHAN WILSON

MARC CHAGALL

NEXTBOOK · SCHOCKEN · NEW YORK

With thanks to the Marc and Ida Chagall Archives.

Due to limitations of space, permission to reprint previously
published material can be found following the chronology.

Library of Congress Cataloging-in-Publication Data
Wilson, Jonathan, [date]
 Marc Chagall / Jonathan Wilson.
 p. cm. — (Jewish encounters)
 Includes bibliographical references.
 ISBN: 978-0-8052-4201-0
 1. Chagall, Marc, 1887–1985. 2. Jewish artists—
Russia (Federation)—Biography. I. Title.
 N6999.C46W55 2007
 709.2—dc22
 [B] 2006021080

www.schocken.com
Printed in the United States of America
First Edition
2 4 6 8 9 7 5 3 1

Lovers by Marc Chagall, 1929, oil on canvas. Collection of the
Tel Aviv Museum of Art. Copyright © Tel Aviv Museum of Art.

For Sharon

AS IT IS EACH DAY

CONTENTS

	Introduction	ix
1.	Vitebsk	3
2.	St. Petersburg	22
3.	Paris	33
4.	Bella	54
5.	Return to Vitebsk	66
6.	Yiddish Theater	75
7.	Berlin	86
8.	Return to Paris	91
9.	Palestine	103
10.	Vilna	111
11.	Villentroy, Gordes, Marseilles	126
12.	New York	135
13.	Virginia	151
14.	Orgeval	164
15.	A Problem of Conscience	178
16.	Vava	188
17.	Blessings	204
	Coda	216
	Acknowledgments	221
	Bibliographic Note	223
	Chronology	225

INTRODUCTION

She loved Chagall
and wasn't ashamed of that.

—T. CARMI, "In Memory of Leah Goldberg"

In 1968, when I was in my first year at university, I had a cheap poster of a Chagall painting, *Double Portrait with Wineglass*, on the wall of my dormitory room. The airborne figures, a young man and woman floating above a Russian town, the woman with a sexy slit in her low-cut white dress (possibly a bridal gown), the young man in a bright red jacket with his head tipsily displaced to one side of his body and grinning like Harpo Marx, embodied for me precisely the kind of secular, whimsical, neoromantic sensibility that, at eighteen, I found so compelling. The poster, in my imagination, went right along with E. E. Cummings's poem that began "somewhere i have never traveled, gladly beyond / any experience, your eyes have their silence" and *Elvira Madigan*, Swedish director Bo Widerberg's movie about a doomed tightrope walker. I did not, at this stage of my life, have much or any use for the "Fiddler on the Roof" Chagall: his *Praying Jew*, for example, a more or less straightforward earthbound representation of the Rabbi of Vitebsk wearing

his phylacteries (a painting which I later discovered Chagall long prized as his "masterpiece"), appealed to a conservative sentimentality that I associated, rightly or wrongly, with my parents' generation and the crowds packing in to see Topol or Zero Mostel as Tevye. If I were a rich man I would have bought one of Chagall's dreamy garlanded canvases, inspired by his trips into the French countryside, rather than, say, *The Violinist*, which featured an actual fiddler on the roof and which I considered a lachrymose work formed by a nostalgia-tormented shtetl-locked mind. But, of course, I knew nothing of the social context of any Chagall painting, and almost nothing of his personal history. As with so many writers and artists whom I came across in my formative reading and looking years—Kafka, Bellow, Soutine—the salient thing I knew was simply that they were Jewish.

It did not take long for me to learn that sophisticated art aficionados weren't supposed to love or even like Chagall. His lovers and his rabbis, his massive bouquets and his violins were equally dubious, equally cloying, not kitsch, but living somewhere dangerously close to that ballpark.

In the last few years a fresh interest in Chagall's work, partly attributable to the resurfacing of paintings long hidden in the vaults of Soviet museums, has spawned a number of blockbuster shows. The "new" work, which includes a series of outstanding murals created for the Moscow State Yiddish Chamber Theater in 1920, has led inevitably to a reassessment of the "old" work.

Chagall's oeuvre, when seen in its entirety, seems altogether more historical, more political, harder and edgier

than conventional wisdom would have us believe. There is, too, strikingly and unavoidably, a long Jewish story to be told through Chagall's work. His career spanned two world wars, the Russian Revolution, and the birth of the state of Israel, and his work directly addresses these transforming events through the prism of a Jewish consciousness. Chagall's perceptible ambivalence about his role and status as a Jewish artist only deepens the content of the story: drawn to sacred subject matter, he remains defiantly secular in outlook; determined to "narrate" both the miraculous and tragic events of Jewish history, including the Nazi Holocaust, he frequently, almost obsessively, chooses Christ as his central symbol of martyrdom and sacrifice, in full knowledge that, even when wrested from their Christian context, images of Jesus are tough for a Jewish audience to swallow. Born into an Orthodox Jewish family in the Belorussian town of Vitebsk, Chagall (without converting) found his resting place almost a century later in a Catholic cemetery in Saint-Paul-de-Vence in the south of France. Aptly, his stained-glass windows adorn both churches and synagogues. His story, then, as told through his paintings, drawings, lithographs, book illustrations, stage sets, ceramics, tapestries, sculptures, windows, and the acts of his life, repeats both the twists and turns and the pulls and tugs of so much Jewish life in the twentieth century: the serpentine vagaries of history, a nostalgic attachment to the spiritually charged but circumscribed pre-Nazi Eastern European Jewish past, and the magnetic attraction of assimilation into an uninhibited secular present.

Marc Chagall

1

Vitebsk

Marc Chagall was born Moishe (Movcha) Shagal in the run-down Pestkovatik neighborhood of the Belorussian town of Vitebsk (population 65,000) on July 6 (not July 7 as he claimed—he preferred the number 7) in 1887. He was born dead and brought to life by someone who speedily dipped him in a pail filled with cool water. Not far away, a fire raced through the town, destroying 125 shops, 268 wooden houses, and 16 other buildings. Fire and water: a sturdy elemental beginning for a painter.

If baby Shagal's startled eyes had been able to take in his surroundings, or if his body had been able to levitate with the ease of the figures in his adult paintings, he would have seen close to his birthplace the walls of both the town's prison and its lunatic asylum. Already in place too, as if waiting for him, were the neighborhood rooftops on Pokrowskaya Street, the animals in the street, the onion-domed churches, Torah-clutching rabbis, women with baskets, men burdened with the yoke not of the Torah but of milk-filled buckets, and perhaps even someone playing a fiddle and leading a wedding procession.

Marc Chagall

Marc Chagall in Paris, ca. 1925.
(Courtesy Roger-Viollet)

The characters, creatures, and buildings to be found on the outskirts of Vitebsk, where most of its Jewish population lived, and that were to become Chagall's obsessive lifelong subject, were not, however, the whole story of the town. For Chagall frequently chose to collapse broad Vitebsk where it sat on the confluence of the Vitba and Dvina rivers into a narrow frame and reconstruct it in his memory as a landlocked shtetl, a small Jewish village more like Lyosno, some thirty miles away, where his maternal grandparents lived.

The Vitebsk that Chagall's paintings gave the world has been accepted as a representation of a lost Jewish world that can be happily regarded with nostalgia. And indeed it is. But a visitor in 1887 alighting in Vitebsk from a train en route from Odessa or Kiev to St. Petersburg, or from Riga on the

way to Moscow, would have searched long and hard for a fiddler on the roof. Instead, he or she would have seen the impressive Uspensky Cathedral, or the new railway bridge, and, if in search of music, might have headed for one of the city's other imposing buildings that functioned as temporary homes for the visiting theater companies or famous musicians who gave concerts there.

Sometimes these local Vitebsk landmarks appear in Chagall's art (as in *Double Portrait with Wineglass*, 1917–18), but they are not its important symbolic sites. Throughout his painting career Chagall insistently brought the world of big history to the little streets of his old neighborhood as he knew it in early childhood: the Holocaust takes place on the streets where Chagall grew up, and Jesus, frequently wearing a tallith (prayer shawl) around his waist, is repeatedly crucified there. If he is not bringing history to Vitebsk, then Chagall is carrying Vitebsk with him, as in a suitcase of the mind, wherever he goes. He has only to unpack his imagination, peer out of his window in Paris, and there are Pestkovatik's tiny houses, shops, and *stiebls* (small, one-room synagogues) lining up sideways under the Eiffel Tower.

Much of what we know of Chagall's early life is to be discovered in his memoir *My Life*, written when he was only thirty-five during a tumultuous year that he spent in Moscow from 1921 to 1922. Like Chagall's paintings, however (and the text is accompanied by a number of his etchings and drypoints), his writing tends toward the ahistorical, and proceeds via anecdote and association. There are no

dates to set parameters for the reader; instead there are charged descriptions of individuals, rhetorical flourishes, lyric passages, sentimentalized recollections, and a considerable amount of self-aggrandizement. The latter is quite understandable for an artist with a singular and established reputation who had, at his time of writing, been packed off by the local Soviet Narkompross (People's Commissariat of Enlightenment) to teach drawing to two colonies of war orphans in Malakhovka, on the outskirts of Moscow. But I am getting ahead of the story.

"My father's clothes shone with herring brine," Chagall writes in *My Life*; "he lifted heavy barrels and my heart used to twist like a Turkish bagel as I watched him lift those weights and stir the herrings with his frozen hands." Poor laborers in the herring business worldwide, even those without a heartfelt attachment to the circumscribed rubrics of Hasidic Jewish life, have rarely shown great enthusiasm for the life of high art. Sachar Shagal was no exception. This father of eight had other aspirations for his eldest son along the familiar "paying job" lines. However, when the crunch came and Chagall needed money to enroll in a St. Petersburg art school, Sachar reached deep into his pockets, produced the necessary rubles, and mischievously rolled them under the kitchen table for his son to scramble after. In his memoir Chagall recalls this moment of combined joy and humiliation with a wave of the hand: "I forgive him, it was his way of giving."

As if to confirm this exculpation, Chagall's 1914 portrait

My Father is decidedly empathetic. This watercolor on paper, which presently hangs in St. Petersburg's Russian Museum, presents a stoop-shouldered figure with trouble in his eyes. He sits in his kitchen, a glass of tea and lumps of sugar on the table before him, a cat and an old babushka to his left. The herring brine shine is not visible on his royal blue jacket or matching cap. In his outfit he resembles van Gogh's postman. In the top right-hand corner we can clearly see the bolt on the door. Behind his left shoulder, through a window, sheets are hung out to dry. Chagall's father was fifty-one and his son twenty-seven when this painting was accomplished. Chagall had already been to Paris, achieved some fame if not fortune, and returned. The father is in a reduced place, and the sense of a life sacrificed to hard labor is palpable. He is similarly downcast in the 1911 pen-and-ink sketch *My Father, My Mother and Myself,* where, by contrast, Chagall's mother wears a superb hat and a cheerful smile.

As an accompaniment to his memoir (or perhaps it is really the other way round) numerous paintings and drawings completed by Chagall in his early twenties also tell the story of his childhood in Vitebsk, including *Sabbath* (1910), *Our Dining Room* (1911), *Village with Water Carriers* (1911–12), and *The Village Store* (1911). But perhaps none of them unlock the past with such a ripple effect as *The Dead Man* (1908). Chagall executed this important painting when he was a twenty-one-year-old student in Leon Bakst's class at the Zvantseva Academy in St. Petersburg.

The specific inspiration for *The Dead Man* is a memory of

childhood that Chagall records in *My Life*. "Suddenly . . . well before dawn . . . a woman, alone, running through deserted streets." The woman's husband is dying and she implores the neighbors, who include young Chagall, to save him. "The light from the yellow candles, the color of that face, barely dead . . . The dead man . . . is already laid out on the floor, his face illumined by six candles."

From a biographical rather than a pictorial point of view, what intrigues in this painting are its departures from Chagall's inspirational memory. In *The Dead Man* "deserted streets" are no longer deserted. Instead we see, in addition to the screaming woman, not only the body laid out but also a preoccupied street sweeper (grim reaper?) plying his predawn trade. Most significantly, Chagall has moved the action that in life he witnessed indoors to the outdoors, and the corpse, displaced into the street but still surrounded by six burning candles, now strikes a decidedly un-Jewish pose.

If artists have one big job, it is to move what is inside to the outside, to reveal secrets, and in so doing to allow us to discover who we are. At the beginning of his career, Chagall crossed a number of necessary boundaries with *The Dead Man*, which is at once an attempted farewell to Vitebsk and a lamentation; a recording and transgression of the Jewish world he knew so well. Moreover, the striking disproportions in the painting, in which figures are larger than houses, points as much to the disproportionate weight of childhood on Chagall's imagination (a mismatch that, as for most of us, was to be lifelong) as it does to the influence of the neoprimitivist style in vogue at the time.

Like so many great artists, Chagall retained a persistent obsession with the place that he needed to leave behind in order to create his art, and there is little difference in this regard between Chagall's relation to Vitebsk and that of James Joyce to Dublin or Philip Roth to Newark.

In *The Dead Man* we also find the inevitable fiddler on the roof, and a word about that emblematic Chagallian figure is appropriate here. The first rooftop violinist in Chagall's oeuvre is not the least bit contrived. He's simply a guy in a hat (no beard) on a roof playing what one assumes is mournful music. Or perhaps, like the street sweeper, he is indifferent to the dead man and the grieving woman below him. A large boot indicating a cobbler's shop hangs from the eaves of his roof (Chagall has written that his Uncle Neuch "played the violin like a cobbler"), but the fiddler's location is not magically realistic. It was not at all uncommon for shtetl and town residents alike to take to their rooftops, sometimes out of fear and sometimes for fun. Chagall's grandfather, for example, liked to climb up on high to chew a few carrots and watch the world go by.

But without doubt the fiddler is an important figure for Chagall: that local musician in Vitebsk's poorest neighborhood was probably Chagall's first apprehension of a performing artist; a creative individual who has both distance from the emotions that he excites and a commitment to technique. The fiddler is also a gypsy wanderer, a musical peddler whose art eases his passage between disparate worlds. There is a great seduction in vagabond heels.

If the fiddler was a part of Chagall's sentimental educa-

tion, so too was his local synagogue. On Yom Kippur, the Day of Atonement, Chagall's father wrote an instructional "Weep" in his wife's prayer book next to certain passages. Feiga-Ita, like the other wives in the assembly, followed orders: "When coming to the sign 'Weep,' " Chagall writes, his mother "would begin . . . to shed divine tears. Their [the women's] faces would redden and little moist diamonds would trickle down, drop by drop, sliding over the pages." This anecdote tells us something about Chagall's early introduction to the mechanics of sentimentality, but it might also be read as a useful allegory of Chagall's relationship with his audience when he is not at the top of his game: an appeal for a ritualized lachrymose response to work that carries the memory of suffering or joy without necessarily representing it fully.

But perhaps it is better here to focus on Feiga-Ita herself. For when it came to her son's career, this loving and lovable daughter of a kosher butcher in nearby Lyosno, who ran a small grocery store by day and her Old Lady Who Lived in a Shoe household in her off-hours, was not always so dutiful. In the face of her husband's early opposition, she encouraged Chagall to indulge his talent even while she remained baffled by it. And when, probably at around the age of thirteen, Chagall implored her, "Mama . . . I want to be a painter," she brought him, against her own better instincts (she thought clerking might be a good profession), to the local art school run by Yehuda Pen. It was there at "Artist Penne's School of Painting and Design" that Chagall took his first significant steps toward mastery.

Yehuda Pen had sectioned off one room in his central Vitebsk apartment and opened his art school in November 1897. Like Chagall he had grown up in a large and struggling Jewish family. His gift for drawing had become apparent in cheder (Hebrew school) as he decorated Purim rattles and the title pages of books. As he grew older he became known in his local town of Novo-Alexandrov for his sketches of local inhabitants, including mounted Cossacks. Pen's mother (his father had died when he was four) disapproved of his calling; unlike Feiga-Ita Shagal, she was indifferent to her son's talent, so she left him to make his own way in the world. The obvious stopgap direction for Pen when he needed money was house or sign painting— the latter a job that would also be Chagall's for a while. Indeed, the trajectory of Pen's early career matches that of Chagall in numerous ways, but precedes it by some twenty-five years.

Until the 1917 Revolution Jews did not have the "right of residence" in St. Petersburg but were confined to their Pale of Settlement. This presented a significant problem if you wanted to achieve any kind of higher education. As Chagall was to do later with dire consequences, Pen lived illegally in St. Petersburg (he bribed his "yardkeeper") and managed to enroll in the Academy of Arts. A stellar student, Pen graduated in 1885 with the prestigious Silver Medal. He was then lucky enough to find a patron in Baron N. N. Korf, who invited him to work on his estate outside Kreizburg, not far from Vitebsk. Pen stayed five years, and shortly after a brief unsuccessful return to St. Petersburg he was lured to Vi-

tebsk by members of the town's local Jewish intelligentsia, who both encouraged him and lent him the financial support necessary to open his art school. The young man who was to become his most famous student showed up nine years later.

Like Chagall, Pen emerged from a Hasidic milieu, and a great deal of his work records its figures and structures. While he sometimes worked from photographs, Pen preferred to use models and to draw or paint from life. For the most part his oil paintings are technically sound and essentially conservative naturalistic genre portraits: *Portrait of a Jew in a Black Cap* (ca. 1900), *An Old Woman with a Book* (*Chumash*) (ca. 1900), and *Letter from America* (*The Artist's Mother*) (1903) hold no surprises. Nonetheless, his influence on Chagall, even as a force to be challenged rather than emulated, should not be underestimated.

"Yes, he has some ability," were Pen's first words to Chagall's mother, after he had glanced through Chagall's "portfolio," which consisted of works copied from the magazine *Niwa*. Chagall's unspoken response, as he remembers it, was combative. "I feel instinctively that this artist's method is not mine. I don't know what mine is. I haven't time to think about it." Chagall's "method," as it eventually emerged, revealed a quite different absorption and internalization of the Hasidic world familiar to both pupil and teacher. Pen, schooled in a rigorous late-nineteenth-century academy, approached his subject matter no differently from any number of painters addressing their outside worlds. The inner life of the Jews that Pen chose to represent, albeit a brave

choice of subject (at the St. Petersburg Academy Jewish students were generally treated with suspicion and hostility, and they tended to keep to themselves), affected his method hardly at all. A Hasid pictured bathing a horse in *Bathing Horse* (1910) is, more or less, what it says it is.

Chagall, who shared with his teacher poor, unsophisticated, and ill-educated beginnings (Chagall was never really altogether comfortable in any language other than Yiddish), took something quite different from his upbringing, and that is the joyous, populist spirit of Hasidism. From the earliest, Chagall began to translate into painting both a philosophy of life and a way of speaking. Paradoxically, his work is frequently a literalization of metaphors, or turns of phrase—for example, linguistic tropes commonly used in his community to make the mundane and earthbound appear meaningful and airy. The word *luftmensch*, which denotes in Yiddish an individual overly involved in intellectual pursuits, literally means "man of the air," a prompt for Chagall to set him flying. Chagall paints, in other words, or in the same words but with a different meaning, in Yiddish. Moreover, Yiddish folktales, even those produced from outside the Hasidic movement, had long been a repository of flying animals and miraculous events.

The Hasidic movement dates back to the middle of the eighteenth century and gathered around its founder Rabbi Israel Ben Eliezer, more commonly known as the Ba'al Shem Tov (Master of the Good Name) and frequently referred to by his acronym "the Besht." The Hasidim (literally, "the

pious") grew in strength in the first half of the nineteenth century, and for the next fifty years retained a powerful influence in certain areas of Jewish settlement in Eastern Europe, including Vitebsk, which was dominated by the Lubavitch, or Habad, sect. Pietistic, populist, and essentially anti-intellectual, Hasidism had early on drawn the ire of its more scholarly adversaries the Mitnageddim (opponents), whose founding rabbi, Solomon, the Gaon of Vilna, had issued a ban on the movement. Its appeal lay in its emphasis on simple faith, inward passion, and fervent prayer.

The Besht's teachings were oral in form, transmitted through tales written down by his disciples. Stories about the Besht, and other rabbinical wonder-workers in God's service, found a huge audience. Ironically, the stories frequently revealed a suspicion of book learning. Hasidic tales are soundly ahistorical, mystically inclined, and replete with miraculous objects (amulets, candlesticks) and occurrences. As late as the 1950s tales are told in the Hasidic community of levitating rabbis.

Chagall's family and friends were undoubtedly familiar with the pious folk stories of the Hasidic world. Additionally, instructed to search for sparks of restorative heavenly meaning and joy in the darkest places on earth, Hasidim, while Orthodox in observance, illuminated their lives through acts of charity and enhanced their prayer with trance-inducing dance. It is not hard to see where the mystical center of Hasidic life enters Chagall's dreamlike paintings, nor is it difficult to understand why, throughout his

career, Chagall remained skeptical about intellectually fashionable artistic movements and theories. Frequently, Chagall's work seems closer to Hasidism than to Cubism.

In all likelihood Chagall studied with Yehuda Pen for a period lasting between four and seven years. While Chagall always felt the need both to diminish the impact that his teachers had upon him and to misrepresent the amount of time that he spent under their supervision (his memoir claims that he was with Pen for only a month and a half), he was also capable of acting generously toward them and tended to remember them as "father figures." When, in August 1918, Chagall was appointed commissar for art in the postrevolutionary government of Vitebsk and five months later established the Vitebsk Academy, Pen was among his first teaching appointments. In 1937, when the eighty-three-year-old Pen was brutally murdered in his home, in all probability by Stalin's NKVD, Chagall commemorated him in three stanzas of his long poem "My Distant Home," the last of which reads: "Your Jewish painting in the mud / A pig's tail daubed it over— / My teacher, I'm sorry / I left you long ago."

Hommage aside, it was, it seems, the atmosphere of Pen's studio, rather than the master's actual lessons, which penetrated Chagall. Young Chagall was intoxicated not only by "the smell of paints and paintings" and the appealing clutter familiar to anyone who has visited an art school, but also by the other whispered promise of that institution, arrestingly sexual and seductive. "No beautiful lady in our

city reached her twentieth spring without being invited by Pen to pose for him—however she liked. If possible down to the breasts—so much the better."

And perhaps this should be the moment to dispel the myth that the Second Commandment's prohibition on the creation of graven images stymied Jewish representative and figurative art until Chagall and his contemporaries broke free in prewar Paris. In fact, as the art historian Monica Bohm-Duchen has outlined with great clarity, by the mid-nineteenth century many Jewish artists, rather than engaging in the production of ritual objects, had, like the Impressionist Camille Pissarro, embraced progressive art movements. In the mid-1870s the Russian sculptor Mark (Mordecai) Antokolsky, who had been the first Jewish student at the Imperial Academy of Arts in St. Petersburg, produced a series of realistic works drawn from Jewish life and history. Among these works was a controversial statue of a youthful Jesus sporting *payyes* (the sidelocks worn by Orthodox Jews), *Ecce Homo* (1876). Jesus the Jew was also to play a remarkable part in Chagall's oeuvre, but the significance of Antokolsky's works, and those of some of his Jewish contemporaries, such as Jozef Israels in Holland, lies in its essential indifference to the Second Commandment, and the fact that the artists themselves did not view their disregard for the ban on graven images as in any way inconsistent with either their Jewishness or the art that they produced.

Harold Rosenberg once speculated that the Second Commandment can be explained not as a response to the dangerous connection between figurative art and idol worship but

by the fact that the Jews, slave laborers in the construction of temples, were literally crushed by art while they were in Egypt. Sculpture, he says, "must have induced tribal nightmares." His further speculation, altogether less fanciful, is that the authors of the Hebrew Bible had erased the need for art objects by filling their stories with people and things that "glisten with meaning and become memorable." Thus, Joseph's coat, the burning bush, and Aaron's rod become objects of the imagination that transcend the need for an intervening representational art. "If there were a Jewish Museum with those items in it, would anyone miss madonnas?" Rosenberg asks. But the point he makes is that the Hebrew Bible functions precisely *as* a Jewish museum, its readers are the museum's visitors, and "when the mind of the people is loaded with magical objects and events, which unfortunately cannot be assembled physically, what is there for artists to do but make cups for ceremonial drinking and ornaments for the Torah?"

The stories of the Hebrew Bible remained strong in Chagall's imagination throughout his life, but he never appears to have felt trumped by its charged and electric images. Instead, he moved freely upon the words, using his trademark vivid colors to create singular, striking, and, frequently, subversive paintings and illustrations. *Jacob's Dream* (1960–66), for example, suffused in blue and purple tones, includes an inverted Jesus on the cross in the painting's upper part, while far beneath him Abraham holds the knife over a bound Isaac.

Significantly, however, what first inspired Chagall was not

the Hebrew Bible but the New Testament, or images drawn from it that he saw in churches and parades. As early as 1910 he executed a painting called *The Holy Family*, followed two years later by another painting, *Madonna with Child*, a drawing of the Crucifixion, and the monumental and astonishing *Dedicated to Christ*, later renamed *Golgotha*.

As with Hebrew Bible stories, Chagall brought a subversive eye to Christian narratives. His "holy family" both parodies and explodes the Russian iconic tradition (until the mid-eighteenth century Russia had no art beyond icons) in color, scale, and subject: the baby (Jesus?) is issued into the world as a miniature man with a full beard, while his parents, instead of constituting the expected manger grouping, are shtetl figures in a shtetl environment. *Pregnant Woman or Maternity* (1913) directly parodies the iconic penchant for medallion-like circles that hang a saint or the holy child's face on the surface of his mother's body. Chagall's village woman points to the baby in her womb, naked and upright in an oval that covers her skirt from her waist to the top of her thighs. Vitebsk is in the foreground, and the Egyptian pyramids are in the distant background. As in *Jacob's Dream*, the stretch and sweep of Jewish history, which may include enslavement in Egypt as well as Jesus's Crucifixion, is engaged.

Chagall's chubby neo-Cubist Jesus in *Golgotha* crosses not only historical but also mythological boundaries. In this remarkable work a Charon-like figure waits, it seems, to row Jesus's body across a river (in an early drawing this same figure, sailing in the rear of a far more conventional Crucifixion

scene, looks more like a fisherman on the Sea of Galilee), and Jesus appears, as almost always in Chagall's work, first and foremost as a suffering Jew, rather than as a haloed and hallowed son of God.

The mix-and-match quality of Chagall's work—Jesus in Jacob's dream, Charon at Golgotha, pyramids in Vitebsk—illustrates the ease with which his imagination circumnavigated not only the fundamental taboo of the Second Commandment but also the apparent limits of genre. Paradoxically, this too probably has its roots in Chagall's familiarity with fanciful modes of Jewish storytelling in which history and myth are frequently collapsed in the service of a good idea. It is not at all uncommon in Jewish midrashim for a second-century rabbi to bump into Moses while he is walking down the street.

Chagall left Yehuda Pen's school in 1906. In his last year he had secured a tiny income by working as an apprentice in photographic retouching with the local photographer Mieschaninov; it was a job that Chagall hated and never mastered, although he had fun altering the faces of the clients with whom he was acquainted. At Pen's Chagall had befriended a fellow student, Victor Mekler, the son of a wealthy Jewish industrialist. Mekler introduced Chagall to his circle of friends, a sophisticated group made up of the children of professionals and successful merchants. Among their number was Berta (later Bella) Rosenfeld, the daughter of a relatively prosperous local jeweler: she was to become Chagall's first wife.

By the winter of 1906 Mekler was planning to move to St.

Petersburg to continue his art studies there. Chagall decided to accompany him. Chagall's description of his first meeting with Mekler in *My Life* is revealing because it is surprisingly coy in its representation of the two young men bonding over their mutual fascination with colors: "Don't you think," he said to me, "that that cloud . . . is intensely blue? Where it is mirrored in the water it turns to violet. Like me you adore violet don't you?" Chagall comments obliquely, "That boy had a rather pleasant face and I was often at a loss to know with what to compare it."

It is quite possible, as we shall see, that at the age of nineteen Chagall was a little bit in love with Mekler as well as with Bella. Although the young Chagall of *My Life* seems quite unconscious of homoerotic desire, not so those around him. In his late teens Chagall, alone among his peers, rouged his lips and cheeks and wore eye shadow. According to Chagall, the makeup was to "please . . . girls," but Bella's mother, for example, certainly had her suspicions about it, and wondered openly if a boy who painted his face was a suitable companion for her daughter.

Chagall left Vitebsk for St. Petersburg in the spring of 1907. He left behind his blossoming relationship with Bella—this bold young woman had already shocked Chagall's mother by posing in the nude, and inspired neighborhood gossip by climbing in and out of Chagall's bedroom window. Sadly, after Chagall's departure the family was to lose two of the eight children: Chagall's sister Rachel, who died from eating charcoal, and his brother David to tuberculosis.

Chagall also left the hum of prayers, the horses and the cows, the smell of herring, tanned cowhides, and kerosene, the entire landscape of his childhood and adolescence, its sandstone roads, cypress trees, cold night skies and variegated fields, its market vendors with their sunflower seeds, flour, and crockery, a little church where at night "the icons came to life," the handpainted signs "Gourevitch Bakery and Pastry Shop" and "Warsaw Tailor." He left people, places, scents, sounds, and images, almost all of which he would carry with him over the decades and try repeatedly to translate, via poetry or painting, into art.

2

St. Petersburg

Chagall's three years in St. Petersburg began brightly but soon took on a Dostoyevskian hue. As a Jew he was restricted from permanent residence in the city without an authorization that was only (and not always) given to academy members and their employees, artisans, and provincial tradesmen. Initially, Victor Mekler's father probably arranged for Chagall's temporary residence permit, although it seems that Chagall had also (possibly through the intervention of his own father) found employment as a "retoucher" with a St. Petersburg photographer named Jaffe.

Chagall's savings at the time consisted of what was left of the twenty-seven rubles that his father had disdainfully rolled under the kitchen table with the admonition that this was to be the last subsidy coming his son's way. This was not nearly enough money for the young painter to live on. Immediately after arriving in the Russian capital, Chagall went to take the entrance examination for admission to the prestigious Baron Stieglitz School of Arts and Crafts. A pass would have guaranteed not only a subsidy but also the per-

manent residency that he hoped for. The test involved studies of "long plaster decorative designs" that looked to Chagall like "things in a department store." He failed. His explanation for his failure is not perhaps what one might expect: "I thought: those designs have been chosen on purpose to frighten, to embarrass the Jewish pupils and keep them from getting the authorization they need." Why the Jewish pupils should have been unhinged by "decorative designs" is a little mysterious, unless Chagall is suggesting either that the Jewish pupils were unschooled bumpkins, too naïve to be able to engage with the decorative art of the sophisticated capital, or that the Jews were somehow *too serious*, and thus alienated from the material decadence implicit in the designs that they were supposed to render.

Chagall, who mostly chose not to, might have legitimately used anti-Semitism as an explanation for any number of the numerous difficulties that he experienced in his life, both at this time and later on, but in this particular case his excuse for "failure" appears intriguingly far-fetched.

Chagall swallowed his pride and quickly enrolled in the "easier" School of the Imperial Society for the Encouragement of the Fine Arts, where he remained as a student until the summer of 1908. Although he was a successful student there, winning prize scholarships that carried vital stipends of ten to fifteen rubles per month, Chagall found the atmosphere stifling. The plaster heads of ancient Greek and Roman citizens that projected from every corner of the studio, and shadowed the students like the giant statuary over

the tiny figures in Watteau's paintings, enraged Chagall: "Sometimes I walked up to those noses and punched them." He cast himself as the insurgent "country boy" bringing the scent of earth and grass to the stultifying environs where his mediocre fellow students labored over their canvases. Apparently, only a bust showing Venus's "dusty breasts" stirred his interest and desire.

Art historians tell a slightly different story of Chagall's days at the Imperial Society, one in which he benefited considerably from the enlightened instruction of the school's director, Nikolai Roerich, a talented and open-minded artist and set designer who also worked with Diaghilev's Ballets Russes. Roerich encouraged his students to visit the local museums and introduced live models to the art school— breasts that were not so dusty. Roerich, whose fate eventually brought him to New York City, where he founded the Roerich Museum on Riverside Drive, also performed one of the most significant acts to affect Chagall's life: he secured a military deferment for him when Chagall reached the age of conscription at twenty-one. Chagall's letter of request for help from Roerich (he was still signing himself "Shagal" at this time) is at once desperate, manipulative, and fawning, but one can certainly understand why Chagall tried everything he knew to stay out of the czar's army. "I love art too much," he wrote, "to accept the idea of wasting three years on military service." Roerich's letter (or possibly letters) on Chagall's behalf, written in the fall of 1908, is all the more generous when one realizes that Chagall had actually abandoned his studies in July after a disagreement with one of his

teachers. Chagall had not taken kindly to the question "What kind of asininity have you drawn there?" He did not even bother to pick up the August stipend to which he was entitled.

Roerich figures in Chagall's memoir as a terrible teacher and as an author of "unreadable poems," which he apparently foisted upon his students while they were trying to work. Chagall would remember the studio on the Moyky Canal only with bitterness: a place freezing in winter and permeated with the stale smell of "pickled cabbage and stagnant water." One senses that the Stieglitz rejection hit him harder than he ever admitted; he certainly felt superior to everyone at the Imperial Society.

For Chagall, St. Petersburg was a city of "stifling granite," while he yearned to be in nature in order to draw; at least this is how he presented his feelings to Roerich. However, he did not move out of the city once his deferment had been approved. Instead he spent a year in the wilderness, painting somehow and taking cheap lodging wherever he could find it. He frequently could not afford a room and was obliged to make do with "nooks and alcoves," sometimes even having to share a bed with another tenant. The rooming houses and the inhabitants whom he describes seem to have stepped out of *Crime and Punishment*: a wild drunk demanding sex from his wife, then pursuing her, knife in hand, down a corridor; snoring laborers; a workingman who kindly flattens himself against the wall so Chagall can have more room in the bed.

Ten years after these miserable times Chagall painted *The*

Apparition (*Self-Portrait with Muse*) (1917–18), which records a powerful dream that came to him one night as he scrunched himself into one of the "communal recesses" that passed as his bedroom. The painting, one of Chagall's strangest, features a sculptural winged angel, white marble come to life (he or she bears a remarkable resemblance to Emma Thompson bursting through the ceiling in Tony Kushner's *Angels in America*), and a painter sitting at his easel, palette in hand, but turned away, eyes closed, from a blank canvas. *The Apparition* is qualified as a *Self-Portrait with Muse*, but the painter on his stool looks nothing like Chagall. To the contrary, the figure, in flowing black clothes and a large white collar, bears a striking resemblance to Bella, and in particular to Bella as she is represented in *Bella with a White Collar*, painted in the same year as *The Apparition*. So too the angel, described by Chagall as a "he" in *My Life*, seems quite female in form, or at best androgynous. "Self-Portrait *as* Muse" would seem a more appropriate title for this work, in which the inspirational female forces at work on Chagall from the outside are both internalized and dramatized.

The chronology of Chagall's life at this period is hard to pin down, and information about it has proved resistant even to his most diligent biographers. Nevertheless, it is clear that at some point Chagall found a patron for a few months in Baron David Guenzburg, a leading figure in the St. Petersburg Jewish community and the head of the Society for the Promotion of Culture among the Jews of Russia. Guenzburg coughed up ten rubles a month for four or five

months before sending his manservant to the door with a message quite familiar to Chagall from his days at home: "You're on your own."

Chagall claims in *My Life* to have been seventeen when Guenzburg cut him off, but I think we may understand his lopping off at least four years from his actual age at the time as a device to make Guenzburg's action appear unacceptably heinous to his readers. After this Chagall suffered another humiliation when he was forced to accept the formal status of an indentured servant in the household of a Jewish lawyer named Goldberg, who, as a "privileged Jew," could secure rights of residence for his Jewish employees.

Chagall's behavior at this time veers between poles of self-effacement and self-aggrandizement, anxiety and self-confidence. Chagall carried a gift, his own spectacular talent, and he knew that he carried it from early on. Before that gift could be recognized for what it was by the outside world, he was dependent for his survival, like many artists before him, on the whims and shifting tastes of his wealthy patrons. In this unenviable situation Chagall maintained his equilibrium by holding fast to the notion that he was a unique and superior artist. It is mortifying, in this regard, to read of his nervousness in the company of those he needed most to impress, a condition attested to by his constant stammering.

The low point of Chagall's days in St. Petersburg probably arrived when, after returning from one of the occasional visits that he made to Vitebsk, he was arrested on the street for the double crime of entering the city without an updated

residence permit and possessing insufficient funds to bribe the police commissioner. In his long life Chagall was jailed twice, and on both occasions his "crime" was the simple one of being a Jew. In St. Petersburg in 1908 the consequences were not threateningly grave, as they were in Vichy France in April 1941, when Chagall, along with a number of other Jews awaiting passage from Marseilles, was rounded up and imprisoned.

It is not clear how Chagall achieved his release in St. Petersburg. Probably he spent no more than a few nights in his cell, and it was an experience that he looked back on as both amusing and educative—he liked listening to the banter of the thieves and prostitutes down the hall, and he was fascinated by the bathroom graffiti—although his 1914 gouache *In the Prison*, which shows four male figures in a bleak room, one staring forlornly out of a dark window, tells a harsher story. In both of his imprisonments Chagall displayed a surprising nonchalance in the period leading up to his arrest, as if he could never quite fully digest the threat that his Jewish identity posed to his own safety.

In order to keep himself from being jailed again in St. Petersburg, Chagall became apprenticed to a sign painter. According to him he produced a whole series of works that found their places above the entrances to local butcher shops and groceries. It is pleasant to imagine these pigs and "a chicken tenderly scratching itself" as Chagall's first major outdoor exhibition, paintings battered by the elements and splashed with mud.

Eventually, in the autumn of 1909, Chagall found his way to the art school that had been founded by Elizaveta Zvantseva and whose dominant teacher was Leon Bakst. At some point, shortly before commencing his studies, Chagall had brought a number of his paintings (possibly between fifty and a hundred) to a local picture framer and dealer. When Chagall returned to see if any sales had been made, the dealer denied all knowledge of ever having received the work. This strange loss, against which, it seems, Chagall had no redress, perhaps because his finances were so meager, is characteristic of both the vagueness that surrounds many stories of Chagall's early life (Did Chagall get angry? Did he threaten the dealer? Did he call the police?) and his early naïveté. Because others frequently took advantage of this trait, in later life it often translated into a deep suspicion of those handling his work that sometimes verged on paranoia.

Alicia Berson, a wealthy St. Petersburg Jewish woman with an interest in art, agreed to pay Chagall's fees at the Zvantseva Academy, and after a typically unnerving interview at Bakst's home in which Chagall played the timid, impoverished, sickly ingenue to Bakst's languid master, Chagall began his studies.

At Bakst's house Chagall had been greeted in a room where the walls were decorated with paintings of Greek gods placed incongruously next to a black velvet curtain, embroidered in silver, of the type and design that usually hung before the ark in a synagogue. The Zvantseva school offered a similarly eclectic atmosphere in its ateliers, where

the influences of Paris, Fauvism, and orientalism were reflected in both the decor and the instruction.

Bakst was a cosmopolitan. Born Schmuel Rosenberg in Grodno, he renamed himself Leon Bakst after moving to St. Petersburg, where he quickly established a reputation both as a painter and as a sophisticated and much revered set and costume designer. He had spent the 1890s in Paris, where he had been a founding member of the group associated with the journal *Mir Iskusstva* (World of Art), a Russian version of the aesthetic and Symbolist movements that sprang up elsewhere in Europe in the same period. Bakst's designs often seem like a visual companion to the resplendent decadence of novels like Huysmans's *A rebours* (Against Nature), with its jewel-studded turtles, exotic flowers, and assault on convention of all kinds. One can see why Chagall's vision, quirky, but more in keeping with the down-to-earth, folk-inspired movement in Russian art, would not immediately appeal to Bakst. Moreover, it seems possible that Bakst, who had worked hard to erase at least some elements of his Jewishness, was threatened by Chagall's insistent ethnocentricity and the claims that Chagall made upon him as a fellow Jew.

My Life contains Chagall's bizarre suggestion that Bakst still sported recognizable *payyes*. "He could have been my uncle or my brother" at their time of meeting. In fact Bakst had converted to Lutheranism in 1903, and it was to be another seven years before he reverted to Judaism. Chagall, it seems, liked both to identify with his teachers and to reject them.

The difficulties that Chagall experienced as a twenty-one-year-old while a student in Bakst's class at the Zvantseva Academy have frequently been read as stemming from their irreconcilable clash of styles: Bakst, primarily a stage and costume designer whose contemporary reputation has its locus in the radically erotic outfits that he made for Nijinsky's performances in Diaghilev's *L'après-midi d'un faune,* championed a decorative, mannered, highly stylized aestheticism that, whether practiced by hetero- or homosexuals, we would probably have no problem in describing today as "gay," against which Chagall's ethnocentric, folk-inspired work apparently appeared threateningly "earthy." An irritated and deflated Chagall fled Bakst's class after only a few weeks.

Quite possibly it was not only Bakst's harsh or suspended judgments of Chagall's work that unnerved him. Nijinsky, Diaghilev's sometime lover, was a fellow student of Chagall's, as talentless in drawing as he was brilliant in ballet. Nevertheless, Nijinsky was doted on by Bakst, while Chagall found himself mostly on the receiving end of his master's disapprobation. The emasculated stereotype that attached to the artist's calling in Bakst's circle may well have frightened Chagall off, and frightened him particularly because he had not yet sorted out his feelings for Victor Mekler.

Whatever the actual relationship between Bakst and Chagall, and whatever their impact upon each other, it is certain that while he was under Bakst's tutelage Chagall became exposed for the first time to the work of Manet and Monet,

to Cézanne's bold distortions, and, most important, to the ravishing colors of Matisse. In St. Petersburg at this time he could also visit exhibitions of paintings by Gauguin, Bonnard, Vuillard, and Derain. Paris beckoned. Bakst offered Chagall a hundred francs with the promise that if Chagall learned how to paint scenery he could accompany him to the French capital.

Chagall, however, had his own ideas. He made a return visit to Vitebsk, where he found the town, as usual, inspirational but severely wanting as a domicile for an artist with ambition. "Vitebsk, I'm deserting you. Stay alone with your herring!" he wrote in *My Life*. Not even Bella's beauty and sensuality could hold him. As often seemed to be the case with Chagall, a benefactor came forward at just the right moment to help him out: Maxim Vinaver, a prominent St. Petersburg lawyer and a member of the Duma (parliament), granted him a stipend large enough to cover his expenses for a year in Paris. Chagall regarded Vinaver, a cultured and generous man who also edited the Jewish journal *Voshkod* (Dawn), as the prime mover and shaker in his career as an artist. Both men benefited from their relationship: Vinaver as a collector of Chagall's early works, and Chagall as a free painter in Paris.

3

Paris

Chagall arrived in Paris in the late summer of 1910 after a train journey from St. Petersburg that lasted a grueling four days. When he disembarked at the Gare du Nord and walked up the platform in the warm August air, Victor Mekler was there to greet him. The nature of the two young men's relationship is not entirely clear, but a letter that Chagall wrote to Victor shortly after his arrival in Paris, and possibly never mailed, incorporates a strong homoerotic element. Chagall recalls their parting in Russia and "the last resonance of our smoke-filled kiss at the railway station" and also refers obliquely to the "*such, you know* . . . feminine" in both of them. The scholar Benjamin Harshav, the first translator of this letter into English, has noted how the twenty-three-year-old Chagall struggled, in his first months in Paris, not only with religious and artistic but also with sexual ambivalence. Did Mekler chuck Chagall in Paris for their fellow Jewish artist Abram Kozlov? The possibly unsent letter from Chagall seems to indicate as much. "I shall not invoke any curses. They have no impact on you. I

only want to tell you, perhaps for the last time, that you treat me unjustly as a swine. After 6–7 years of our friendship, you could have been softer. I left the café on St.-Michel then because my self-esteem was offended. You told Kozlov (that fallen man of St. Michel), among other things: 'Watch out that I don't abandon you as I left Moysey.' " "Moysey" was Victor's name for Chagall.

Chagall's relationship with Bella, whom he loved with all his heart, is well documented, and because of its well-known passion and intensity has probably obscured the homoerotic elements in the painter's early life and in his work. In addition to his facial makeup, Chagall's personal style was often dandified. The portrait of him painted by Yehuda Pen in 1914 presents the image of a feminized romantic artist clutching his palette and wearing a floppy black fedora, a green jacket, and a loose, broad-collared shirt. Chagall also appears to be wearing white kid gloves. A 1923 photograph of Chagall with his family in his Paris studio on the avenue d'Orléans shows him in a wide-striped, almost clownlike jacket and loosely tied cravat. Oddly, in interviews Chagall claimed that he had no dress sense whatsoever, and flung his clothes on haphazardly, without attention to taste or style. It seems possible, however, that he liked to station himself in manly opposition to the suggestively effete, precisely because at times his own self-presentation was sexually insecure.

Chagall did not have the in-your-face macho personality of a Picasso or a Hemingway (he does not paint bullfighters—

neither did he box or fish for tarpon), and much of his work, replete with flowers and sky-high lovers, plays off the conventions of romantic love. Thus it is not surprising, given the cultural milieux that he inhabited, effete in St. Petersburg and macho in Paris, that Chagall felt a need to balance both his own posturing and the potentially sentimental subject matter of his art by finding ways to line up on the tough guy's side of things—where, say, only women spend time thinking about what to wear. Whatever his sexual proclivities as a young man, Chagall exhibited a floating anxiety which we can only surmise stemmed from an occasional alarm about his own ambivalent feelings.

Since the turn of the century trains from the east and from the south had brought hundreds of ambitious young painters to Paris, then both the Mecca of European art and the crucible of an experimentation that was utterly to transform the world of painting. By the time that Chagall arrived in the city, Modigliani, a Sephardic Jew from Livorno, had already been living in Paris for four years, and Pascin, a Bulgarian Jew born Julius Pincas (Pascin is an anagram), had been there for five. Picasso had established himself in his Montmartre studio in 1904.

Chagall spent his first few nights in the City of Light in Mekler's hotel room on the carrefour de l'Odéon before renting a small studio at 18 impasse du Maine that belonged to the Russian painter Ehrenburg, a cousin of the writer Ilya Ehrenburg. Here, Chagall began to paint, saving pennies by painting over old paintings that he purchased in the local

market and even going so far as to do the same to some of Ehrenburg's own work, landscapes that Chagall judged to be worthless efforts.

Both the local ambient light and the inspirational paintings that Chagall discovered in the Louvre, in particular the works of Veronese, Manet, Delacroix, and Courbet, glued him to Paris whenever he felt homesick. In *My Life* he waxes rhapsodic over both the luminosity and the art, but the light that Chagall knew in his first months in Paris was autumnal descending into wintry, not the brightness falling from the air that later drew him, along with Matisse, Picasso, and so many others, to the Mediterranean, where the sea kissed the French Riviera.

Chagall's light was also metaphorical, a "light of liberty," as he called it. Indeed, after his experience of the endemic anti-Semitism of the czar's declining empire, the open freedoms of Paris (the city's Jews, we should remember, had been granted religious autonomy by the Napoleonic Civil Code of 1804, and they certainly did not require a "pass" to wander in its streets), its roaring cafés and lively art scene, were heady stuff. The most prestigious of the city's art schools was the École des Beaux-Arts de Paris, where both Pissarro and Cézanne had once taught. Chagall took (or more accurately resisted) instruction at two less distinguished art schools: the Palette and the Grande Chaumière, although he soon conveniently "forgot" that he had ever been in attendance at either place.

When he wasn't producing life studies (the drawings

include *Art School Nude* [1911] and *Seated Model* [1911]), or at
work in his own studio, or standing in rapt attention before
the masterpieces in the Louvre, Chagall searched out gal-
leries, Durand-Ruel's or Bernheim's or Vollard's, where
paintings by van Gogh, Gauguin, and Matisse were on dis-
play. He also took in the Salon d'Automne, heading, as he
wrote, "straight to the heart of French painting in 1910."
There he was able to see in person for the first time works by
artists that previously he had known only from the pages of
books or magazines.

The first paintings that Chagall produced in Ehrenburg's
studio in 1910, including *Studio*, *The Model*, *Lovers on Bench*,
and *Nude with a Fan*, are bright with color and clearly reveal
the influence of van Gogh, Gauguin, and the Fauves who fol-
lowed them, most particularly Matisse. Chagall quickly har-
nessed the dazzling colors of the Fauves—literally "Wild
Beasts," and so named because of their "wild" nonrealistic
use of pure color—to his domestic beasts: the cows, horses,
and chickens that inhabited his own memory and imagina-
tion. The transformation in Chagall's work is striking, as the
muted browns and greens of his Russian paintings give way,
via a dramatically altered palette, to the saturated vibrant
blues, greens, purples, and yellow ochre of his early Paris
works. *The Wedding* (1910) is a particularly compelling exam-
ple of Chagall's Parisian metamorphosis. The subject matter
is familiar. In fact, the figures are repeated from an earlier
version of the painting: a wedding party on the streets of
Vitebsk, a fiddler and boy piper leading the bride and groom,

rejoicing relatives behind them, and, elsewhere, a Jewish worker burdened with the yoke of two heavy pails, carrying on his solitary business much like the street sweeper in *The Dead Man*—the struggle of a hard life unaltered by the interruptions of birth, marriage, or death. But what is unfamiliar is the riot of color, a sky shaped in narrow panels of red, green, and blue, not quite a Cubist sky but getting there, and the members of the procession incongruously dressed in coats of many colors. Chagall, it seems, was determined to transport the exuberance and freshness that he felt in Paris back to Vitebsk, as if through the magic medium of paint the past itself could be transformed.

In the winter of 1911 (or possibly the spring of 1912) Chagall moved to La Ruche (the Beehive), a honeycomb of 140 narrow, high-ceilinged little studios at 2 passage de Dantzig. Through Chagall's windows on the top floor (Vinaver's money secured the elevation) wafted smells and noises from the slaughterhouses in the Vaugirard district. Things, at this time, had not been going well in Chagall's career: his work, sent home, had been rejected from one significant exhibition in Russia and stuck away in a corner at another. At La Ruche, however, dividing up a herring for his daily meals and painting all night, alone and often naked (Chagall had a quasi-erotic relation to his own work), his mind totally absorbed with the canvas before him, he was to produce what most commentators believe to be the finest paintings of his life.

The masterworks that Chagall created in his La Ruche

studio include *I and the Village* (1911)—from a twenty-four-
year-old!—*Homage to Apollinaire* (1911–12), *Self-Portrait with
Seven Fingers* (1912–13), and *Paris through the Window* (1913).
His breakthrough was profound, no less so in its own way
than Picasso's with *Les demoiselles d'Avignon*, although *that*
painting of Paris whores with African mask faces was to spin
out ripples into the art world for a hundred years, whereas
Chagall's brilliant harnessing of his Yiddish past to mod-
ernist techniques could have only a restricted influence
because his subject matter collected around beautiful losers
in a dying culture. As with Isaac Bashevis Singer, Chagall
could have no followers (until, perhaps, Gabriel García
Márquez squeezed Colombia's folk culture to his heart and
levitated an inhabitant or two in the fictional town of
Macondo). But unlike Singer, Chagall had no precursors
either.

Chagall, whether he believed that he was doing so or not,
sneaked Yiddish culture into twentieth-century painting
though the back door. Hardly anyone, with the exception of
the odd French anti-Semite, noticed what was happening
because the vibrant visual expression of his paintings car-
ried the stamp of the modern and not the stigma of a dying
language. Sadly, Chagall's genius spawned a host of artists
who specialized in Jewish kitsch, whereas Picasso's had an
impact on almost every great painter who came after him.

Like the Jets and the Sharks in *West Side Story*, young
painters in Paris occupied competing turfs. Picasso and his
gang lived in and around the more established and margin-

ally fancier Bateau Lavoir studios in Montmartre, while new arrivals, including the majority of the Jewish painters in the city, inhabited La Ruche in the yet-to-be-discovered neighborhood of Montparnasse. One might imagine that the Yiddish-speaking Chagall would have gravitated to the congregation of young Jewish painters and sculptors in the studios adjacent to his own. In fact, he kept aloof, preferring the company of French poets like Guillaume Apollinaire and Blaise Cendrars, who was to become one of his closest friends.

In Russia Chagall had felt like a Jew "at every step," and it hadn't always been a beguiling experience. In Paris, his initial separation from other Jewish artists grew not only from relief at temporarily setting aside an identity that had defined him by confining him but also from a desire to place himself in opposition to certain burgeoning ideologies of "Jewish art."

La Ruche was home to a small group of Eastern European Jewish artists, including Joseph Tchaikov, Leo Koenig, Yitzhak Lichtenstein, Marek Szwarc, and, briefly, Pinhas Krémègne, who called themselves the Machmadim (*Machmadim*, a word that appears only once in the Hebrew Bible, in the Song of Songs, is sometimes translated as "Beloved," although it more accurately means "Desire of my eyes") and produced and published a magazine of the same name. Only seven issues, reproduced on a hectograph and made up exclusively of pictures, ever appeared. The Machmadim were committed to producing a modern, international Jew-

ish art that was nonetheless grounded in Jewish folklore and biblical tradition. For example, one issue of the magazine contains a drawing by Marek Szwarc of the expulsion of Adam and Eve from paradise, while another issue, called "Sabbath," contains his line drawing of two pious Jews in deep conversation. And yet, in execution, the work of the Machmadim is essentially conservative. Chagall had nothing but disdain for the "foolish, senseless ideas of my neighbors about the fate of Jewish art." However, as critics have not been slow to point out, Chagall's own work, with its surreal shtetl and biblical scenes, in many ways fulfilled the dreams of the Machmadim in paintings that they themselves perhaps had neither the imagination nor the daring to create.

Chagall, of course, was not exclusively Jewish in his thematic considerations, whereas the Machmadim worked within their self-prescribed borders. In 1913 Szwarc made his debut at the Salon d'Automne with a plaster bas-relief of a chaste Hebrew Bible "Eve" marked in style by the classical education he had received at the École des Beaux-Arts. In contrast, Chagall had made his own first successful salon appearance in the Salon des Indépendants a year earlier with the highly erotic and suggestive *Dedicated to My Fiancée*, originally entitled with pagan gusto *The Ass and the Woman*, a painting that was ordered to be removed from display because it was considered "pornographic." It would be interesting to know what Bella (Chagall's fiancée at the time) made of the work, which shows a reclining man in a scarlet robe with a bull's head (Apollinaire, missing the horns, mis-

took it for that of a donkey) enjoying a heavy embrace from a woman whose head, inverted and twisted around the bull/man's shoulder, resembles that of a grotesque Queen of Hearts. Whoever she is, she is spitting something—saliva or semen?—into the bull's contented face. In the bottom right-hand corner is the offending "pornographic" object, a penile oil lamp cum opium pipe that, in the context of the painting, was apparently too much for the Parisian judges.

La Ruche was undoubtedly a place of intoxicants and sex. Modigliani, who lived there intermittently from 1911 to 1913, was a great consumer of hashish (supplied by his doctor and patron Paul Alexandre) and frequently worked while stoned. Chagall, however, was not known as a party animal. Despite his fellow artists' appeals to come out to play—drunk and rowdy, they threw pebbles and shoes at the windows of Chagall's studio—he preferred to remain alone. Chagall, according to some reports, was not particularly well liked by other artists in his building, one of whom accused him of stinginess. Perhaps this explains the sense of slightly forced effect that pervades *Dedicated to My Fiancée*. It is as if, in announcing himself to the salons, Chagall wished to present himself as "one of the boys" when his heart wasn't really in it.

He would never again be cause for controversy as a supposed pornographer (very little of Chagall's work is powerfully erotic—the ink on paper *The Raised Blouse* of 1911 is a rare example), although he would arouse resentment as a Jew when he took on subject matter, such as the *Fables* of La Fontaine, believed by some to be appropriate only for inter-

pretation by French-born Christian artists, and a commis-
sion to paint the ceiling of the Paris Opéra, a location which,
for many French conservatives, should also have been off-
limits to non-Christians.

There were Jewish artists in Chagall's league in Paris—
Modigliani immediately springs to mind, and of course
Chaim Soutine, who arrived in 1913 and went on to become
the leading figure among the Jewish artists of Paris, despite
the fact that there is no Jewish subject matter in his work.
Modigliani got into fistfights with anti-Semites on Parisian
streets, announced himself to the salons with a painting
called *The Jewish Bride*, and occasionally included Hebrew
letters in his drawings, but his affect, in his work and in his
life, was more Italian than Jewish. Chagall thought him "a
prince," and indeed he spent far more time living in the rela-
tively princely Montmartre than he did in the shtetl of La
Ruche.

Soutine, six years younger than Chagall, hailed from an
intolerably tough and impoverished background in Smilo-
vichi, a small Jewish village of some four hundred homes in
what is now Belarus. He was the tenth child in a family of
eleven children ruled over by his unpleasant and aggressive
father, who was the "town mender," a position one step
lower than a humble tailor. Soutine's father frequently tried
to beat the aspiring artist out of his son and also punished
him by locking him in the cellar of their tiny home. Ironi-
cally, Soutine's career was jump-started by a street beating.
While he was trying to sketch the local rabbi, the pious

gentleman's sons attacked Soutine and beat him severely. The result was a twenty-five-ruble payoff, which enabled him to sign up for art school.

One might have thought that Soutine would have been a natural companion for Chagall in Paris, but Chagall kept his distance. He found Soutine uncouth: a crude figure with poor eating habits and dirty clothes. Instead it was Modigliani and Soutine, prince and pauper in appearance and grace of personality, who teamed up as inseparable friends.

From his Paris beginnings the feverish passion of Soutine's Expressionism was, and remains to this day in some circles, frequently regarded as emblematically "Jewish." The grounds for this assessment cannot travel beyond a stereotypical association of Jews as a people who overemote. By extension the association could attach itself to Mark Rothko's (born Marcus Rothkowitz) overpowering, meditative abstractions or Philip Guston's (born Philip Goldstein) dramatic, cartoonish Ku Klux Klan figures. A Jewish hand at work with a Jewish consciousness guiding it may indeed produce Jewish painting, but when Jewish subject matter is absent, it cannot promote anything other than highly speculative discussion.

The paintings of Modigliani and Soutine were in Chagall's purview, but they were not on his mind. The artist who occupied his thoughts, as two small works make readily apparent, was the decidedly non-Jewish Picasso. *Thinking of Picasso* (1914) and *Chagall, tired of Picasso* (1921) confirm what everyone in Paris must have known from day one, that all

brushstrokes on canvas led, like it or not, to an engagement with the presiding genius of the city.

Chagall's relative isolation from his fellow painters at La Ruche can be ascribed to a number of factors, including his worse than poor French, his less than perfect Russian, and his feeling of superiority (justifiable in aesthetic terms) toward his fellow Yiddish-speaking Jewish artists. His awkward sociability was compounded by his indifference to the inebriation and girls scene, a product, most likely, of his loyalty to his fiancée, Bella, who was studying in St. Petersburg— although the intriguing possibility remains that his sexual interests did not lie dormant, but elsewhere.

A four-year separation from the love of one's life is a significant event, but whether the energy that Chagall might otherwise have dedicated to love was channeled into painting or whether he received inspiration from his distant muse, the results are both wondrous and strange. *Homage to Apollinaire* (1911–12), for example, a large, seven-by-six-foot, neo-Cubist, neo-Orphic work, romantically dedicated via a pierced valentine heart on the canvas to the poets Apollinaire and Cendrars, and also, somewhat disingenuously, to the gallery owner Herwarth Walden and the art critic Ricciotto Canudo, centrally features the spliced figures of Adam and Eve, who share two legs and a vagina. Adam's (or possibly Eve's) left arm and hand, curled like the body and head of a snake, offer a compensatory phallic gesture. This painting, marked with allusive Hebrew and English letters and dates, famously stimulated Apollinaire to cry out "Sur-

naturel!" (Supernatural!), a yawp that Chagall tells us spawned Surrealism (although he did not believe his own work fitted the category). But despite the supposedly arcane or even kabbalistic mysteries that have been read in and out of it, *Homage to Apollinaire* is of a piece with the other works that Chagall produced in this time away from Bella in its representation of sexual and religious confusion.

The absorbingly brilliant *I and the Village* yokes subject matter from Chagall's recent past—cows, milkmaids, Russian peasants, Orthodox churches—with a grab bag of techniques from the modern: a geometrically divided canvas, bright Orphic colors, Cubist planes, Surrealist dreams. It centers on a loving look in profile between a green-faced man with a cap and a soft-eyed multicolored heifer. The heifer is wearing a pretty necklace, while green-face sports a similar piece of jewelry but with a crucifix attached. Jacob Baal Teshuva, who knew Chagall well, has identified the man with the green face as a self-portrait: if so, the crucifix becomes as charged an object as Adam's (or Eve's) shared vagina.

Self-Portrait with Seven Fingers is similarly revealing. The title derives from a Yiddish expression: to do something "with seven fingers" is to do it very well or very nimbly and quickly. A dandyish (bow tie, boutonniere), Cubist Chagall sits at his easel in his Paris studio. He is at work, seven fingers splayed on one hand, on one of his own paintings, the nostalgic *To Russia, Asses and Others* (originally titled, less grandly, *The Aunt in the Sky*). The Eiffel Tower offers itself as

a view through the left-hand window, while the top right-hand corner shows the artist's daydream, a Vitebsk scene with picturesque church. There isn't a synagogue in sight. Along the top edge Chagall has inscribed in Yiddish the words "Paris" and "Russia."

Here we have a twenty-five-year-old in a not unfamiliar situation, pulled in conflicting directions by competing elements from his past, present, and imagined future: Russia, Paris, Yiddishkeit, Christianity, Cubism, neoprimitivism, and we cannot help but notice the painter's long wavy tresses and the "such you know . . . feminine" of his self-representation.

Paris through the Window repeats an aspect of Chagall's inner struggle, that between on the one hand Bella and Vitebsk, where his love lies, and on the other the lure and allure of the great cosmopolitan city. And yet, as in the other paintings, Chagall finds, paradoxically through fragmentation and spatial ambiguity, a resolution within the overall inside/outside balanced structure of the work itself. In the bottom right-hand corner we see a man who has a single head but two faces pointed in opposite directions. Directly above him two tiny airborne figures are walking the street; at first glance they appear to be horizontal Hasidim, but on closer inspection they turn out to be Paris gentry, a woman in a broad hat and a man with a walking stick. High above them a figure parachutes to earth from the top of the Eiffel Tower holding a conical tricolor. In the foreground, on a reddish brown windowsill sits a yellow ochre cat with a human

face. An upside-down train is heading somewhere (back to Vitebsk we assume). The man with two faces has a heart imprinted on his hand.

It was Chagall's great talent as an artist to absorb influences without becoming a slave to them. He was not an intellectual, and he powerfully resisted ideologies and theories while, magpielike, stealing what he fancied from the various isms that surrounded him. This characteristic preserved Chagall's artistic integrity in Paris but inevitably got him into trouble in Russia after the Revolution.

In Paris Chagall went his own way, and it was probably fortuitous in this regard that he did not meet Picasso until much later in his life. At Baty's restaurant in Montparnasse one day, shortly after he and Apollinaire had watched a frowning Degas cross the street, Chagall asked the poet why he hadn't introduced him to Picasso. Apollinaire replied, "Do you want to commit suicide? That's the way all his friends end." This of course was a reference to the powerful, overwhelming combination of Picasso's art and personality. Picasso was six years older than Chagall and had painted the groundbreaking *Les demoiselles d'Avignon* (a work as important to twentieth-century art as Joyce's *Ulysses* was to be to literature) three years before Chagall had even arrived in Paris. Picasso's over-the-top personality, his Spanish machismo, womanizing, and extraordinary confidence made him a dangerous friend. He was, if you like, the bull of the corrida to Chagall's shtetl cow. Apollinaire had exhibited no such qualms in introducing Braque to Picasso, but perhaps he

sensed that Chagall was not yet strong or formed enough for the challenge. In later years the two men developed an on-off relationship. Picasso veered between admiration, especially for Chagall's use of color, and disdain. For his own part, as we shall see, Chagall could not take his mind off Picasso's work for a number of years, and was obsessed with his status. He also frequently found him unbearable as a man.

Chagall did make friends, although not many, among the painters of Paris, most importantly with Robert and Sonia Delaunay. Robert's color disks inspired the background to *Homage to Apollinaire*, and one of Chagall's biographers has puckishly questioned why this didn't merit him a mention in the painting's valentine. For Chagall, Delaunay was a voluble and entertaining talker, although this wasn't a view shared by all; Gertrude Stein, for example, characterized him as a relentless self-promoter and a negligible painter.

Chagall shared an affinity with Sonia Delaunay (née Terk). They were almost the same age, both from Russian Jewish homes (although Sonia's had been far better off than Chagall's), and both had studied art in St. Petersburg. Sonia Delaunay, however, had little interest in the left-behind Jewish world of places like Vitebsk, and her artistic ambitions were more single-mindedly focused on the exciting possibilities of the new art in the rapidly transforming city of Paris. Her husband was one of the first painters to use the Eiffel Tower as an iron symbol of "the modern" in his works. The borders that Sonia preferred to cross were not those between the Old World and the New but rather those that had been

arbitrarily established between art and design and art and fashion.

It is possible that Chagall was drawn to the Delaunays because they (or certainly Sonia—Robert was not Jewish) presented a seductively assimilated alternative to the Jewish-centered world of the Yiddish-speaking Machmadim. Later in life, Sonia Delaunay and Chagall shared, perhaps longer than most Jews in their adopted country, an understandable but sadly naïve faith in the protective powers of their French citizenship, until both had a rude awakening when the Vichy authorities came in search of them.

The most important and closest relationships that Chagall developed in Paris were with the poets Guillaume Apollinaire and Blaise Cendrars. It is not unusual for painters to cultivate friendships with poets; perhaps there is some relief in the shared artistic enterprise but absence of direct competition. In Chagall's case there was, additionally, a striking affinity between his allusive paintings, which had both a measure of abstraction and an implied symbolic narrative, and the poems of his two friends, which also aspired toward abstraction or the surreal but were tied to some kind of story by the recalcitrant referentiality of language. (It would be half a century before William Burroughs, with his "cut-ups," attempted to match the collages and pure abstractions of the early modernist painters. According to Burroughs, writing always lagged several decades behind painting in radical experimentation.)

Chagall and his poet friends formed a mutual admiration

society. He painted and drew Apollinaire several times, and Apollinaire returned the favor in his poem "Rotsoge": "Your round house where a smoked herring swims in circles . . . a man in the sky, / a calf peers out of his mother's belly . . . When I think of your childhood it brings tears to my eyes." Cendrars, who frequently provided Chagall with arresting titles for his paintings, incorporated portraits of Chagall and descriptions of his works into several of his poems. In the first section of his evocative *Nineteen Elastic Poems*, Cendrars builds to a wild climax in his exaltation of Chagall:

> Christ
> He's Christ
> He spent his childhood on the Cross
> He commits suicide every day
> Suddenly, he's no longer painting
> He was awake
> he's asleep now
> he is choking himself with his tie
> Chagall is surprised he's still alive.

To be identified with Jesus was never something that particularly bothered Chagall; indeed he embraced the connection, and in the deep gloom of the 1940s he produced a number of his own poems, penned in Yiddish, which parceled his own suffering into Christ's.

For almost three years in Paris, Chagall hardly sold a painting. Then his luck changed: the valentine that he had extended to the German Jewish art patron, publisher, and

gallery owner Herwarth Walden in *Homage to Apollinaire* worked its magic—along with a little prodding of the curator from Apollinaire himself. In September 1913 Walden exhibited three of Chagall's major works, *Dedicated to My Fiancée, Dedicated to Christ* (later renamed *Golgotha*), and *To Russia, Asses and Others*, as part of his First German Autumn Salon, held in his Berlin gallery Der Sturm, which was also home to Walden's influential arts and cultural magazine of the same name. Walden, an intense, vital personality, as significant as Henry Kahnweiler in his discovery and promotion of new talent, had opened his gallery in 1912 with a show by the Austrian Expressionist Oskar Kokoschka—the show included Kokoschka's portrait of Walden, who was clearly not immune to flattery.

Walden quickly sold *Dedicated to Christ* to the Berlin collector Bernhardt Kohler. Chagall, on the premises for the opening, with Cendrars along for the ride, thus witnessed his first major sale outside Russia. It is a more than passing irony of course that it was this work which kick-started the career of the man who was to become the emblematic Jewish artist of the twentieth century.

In the spring of 1914, Walden included Chagall in a two-man show alongside the Austrian painter Alfred Kubin, and almost immediately began to arrange Chagall's first major one-man show for the summer. Chagall planned to attend the June opening and then travel on to Russia in order to attend his sister's wedding and, rapturously, as he imagined, to reunite with Bella. In Berlin, Chagall wrote, "my pictures

swelled in the Potsdamerstrasse while, nearby, guns were being loaded." There were 40 oil paintings on display and 160 other works—gouaches, watercolors, and drawings—all results of the furious, inspired, heated labor of Chagall's Paris years.

The moment before a European war was no doubt a strange time for Chagall to make his European debut. It did not evade Chagall's notice that artistic relevance itself was under siege. "Europe was going to war," Chagall remembered thinking years later. "Picasso, Cubism is done for!" (Chagall, as we see, even on the eve of his huge exhibition, was still "thinking about Picasso.") June in Berlin, Bella in Vitebsk, the scents of war and love were heavy in the summer air. Chagall put in his obligatory appearance at the opening, and only days later, on June 15, embarked on his train journey to Russia. He sent a postcard to Robert Delaunay complaining about the general unattractiveness of German girls and then he was gone. Eight momentous years would pass before he was able to return to Paris.

4

Bella

"We all hate home/And having to be there," wrote the English poet Philip Larkin, himself one of the world's great stay-at-homes. On his return to Vitebsk Chagall found his hometown, which had inspired only nostalgia while he lived in France, "strange, unhappy and boring." His response to such disappointment was characteristically energetic and productive. He began to paint, almost without discrimination, everything he saw. In his rush to document the world around him, and perhaps because his immediate local audience lacked sophistication, his urge to experiment fell away (although not entirely) and he produced a number of works in muted colors and a more or less naturalistic style.

He did not, however, relinquish his airborne figures. *Over Vitebsk* (1914), for example, features a larger-than-life bearded peddler with a yellow ochre sack over his shoulder, floating past the blue-black onion domes of an Orthodox church above snow-filled streets. Here, Chagall's levitating figure is once again a visual literalization of a Yiddish expression—

in that language any door-to-door wanderer was described as "going over (rather than around) the town."

With war approaching, supplies of all kinds dwindled in Vitebsk, and canvas was among the missing. Chagall painted mainly on cardboard and paper. He found his models among street beggars, draping and adorning them with his father's prayer shawl and phylacteries. He paid twenty kopeks for a sitting but sometimes dismissed his model after half an hour because "he stank too much."

Almost inadvertently (he had planned to stay in Vitebsk no longer than three months, and he never stopped trying to return to Paris until it became absolutely impossible for him to do so) Chagall documented, or perhaps it would be more accurate to say represented, the twilight of a Jewish world, its rabbis, peddlers, musicians, newspaper vendors, fashionably dressed young women and men, old folk, young lovers, street signs, butcher shops, domestic and sacred interiors, sukkahs, synagogues, and cemeteries. Chagall was well aware of the ever present anti-Semitism in Russia, and it crossed his mind that he was working somehow to preserve the characters who surrounded him, and whom he loved, by "keeping them safe" on his canvases, but he could not have known that his instinct to memorialize was prescient.

The body of work that Chagall created as a direct result of his unplanned lengthy sojourn in Russia, including *The Red Jew* (1915), *The Pinch of Snuff* (1912), *Feast Day* (*Rabbi with Lemon*) (1914), and *The Praying Jew* (*Rabbi of Vitebsk*) (1914), has probably done more to shape his reputation

among Jews in the post-Holocaust years than anything else in his massive oeuvre. Chagall's stylized Vitebsk, with its magic realist figures and environments (wholly appropriate, like García Márquez's Macondo, to the religious and folk culture that were their inspiration), became charged with the nostalgic burden of the pre-Hitler lost Jewish world. It is Chagall's *Praying Jew* of 1914 that haunts the lachrymose post-Holocaust Jewish imagination, and not, say, either his *White Crucifixion* of 1938, in which a shtetl goes up in flames behind a crucified Jesus, or any of his starker paintings from the Holocaust and immediate post-Holocaust years that directly take on Jewish suffering under the Nazis.

While he worked, Chagall renewed his courtship of Bella. Her most recent letters to him in Paris had, so he sensed, lost a measure of their usual passion, and he returned to Vitebsk beset by an anxiety over how Bella would receive him. While Chagall was painting his heart out in Paris, Bella had been studying history, philosophy, and drama at Moscow's Guerrier College for Girls (she had written a thesis on Dostoyevsky). While in the early days of their relationship she had daringly posed nude for Chagall, in all likelihood she had not slept with him. Four years is a long time in a young woman's life, and Chagall probably had good reason to worry that he had better not leave the "new" Bella, an attractive, wealthy, well-educated, and sophisticated young woman, alone for long. Indeed, he seems to have developed jealous thoughts about her relationship with, of all people, Victor Mekler, who had himself returned to Vitebsk from

Paris some years earlier. But it was Chagall whom Bella loved.

At first her parents opposed the marriage on simple and time-honored grounds: Chagall didn't earn enough money, his father's banquet wasn't big enough, his family held lowly jobs, in contrast with the Rosenfelds, who owned three jewelry stores in town. Then there was a less time-honored gripe: Bella's mother was perturbed by the fact that Chagall continued to rouge his cheeks. The anxiety that lay behind that particular observation of Mrs. Rosenfeld's prompted her to ask her daughter, "What sort of a husband will he make, that boy as pink-cheeked as a girl?" It does not seem outrageous to speculate that those pink cheeks somehow also contributed to the vague, unspecified, and floating jealousy in the Mekler-Bella-Chagall triangle.

But here comes Bella into Chagall's rented studio, her arms full of aphrodisiacal sweet cakes, broiled fish, and boiled milk, and after she puts the food down she creates a sexually charged salon in the little room by unwrapping shawls, silk scarves, and an embroidered bedspread for the fiancés. Clearly, she was unmoved by her parents' opposition to her relationship with Chagall. Eventually, as parents generally do in the face of a stubborn daughter's desires, the Rosenfelds relented, and Chagall and Bella were married under a red chuppah on July 25, 1915. The utterly enchanting painting *The Birthday*, executed by Chagall in a flush of sensual and erotic arousal three weeks before the wedding on his twenty-eighth birthday, gives us the decorated room, the

lovers, and their earth-defying love in an ecstasy of reds, greens, blue-black, a silver purse, and a single yellow rose.

In her own memoir *First Encounter* (published posthumously in English in 1983), Bella vividly describes her birthday visit. As she came through the door in the black dress with a white collar that figures in so many of Chagall's paintings of her, and with a bouquet of gathered flowers in her hand, Chagall immediately began to search for a canvas, calling out to her, "Don't move . . . Stay just as you are." Bella continues: "You have thrust yourself upon the canvas which trembles under your hand. You dip the brushes. Spurts of red, blue, white, black. You drag me into floods of color. Suddenly you tear me from the earth . . . both in unison we rise above the bedecked room and we fly . . ." Chagall's urgent need to turn sexual desire into paint, whether on his cheeks or on his canvas via spurting tubes, is nowhere expressed more vividly than here by Bella as she remembers her husband on the cusp of their marriage. Bella is unafraid to objectify herself as the canvas, both the artist's material *and* his inspiration. The finished product, *The Birthday*, unlike Bella's erotically charged prose, but like most of Chagall's work, says little about sex and a great deal about romantic love. Perhaps the sex came after the painting (outside the lovers' window it is both day and night in Vitebsk, before and after), which would explain both the painting and the prose.

The couple honeymooned in Zaolshe, in the wooded countryside outside Vitebsk, a bucolic village that was the

summer home of Shalom Dov-Ber Schneerson, the Luba-vitcher rabbi. Chagall rendered the lyrical qualities of his and Bella's experience both in his writing—"Woods, pines, solitude. The moon behind the forest. The pig in the stable, the horse outside the window, in the fields. The sky lilac"—and in one of his loveliest paintings, *The Poet Reclining* (1915). All the attributes that he later recalled in prose—pig, horse, forest, and lilac sky—are present in the painting, while the "poet," hatless with arms serenely folded across his chest, stretches out in the foreground across the grassy width of the millboard surface. There is a seductive tranquillity to the scene, but of course we cannot help but notice that in this honeymoon painting the "poet" is alone. Initially Cha-gall had painted a female figure next to the male, but for whatever reason, compositional or otherwise, he later erased her. The shadow of the woman is still visible in the painting, down to the alluring shapeliness of her legs. Behind the poet and the shadow, horse and pig face each other with heads bowed; possibly they are eating, but their postures seem almost coy, prenuptial. There is, in *The Poet Reclining*, both a replacement, the shadow for the woman, and a displace-ment, the "poet" for the artist. The poet's eyes are open and his expression is hard to interpret; it is almost melancholy.

Perhaps there is an anxiety present in the pastoral scene. After all, war was in the background and the threat of induc-tion into the czar's army loomed over Chagall. In fact, the military was oddly present on the Chagalls' honeymoon, as in the mornings soldiers belonging to a Russian army base in

the vicinity dispensed their milk products on the black market to the hungry lovers.

Back in Vitebsk the war was also making its presence felt: trains and trucks crowded with soldiers passed through on their way to and from the front, and Chagall saw captured German prisoners arrive, including a wounded man with a beard who reminded him of his grandfather. Chagall's first thought was to get out and back to Paris, but his visa application was turned down. Artists were not without their usefulness to armies during World War I. The Anglo-Jewish painter David Bomberg, for example, was put to work in the British army as a mapmaker. For a while Chagall thought that he might exploit his métier in a camouflage unit, but luckily for him, as it turned out, he secured, through the intervention of Bella's wealthy and influential brother Yaakov Rosenfeld, a far less dangerous job as a clerk in the Office of War Economy. Rosenfeld himself was the director of this office.

Before leaving for Petrograd (as St. Petersburg was named during the war), and as if there was a choice to be made in the decision, Chagall took an unlikely trip back out to Zaolshe to request an audience with Rabbi Schneerson. Chagall's account of their meeting registered his disappointment and recorded a silly exchange. The rabbi blessed Chagall in whatever he decided to do and offered no advice whatsoever. "You would like to go to Petrograd, my son? . . . So be it, my son, I bless you. Go there . . . you prefer Vitebsk, I bless you, go there." Chagall was hustled out before he could

engage the rabbi with the things that were really on his mind: his art, art in general, the authenticity of the Jews as the chosen people, and, most significantly, the "pale face" of Jesus that had been haunting Chagall "for a long time." Schneerson's apparent indifference to Chagall did have one long-lasting effect: according to the artist, from that moment on Chagall responded to advice by doing "exactly the opposite."

Fascinatingly, twelve years earlier, Schneerson, in a crisis of depression and anxiety, had taken the long trip to Vienna to consult with Freud. ("I slept well without Freud," Chagall wrote when he was nearly seventy. "I confess I have not read a single one of his books. I surely will not do it now.") A narrative of the meetings between the great rabbi and the great psychoanalyst, which took place in the first three months of 1903, filtered through Schneerson's son Josef Yitzhak, has been preserved in the archives of the Chabad movement. Schneerson, profound, thoughtful, and sympathetic (it was surely an act of great humility for him to search out advice from a secular psychiatrist at the dawn of psychoanalysis), hardly seems recognizable as the empty figure derided by Chagall in *My Life*: "My God, what sort of a rabbi are you, Rabbi Schneerson!" Apparently Freud was influenced enough by the rabbi's dignity and learning to stop making Jewish jokes, while Schneerson took Freud's advice to get out of his books and into active charity work.

Throughout his life Chagall liked to check in with the highest authority available when he had a big decision to

make. No harm in that, but occasionally his narcissism trumped his reason, as when Chagall saw his first sullen German prisoner of war on a ragged street in Vitebsk, and his first thought was to ask the unfortunate stranger if he knew anything about Herwarth Walden and the fate of the paintings that he had left behind in Berlin in the dealer's custody!

In Petrograd, Yaakov Rosenfeld was exasperated by his brother-in-law's ineptitude with figures, but eventually Chagall stumbled toward some kind of competence in his position. Chagall, who claimed that he had only gone to Petrograd in the first place in order to satisfy Bella's cosmopolitan yearnings, experienced his job as a horrible burden: "Compared to my military bureau," he wrote, "the front seemed to me like a promenade, like exercises in the open air." It is, of course, not unheard of for young men to imagine gunshot and canon as the finest play under the sun, but one doubts that anyone who was actually at the front would have agreed with Chagall.

The Germans won their first victories, and Chagall felt the "poison gases" blowing all the way back to 46 Liteiny Prospect, where he worked, and "choking" him there. Chagall's desire (again, not unusual for the guilt-ridden sedentary office worker in the military) to appropriate the very real suffering of the men on the front lines can also be understood by the fact that in Petrograd his life really was in danger, although not in the way that he liked to imagine. Jews were hardly the most popular ethnic group in town; indeed, they still required special residence permits to live in Petro-

grad, where, despite their small numbers, pogroms were not infrequent. One night a gang, dressed as soldiers and out looking for Jews, confronted Chagall on a dark cobblestone street. He escaped by the skin of his teeth only to witness the shooting of other Jews, whose bodies were then tossed unceremoniously into the river.

On May 18, 1916, not quite ten months after her marriage to Marc, Bella gave birth to a daughter, Ida. Chagall was initially dejected not to have fathered a son, and he stayed away from Bella and Ida for four days before his better sense prevailed. Even so, he found that his instincts were not as "paternal" as he might have wished; his angry reactions to an apparently inconsolable crying baby and proximity to some unpleasant odors, not at all unusual for a first-time father, made him feel monstrous.

Despite the vagaries and deprivations of war, the months of Bella's pregnancy had been both relatively calm for her and productive for Chagall. In March 1915 he showed twenty-five paintings in Moscow at the Michailova salon and a month before Ida's birth he exhibited sixty-three paintings in Petrograd at the Dobitchina gallery. In November 1916, forty-five of his works were featured in the group show of the avant-garde "Jack of Diamonds" collective in Moscow. Soon after, Chagall received his first public commission, murals for a cheder in the largest Petrograd synagogue. By the time of the February revolution in 1917, Chagall had sold work to a number of well-known collectors and drawn serious, if controversial, critical attention. "Why do the Jews have to

be so dirty, with such idiotic and animal looks?" asked one offended Russian reviewer.

It didn't seem as if there could be any better news for Russian Jews than the fall of the czar in March 1917. Chagall was swept up in the general exuberance; his first thought was enormous relief that his days as an "illegal" resident in Petrograd were over. In Chagall's memoir the months of Kerensky's short-lived semi-democratic Duma are parsed in a few quick ecstatic sentences, emblems of the freedom from restriction that Chagall undoubtedly felt, but they build to the dramatic and ominous arrival of Lenin at the Finland Station. Something about the famous "sealed train" sent shivers through Chagall, and amid the confusion and fervor of change, for perhaps the first time in his adult life he began to neglect his work.

Was Chagall a political animal? In his memoir he is frequently coy on the subject, often preferring to play the artist-naïf, but his commitment at various times in his life was not insignificant, as is well illustrated in his discursive prose, particularly the articles that he published in the first eighteen months after the Revolution. Moreover, his paintings, anecdotal by nature, often tell a story with a lesson for history. "Lenin turned it [Russia] upside down the way I turn my pictures," Chagall once wrote. But twenty years after the Revolution, painting in full knowledge of the murderous Soviet regime for which Lenin had laid the groundwork, and out of deep despair and disillusion with the entire Bolshevik experiment, Chagall turned Lenin ignominiously

on his head at the center of his monumental painting *The Revolution* (1937).

In the first delirious days of the Revolution, with Jews freely allowed into universities for the first time, equal rights apparently granted, and with powerful Jewish figures, especially Trotsky, on their way to positions of great authority and power, any Jew could be forgiven for imagining that better days were around the corner. In the first weeks of the provisional democratic government, Chagall heard his name bandied about as a possible minister of the arts. He flirted with taking up the position, but Bella, perhaps mindful of the chaos that would surround her new family, or alert to possible future danger, persuaded Chagall to leave Petrograd for the relative security of Vitebsk.

5

Return to Vitebsk

In Vitebsk Chagall threw himself into politics in a way that he had never done before and would never do again. His first thought had been to forget about Lenin and Trotsky and reestablish himself in the role of artist-bohemian-vagabond: a man given to wandering the riverbank, then sitting contemplatively by a mill and staring at an old bridge, or searching out inspirational subjects, like vagrants, peddlers, women with birch switches in their hands, soldiers at the bathhouse. However, the Revolution grabbed Chagall by the throat, and he was quickly immersed, in his own quirky way, in establishing the new order in art on a local level for his hometown. He was a Red Jew quite different from the one-eyed old man with a full red beard whom he had painted in 1915.

In the summer of 1918 he had been summoned for a brief interview at the Kremlin by Anatoly Lunacharsky, the People's Commissar of Enlightenment, a powerful and not unsympathetic figure in the new regime whose charge was transforming Russian education and culture. Lunacharsky, who had once visited Chagall's studio in Paris, offered him

the job of plenipotentiary for the affairs of art in the province of Vitebsk. It is a sign of the confusion, softness, and relative openness of the moment that he considered the painter of levitation and dreams a good bet to fill such a position.

Chagall immediately proposed to establish an art school in Vitebsk. The building that he chose for the People's Art College and Art Museum happened to be the appropriated mansion of a Jewish banker, Israel V. Vishnayek (an uncle of the photographer Roman Vishniac), at 10 Voskresenskaya, a fact that has not been widely disseminated in those contemporary Jewish communities in America where Chagall is frequently celebrated only as the whimsical and sentimentalist painter of the lost shtetl. According to Benjamin Harshav, there is no possibility that Chagall was not involved in the confiscation of Vishnayek's home, which was made official in November 1918. Indeed, after allotting space in the mansion to the new professors, he moved his family into two rooms on the third floor.

The art school opened for classes in January 1919. For several months Chagall's revolutionary credentials went unchallenged, and he plunged into his twin roles as provincial arts commissar and head of the art school with energy and enthusiasm. Not far from Vitebsk the Red Army engaged on the front lines of the Russian Civil War. Chagall's contribution to troop morale involved painting ten sets that formed the backdrop for propaganda plays that were performed almost daily for the embattled and exhausted soldiers.

In his pronouncements and writings as commissar, Chagall

pays more than lip service to the language and ideology of the new Marxist-Leninist order. His proclamations inevitably include disparaging remarks about "bourgeois painters" and the bourgeois audience—"Let the petit-bourgeois malice hiss all around us" and so on—and praise for "proletarian painters." However, Chagall showed demonstrable courage by insisting that, in his definition, proletarian art was in fact avant-garde and broadly experimental and had nothing whatever to do with uplifting portraits of men at work, or indeed any kind of art that might be imagined as "accessible to the masses."

It is almost painful to read Chagall's articles celebrating the first anniversary of the Revolution, as he twists and turns simultaneously to praise "the restoration of the power of Leftist art in Russia" and to claim pride of place for the idiosyncratic and numinous creations of the autonomous artist. His painting of the time is unambiguous. In a wonderful burst of creative energy Chagall celebrated the Revolution's first birthday by transforming Vitebsk into the world of his imagination. He gathered up all the house painters in town and gave them orders to copy sketches that he had made ready for them onto huge canvases to be displayed on the walls and streets of the city and its suburbs. The result was a grand magic circus in Vitebsk: a tuba player on a green horse and blue cows flew over the heads of the celebrants while fireworks fizzed and exploded in the darkening sky above three hundred waving red banners. The higher authorities were not amused. Local Communist leaders drew

a quick distinction between orthodox Marxist-Leninism and Chagall's surreal airborne farm animals and musicians. Their quick corrective to Chagall's carnival was to place a rush of orders for busts of Marx and Lenin to be shipped into town.

In a nod to the past (if one given after considerable deliberation) Chagall hired his old teacher Yehuda Pen for the Art College and also featured his work, along with Victor Mekler's, in a show of Vitebsk artists. But Pen's presence and his outdated naturalism were insignificant next to the subversive transformations offered by two of Chagall's other hires, Kazimir Malevich and El Lissitzky.

Since the opening of the breakaway Donkey's Tail exhibition in Moscow in 1912, which was the first powerful assertion of an independent Russian avant-garde, Malevich had been at the forefront of experimentalism. He had been linked both to Cubism, with its radical assault on conventional ways of seeing in place since the Renaissance and disregard for academic formality, and Futurism, which attempted both to harness and to represent industrial speed and light. He had jump-started the liberation of Russian art.

Malevich showed fifty works at the Donkey's Tail, whereas Chagall, based in Paris at the time, had shown only one. Unlike Picasso and his most slavish imitators, Russian Cubists initially tended to look back for inspiration not to the exotic primitivism of the African mask but rather to their own "primitive" pre-European history, which was essentially religious and iconic. Later others expressed the

Revolution's new respect for engineering and functional design.

In 1913 Malevich had begun to work out his Suprematist system, an art movement that at first championed pure and simple combinations of geometrical elements and evolved into what Malevich called paintings of "pure sensation," black or red squares. By 1917 he had removed all color from his work and produced the "White on White" series, in which squares of white are barely perceptible on a white background. The idea was to create pure form, a triumph over nature and its slavish representation.

In what turned out to be a profound if understandable misconception, Russian artists, Malevich and Chagall included, identified the Revolution in politics and economics with the revolutionary possibilities that they had been pursuing in art. For a few brief years after 1918, until painting and sculpture were put under the centralized control of the Union of Artists, and Socialist Realism, an academicism far more rigorous than anything that had preceded it, was imposed, Russian painting and sculpture continued to flourish under the hopeful but naïve assumption that, given the opportunity, everyone loved an intelligent and brilliant abstraction or a flying cow. Lenin himself, of course, was a philistine; he couldn't bear music, and his idea of an uplifting painting depicted a muscled worker with a hammer in his hand.

It is not uncommon for governments worldwide to imagine a reduced capacity for their constituents to respond to anything except the most banal art, but before the clamp-

down in Russia Chagall was able to transform folk art into his own brand of sophisticated supra-realism, while Malevich, Lissitzky (a former acolyte of Chagall's), and the architect Tatlin, among others, created their synthesizing abstractions under the banners of Suprematism and Constructivism.

It is possible that Malevich and Lissitzky came to teach in Vitebsk, which was not exactly a hotbed of radical painting, because it happened to be one of the few places in Russia at the time where food was adequate if not plentiful. The Civil War had devastated much of the countryside and famine was widespread. Yet the local farms around Vitebsk were functioning and their produce was not, as elsewhere, severely rationed. Whatever the reason for their acceptance of Chagall's invitation to come and teach, these two giants of the avant-garde were unlikely to get on either with the outmoded and conservative approach of Pen and Mekler or with Chagall's color-stormed representational Expressionist Surrealism, which Malevich in particular found old-fashioned and irrelevant.

From the moment of his arrival in Vitebsk in late 1919 Malevich offered a powerful challenge to Chagall. At forty, he was ten years older than Chagall, a huge man, physically imposing, and with a booming voice. He was famous for both his charm and his passionate temper. He also had an erotic power that Chagall jealously alludes to in his memoir. Like Chagall he had grown up against an impoverished background and with a meager education.

By the time that he arrived in Vitebsk from Moscow, Malevich's great work was behind him. Suprematism, he felt, had more or less come to an end, but as a teacher he was still committed to abstract creation (preferably colorless). In stark contrast to Malevich's by turns charming, persuasive, and strident personality, Chagall, while he had quickly donned the boots and red shirt of a devoted Soviet official (although he never joined the Communist Party), nevertheless managed to appear more clown than bureaucrat. Once more he made his rounds with his hair long and his cheeks flecked pink, color that had supposedly "rubbed off from his paintings."

It is a tribute to Chagall's generosity of spirit that he pursued a broad-based agenda for his students rather than simply trying to stamp his own style on the school. As it turned out, he paid a heavy price for his open-hire policy. As head of the art school, Chagall made frequent trips to Moscow and Petrograd, usually in pursuit of increased financial subsidies for paints and materials, but sometimes simply to help secure an exemption from military service for one of his students. In his absence Bella ran the school, which, unsurprisingly, did not sit well with Chagall's eminent colleagues. Chagall did not have an easy job. In response to a famous line in one of Mayakovsky's poems—"We toss reinforced concrete into the sky"—Lenin had remarked, "Why into the sky? We need reinforced concrete on earth," an attitude that was not lost on the local and national bureaucrats with whom Chagall had to deal. Some fell asleep or pretended to

slumber during his presentations, only to "wake up" to ask what Chagall might consider more important, emergency work on a damaged bridge or money for his academy.

In Vitebsk, the military commissar was a callow youth of nineteen, whom Chagall, according to him, apparently won over with a few friendly whacks on the behind. These were not persuasive enough, however, to prevent the arrest of Bella's mother on the unassailable grounds that she was bourgeois and fairly well-off. This fact is recorded nonchalantly, almost jokily, in Chagall's memoir. Other personal events threw darker shadows: in the autumn of 1919 Chagall's father was struck and killed by a truck he had been loading on a street in Vitebsk, and not long after his brother David died in the Crimea. However Chagall internalized these deaths, they did not have any manifest impact on his work.

In May 1920, while Chagall was on one of his begging trips out of town, Malevich made his move. He replaced Chagall's "Free Academy of Vitebsk" sign with a fierce banner announcing the arrival of the "Suprematist Academy." He then took it upon himself to fire a good number of the faculty. Lissitzky, an engineer by training, who had begun his career as an admirer and imitator of Chagall and who, a year earlier, had been quite happily illustrating books for Jewish children with inventive Hebrew lettering, lent his support to Malevich, and according to some accounts even Victor Mekler got in on the act. Naturally, upon his return from Moscow Chagall felt hugely betrayed. According to Chagall, Malevich posted an ultimatum: Chagall had twenty-four

hours to get out of the school. It is hard to pin down the correct sequence of events from the fall of 1919 to the summer of 1920—it seems that Chagall's position had been in jeopardy even before the arrival of Malevich—but at some point Chagall brought his case to the authorities in Moscow, only to discover that critical reports from his colleagues of the "he's a lousy comrade" variety had preceded his visit. Malevich's betrayal was the last straw. In June 1920 Chagall collected his family, packed up his belongings, and moved to Moscow.

6

Yiddish Theater

Russia was in turmoil; poverty and violence were endemic. "They all say they are fighting for justice and they all loot," Isaac Babel noted in the first page that we have of his 1920 *Red Cavalry* diary. And while Babel was riding with his Cossacks, spectacles on his nose and autumn in his heart, a Jew observing the devastation of Jews in towns laid waste by the Polish-Soviet war, Chagall, seven years his senior, was struggling to put meat on the table for his family— at times quite literally. One day the artist heaved half a cow's carcass, procured with a ration card, up narrow stairs to the single room with a hole in the roof that scantily sheltered his wife and child.

Chagall's family situation was desperate, but hardly unusual for Moscow's at once jubilant and agonized population. Once Bella was arrested in the Soucharewka market while bartering jewelry for butter. She was held in prison for a day. Snow did not stop falling until May, and before long it was winter again. Chagall had a meager "official salary" as a state artist, but as the wages were set by a committee that

included his old rival Malevich, who held little admiration for his work, he had been summarily dumped into the miserably paid "third category."

In the midst of his dire living conditions Chagall found an extraordinary outlet for his creative energies in the Yiddish theater. Chagall was no stranger to set design. In addition to the agitprop work that he had done for the Red Army, he had received commissions to execute the scenery for two of Gogol's plays, and, as early as 1911, he had produced a set for a Petrograd company and issued instructions that all the actors were to have green faces and blue hands. In his last months in Vitebsk the Moscow Theater of Revolutionary Satire (Terevsat) had passed through the town and commissioned a set for Gogol's *The Inspector General* from Chagall. He had come up with a wildly radical, almost faux-Suprematist design, with ladders going nowhere and a tiny train engine drawing a huge railway carriage behind it.

Chagall and the theater, especially the Yiddish theater, were a natural coupling: there was the painter himself with his painted cheeks, Chaplinesque demeanor and stature, and self-dramatizing poetic style, matched by his theatrical-poetic art, with its puppetlike, gestural, exaggerated, borderline sentimental figures and the striking setlike backgrounds—a vast swath of blue, for example—on his canvases. Bella herself had once had her sights set on an acting life, and the notion of the world as a stage, and vice versa, was clearly sustaining for both Chagalls as they set about constructing an impenetrable romantic citadel inside the harsh reality of deprivation that they knew daily.

In 1920 there were more than five million Jews in Russia, and for most of them their first language was Yiddish. The country as a whole was 75 percent illiterate. If political messages needed to be got across, the theater wasn't a bad conduit of information. Or so the thinking went up in the Jewish Commissariat of Moscow's new Soviet Education Department. It's hard to see of course what possible effect the tiny ninety-seat State Jewish Chamber Theater, housed on the second floor of a building on Granovsky Street—"abandoned by bourgeois refugees," as Chagall says in his memoir—could have in garnering massive support for the Revolution. Its repertoire of prerevolutionary dramas included some Sholem Aleichem plays rewritten to stress the ideals of the Revolution, and perhaps for this reason its performances were not only tolerated but encouraged.

The new Soviet world was still in flux. In December 1920 Marina Tsvetayeva could still read poems eulogizing White Army soldiers to a Red Army audience in Moscow. An elite group of sophisticated, creative, talented, leftist, secular Jews—artists, playwrights, and performers—could celebrate a Jewish past that they were sentimentally if not yet nostalgically attached to (the past was too close) but generally happy to be rid of, in a Moscow theater unequivocally devoted to their national ethnic heritage, something unimaginable under the czars, when even Jewish residence in Moscow was disallowed.

Throughout an astonishing seven-week period in the dark, freezing winter of 1920, Chagall set himself to paint not only sets for the new theater, but the theater itself: cur-

tains, walls, ceiling, and sometimes even the actors, whom Chagall would splash with paint before they went onstage. For the auditorium, which soon became known as "Chagall's Box," he worked on massive canvases, unleashing in his furious painting both the hidden world of the Jews and an energetic celebration of their new citizenship.

For Chagall, the state Yiddish theater in Moscow was a vital and important public space, his own personal Hermitage. Of the paintings that served as murals, *Introduction to the Yiddish Theater*, currently on display, after decades of confinement to oblivion, in Moscow's State Tretiakov Gallery, fascinates the most for a number of reasons. First, there is the unadulterated joy it expresses; nothing of Babel's or Tsvetayeva's cold eye is here. Instead, figures, one with his phylacteries attached, tumble like circus acrobats, musicians trill and fiddle, a shofar is blown, cows are upended, and in the bottom right-hand corner a man in a worker's cap, penis in hand, urinates nonchalantly onto the head of a pig (something of Henry Miller's Parisian joy, celebrated in *Tropic of Cancer* in the freedom and flow of the streams that he unleashed in the local pissoirs, is suggested here); everywhere ancient and modern are fused and confused, the tambour and the lyre and an angel blowing his horn accompany modern dancers, the lineaments of a temple are scratched in behind a tightrope walker holding an umbrella. Everything topples and balances at the same time. And here comes an image of Chagall himself, triumphantly carried across the stage of his canvas by Abram Efros, the

artistic director of the theater. To the left of Chagall's head the tablets of the Ten Commandments are thinly etched, while the artist's right hand extends his palette, which appears modestly to cover the nether parts of Alexandre Granovsky, the head of the theater, whom Chagall has kitted out in a jacket, tie, and a nice pair of ballet tights. Hebrew letters, running mischievously from right to left, spell out the names of the three men. Elsewhere, the diminutive actor H. S. Krashinsky and the troupe's big star, Solomon Mikhoels, the greatest Jewish actor of his day, dance attendance. All this activity—minstrelsy, mitzvahs, clowns, and goats—is carried out against a dynamic background of whirling Orphic/Cubist triangles, disks, squares, and cones, juxtaposed planes in black, crimson, light blue, brown, and shades of gray on the left side of the canvas, and yellow, purple, pink, and orange to the right.

For the spaces between the windows Chagall executed four vertical paintings: *Music*, *Dance*, *Drama*, and *Literature*. Where the audience entered the theater they were greeted by *Love on the Stage*, an intimate Cubist painting in subtle grays and browns with flashes of blue showing actors or lovers intertwined: the woman a delicate dancer, the man more firmly planted, both of them swung on the axis of a hammock crescent above the wide boards of a wooden stage illuminated by an oil lamp footlight. Chagall's curtain, sadly lost, revealed two goat heads facing in opposite directions.

But Chagall's extraordinary work on the theater did not stop here. His vision permeated everything, including props

and costumes. His effort to control every visual aspect of the performances occasionally led to manic scenes in the wings as Chagall would splash paint onto the costumes of actors about to go onstage and even onto their faces and hands. The theater and every person and object within its walls were simply compositional elements in a vast Chagall painting. In one infamous incident Chagall threw a fit when Granovsky attached a "real" feather duster to the kitchen scenery in a production of Sholem Aleichem's trilogy *The Agents, Mazel Tov*, and *The Lie*.

Certainly, viewers of the immensely popular but quite mediocre plays (especially in their distorted versions) performed by the Yiddish theater must have felt somewhat overwhelmed by the masterpieces that surrounded them. Chagall's genius exerted a powerful control, both artistic and psychological, on the tiny theater. In addition, his horror of lacunae suggests a profound desire to shut out the threatening and troubling aspects of both his and the new Soviet existence. Unlike Babel in his *Red Cavalry* stories, which unflinchingly chronicle the misery and confusion of the Russian Civil War, Chagall eliminates from his work all damaging aspects of the transition to Soviet life. His creation of "Chagall's Box" was a work of frantic courage, a celebration of Jewish freedom, and one of the most powerful works that he ever executed, but his commitment to an exuberant vision allowed no place to represent, say, the snow that fell through the hole in the ceiling of his damp one-room apartment and that one morning covered Ida's bed.

In the winter of 1920 it was not uncommon in Moscow or Petrograd for the poor and hungry, which included just about everybody, to burn their own furniture as firewood. Chagall's artistic spirit resides close to that of the tellers of Hasidic tales, individuals who search out sparks of goodness in the bleakest of events and collect these firefly flashes over a dark sea as acts of *tikkun* (restoration). Hence, in terms of a political statement, we will find no equivalent to *Guernica* in Chagall's massive oeuvre. Even in those works where he takes on the Holocaust, Chagall confines himself to painting the destruction of the shtetl and chooses largely to represent the genocide of the Jews through images of a crucified Jesus. In Chagall's work there is simultaneously both a profound restoration and a massive avoidance.

Chagall's wondrous paintings for the Yiddish theater, produced out of extreme hardship and with insufficient materials—sometimes Chagall dipped lace in paint to secure an impression, or mixed sawdust with his gouache and tempera—endured an unhappy fate. The Yiddish theater's popular success soon led to a search for larger premises, and in 1925 Chagall's paintings were moved to the foyer of the new theater on Malaya Bronnaya Street. However, in 1937, fifteen years after Chagall had left Russia, and at a time when it was no longer acceptable to celebrate "ethnicity," the murals were hastily removed during Stalin's purges and hidden beneath the stage. The paintings were damaged in the process.

On Stalin's orders Solomon Mikhoels was murdered in

1947. The theater where he had performed with such artistry and passion was formally dissolved two years later. A number of Mikhoels's fellow actors were either driven into exile or killed. By this time Chagall had already been persona non grata in Russia for almost twenty years. Luckily, before Stalin's goons could get their hands on them, his murals were taken for storage at the Tretiakov Gallery. There are a number of anecdotes that surround the secret transfer of the paintings to their new home, a cellar that offered the mixed blessing of safety and obscurity. In the most likely version, the murals' preservation was entrusted to one man, Alexandr Tyschler, an artist with the defunct company and an admirer of Chagall's, who single-handedly carried the huge rolled-up paintings to the gallery.

In June 1973, Chagall visited Moscow as a guest of the Communist government. In the presence of KGB agents, the minister for culture, and a solitary journalist from *Paris Match*, he was offered a viewing of his old work. Chagall marked the paintings with his signature. After this staged event the murals were returned to the vaults: they did not see the light of day again until Mikhail Gorbachev opened the windows in 1991.

In a manner that was becoming depressingly familiar to Chagall, he was not paid a kopek of the money promised for his work for the Yiddish theater. His impecunious state bit hard into his life. Bella and Ida had moved from Moscow to the village of Malakhovka, once a popular country home for wealthy Jewish merchants. Since the Revolution the mer-

chants and their families had been evicted and their dachas requisitioned by the government. Chagall spent some nights in Moscow and others at home. On the train into the city he saw through the window a frieze of those even more unfortunate than himself—lines of famished, exhausted people.

When his work at the Yiddish theater dried up, Chagall took a position in Malakhovka teaching art in an orphanage for Jewish children who had lost their parents to the recent maelstrom of pogroms, war, civil war, and revolution. Once again Chagall found himself working in buildings that had been home to bourgeois Jewish families. The job carried no salary, but his employers, the People's Commissariat of Enlightenment, were able to offer board and lodging for the Chagall family. Chagall proved a loving and empathetic teacher. A photograph from the time shows eleven skinny children gathered around the artist, many of their heads shaved as a precaution against lice, and one little girl in a floppy hat with a ribbon. Chagall stands at a miniature easel, paintbrush in hand. He is surrounded by the work that the children have executed. They stare at him with rapt attention. Chagall is thirty-five, he has become famous in Europe, but he does not know this, and many in Berlin and Paris believe that he is dead. He has lost his position as the head of an art school and lost his employment in theater. He has no money. His mother has recently died in Vitebsk, but, as after his father's death, he has not been able to get permission to travel to the funeral. He is teaching the children to paint.

Early in 1922 the Chagalls moved back to Moscow, to a

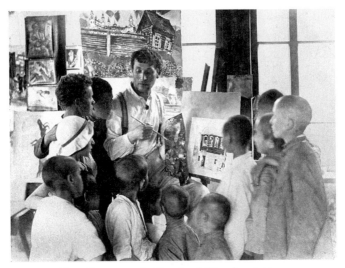

Chagall, surrounded by the children's paintings,
teaching children in the Colony for Jewish Homeless
Children at Malakhova, 1921. (*Courtesy Rue des Archives*)

tiny apartment at 19 Samotedshnaya Sadovaya. Bella had
developed a passion to further her acting career, but during a
rehearsal she slipped and fell. The resultant injury kept her
confined to bed for months. In the summer of 1922, through
the intervention of his old friend Lunacharsky, Chagall was
able to arrange an exhibition in Lithuania and secure both an
exit visa and a passport for himself. The art collector Kagan-
Shabshay agreed to fund his journey.

Chagall was allowed to send sixty-five pictures to Kovno
(now Kaunas) via diplomatic pouch. He also took with him
the manuscript of his uncompleted memoir *My Life*. Bella

and Ida, it was planned, would follow at the end of the year when Bella was fully recovered.

Years after his return to the West, Chagall was to claim that his journey out had been dictated by reasons that were "purely artistic." Whether or not this was so, and it is hard to imagine such purity of thought amidst the economic and political turmoil of 1920–22, it seems likely that Chagall saved his own life by returning to Western Europe. Stalin had a firm and murderous idea of the proper fate for the prominent Jewish artists, writers, actors, musicians, and intellectuals who chose, or were obliged, to stay in Mother Russia.

7

Berlin

After his show in Kovno, Chagall moved quickly on to Berlin. He arrived with the expectation of collecting most of his paintings and, perhaps, receiving a decent infusion of funds. After all, he had left 40 paintings and 160 other works in the hands of his dealer, Herwarth Walden, in 1914.

In Chagall's prolonged absence Walden had certainly gone to work on behalf of his artist, organizing exhibitions and featuring reproductions of Chagall's work in his magazine *Der Sturm*. Chagall's reputation had advanced in leaps and bounds, and perhaps had even been enhanced by the enigma of his disappearance and the morbid frisson that emanated from rumors of his having starved to death inside the closed borders of the Soviet Union.

To his dismay, Chagall discovered that Walden had sold *all* his works to private collectors; to make matters considerably worse, the uncontrolled spiral of postwar German inflation had devalued the money collected on Chagall's behalf and deposited with a lawyer to a worthless pittance. Chagall was obliged to secure the services of his own lawyer, and a

four-year court battle ensued. Eventually, Chagall was able
to reclaim three paintings and ten gouaches that Walden had
"transferred" to his ex-wife during the war. The court also
ordered Walden to give Chagall the names of the private col-
lectors who owned his work, individuals whose identity,
because of the art world's not uncommon financial shenani-
gans, Walden had withheld. Chagall in Berlin had fame but
not fortune.

Late in 1922 Bella and Ida arrived. Until the autumn of
1923 the family lived at four different Berlin addresses. The
city was awash in Russian émigrés, "a kind of caravansary,"
as Chagall once called it, "where all those who shuttled be-
tween Moscow and the West met." Here, Chagall made his
way among former czarist generals now working as cooks
and dishwashers, racketeers, exiled Russian professors,
miracle-working Hasidic rabbis, and Constructivists gath-
ered at the Romanic Café. The Russians formed a small town
within a city, a place that resembled to one of their number
"a giant waiting room" for those en route to Paris and else-
where.

Berlin was then a bleak city without a skyline, ringed by
the S-bahn fast-train network, a den of happy perversions
(Berlin's transvestite balls were famously thronged) in the
feverish atmosphere of Weimar inflation where a roll of
bread could cost a million marks. Here Archipenko produced
his Cubist/Constructivist sculptures, Kandinsky set him-
self up at the Bauhaus, and Chaim Nachman Bialik, the
Hebrew poet, worked on his essays, planned his move to Tel

Aviv, and in the meantime established the Dvir publishing house. Vladimir Nabokov, writing at the time under the pseudonym V. Sirin, courted his Vera and published poems in *Rul*, the leading Russian paper of the emigration. For his part, Chagall, eager to illustrate the memoir that he had recently completed, mastered etching techniques and, in the city that was the home of graphic art, produced his first intaglio prints and received his first lessons in the art of the woodcut.

El Lissitzky, Chagall's bitter enemy from the Vitebsk art school coup, was now also in Berlin, hard at work illustrating, among other books, a collection of short stories by Ilya Ehrenburg. Chagall naturally avoided Lissitzky and, as usual, chose for his friends the tamer creatures in the local menagerie of artists and poets. His financial situation gradually improved with the help of sales from two major exhibitions, one a group show at the Van Diemen gallery in 1922 and the other a one-man show the following year in the same space, renamed Galerie Lutz, that consisted of 164 works executed by Chagall in the previous eight years. Nevertheless Chagall had been buffeted, almost crushed, commercially and politically, by his life in art. No amount of financial or critical success later in life was ever quite able to dispel the aura of suspicion, or drain the well of bitterness, that surrounded a disproportionate number of his relationships, especially, as the art historian Monica Bohm-Duchen has wryly observed, "if money was involved."

In three weeks of heady work Chagall produced fifteen

copperplates to illustrate his memoir; five more were added later. However, problems arose with the German translation of the Yiddish text. The portfolio published as *Mein Leben* by Paul Cassirer in 1923 ended up wordless and illustrating itself.

The subject matter of *Mein Leben*, most of it relating to Chagall's childhood and adolescence, is familiar fare for the artist: gramps on the roof, airborne carts and animals, shtetl musicians, the interior of the Chagall family dining room, and one lovely antic portrait of lovers on a riverbank, the man standing on his head, the woman kissing the heels of his boots instead of lips. Without the text Chagall's etchings reveal his increasing confidence in and mastery of the technique; beside the text, they act as a useful corrective to Chagall's lapses into purple or lachrymose prose. The artist's mature, willful line, his inventive use of the needle stuck hard into the plate to produce holelike marks, his use of white space, all combine to resist the easy sentimentality that too often magnetized Chagall in his prose and poetry. Like all great artists, Chagall knew something in his art that he didn't always know in other areas of his life.

"Come back, you are famous. Vollard is waiting for you." Thus Blaise Cendrars (who had suffered greatly and lost an arm in the war) wrote to Chagall in the kind of postcard arriving from Paris that in the summer of 1923 at least half the artists of Weimar Berlin must have floated in their dreams. Chagall didn't waste any time: Vollard's unspecified project, which turned out to be illustrations for a French

translation of Gogol's *Dead Souls*, coupled with the lure of his old studio in La Ruche and a burgeoning feeling that Paris and not Berlin was "home," had Chagall packing his bags once again. After a small visa problem (microscopic by Soviet standards) the Chagalls boarded a train for Paris and in late summer's antique yellow light arrived at the Gare de l'Est on September 1, 1923.

8

Return to Paris

The Chagalls spent most of the first six months after
their return to Paris in the Hôtel Médical, a run-down
hybrid hospice/boardinghouse on the rue du Faubourg
St.-Jacques that was, in its healthy quarters, a home away
from home for a number of itinerant foreign artists. Within
days of his arrival in Paris, Chagall rushed over to his former
studio in La Ruche, where he had stored approximately 150
works, none of which he had seen for nine years. The door
opened to reveal not the acrobatic figures and color-charged
places that populated his paintings, but a wizened pensioner.
Unbeknownst to Chagall, during the war the French govern-
ment had requisitioned the studios in La Ruche and parceled
them out to the needy. Worse, the paintings were gone,
every one.

That Chagall managed to sustain loss upon loss of his
work in city after city without falling into despair or a pro-
longed period of paralysis is a tribute to his remarkable
resilience, his driven activity in the service of his creative
gift, and, perhaps, to the energizing powers of bitterness

and resentment. However, the shock of his empty studio also produced in Chagall a strange and profound reaction. For years, following the disappearance and dispersal in Moscow, Berlin, and Paris of what were some of his most brilliant and beautiful paintings—including *I and the Village*—Chagall painstakingly attempted to re-create his missing oeuvre from photographs, magazine reproductions, and memory. Sometimes he tried to persuade individuals who owned his work to lend their paintings to him for a brief period so that he could make a copy. Naturally, Chagall's collectors were frequently reluctant to collude in undermining their own investments. How detrimental this time-consuming self-reparation was to Chagall's work has been a debating point among critics for many years. Certainly, his behavior is psychologically fascinating. Unlike writers or composers, whose words or notes can be endlessly reproduced without any loss of originality, painters are masters of the one-off. Hence the commercial value of paintings. Consequently, it has always been the fate of painters that when a wealthy patron comes to call they must, for the most part, kiss farewell to their unique creations. Nevertheless, a choice exists: a painting may be held back from the marketplace out of personal considerations or for beneficial financial reasons. The disappearance or theft of a work is another matter: Chagall was not in a position to "hold back" anything, and he certainly did not have an easy task tracking down his errant canvases. And so he set to work (much to the chagrin of his dealers) enacting on a personal level the task that he had once set himself for Vitebsk and the shtetls

that surrounded it: to restore and preserve a lost world, to remember and reproduce dreams.

And where were the 150 paintings? Chagall was convinced that Blaise Cendrars had scurrilously had a hand in dispersing the works. Certainly, in Chagall's absence Cendrars had authenticated a number of canvases acquired by the critic and collector Gustave Coquiot, who probably believed Chagall to be missing or dead, but the truth was sadder: after the requisitioning of La Ruche, Alfred Boucher, the building's owner, had gathered up all the paintings left behind (not only Chagall's) and stored them in an insecure area. The result was a scavenging free-for-all in which a few of Chagall's paintings found a second life as the roof of the concierge's rabbit hutch.

In general, and perhaps inevitably, Chagall's "copies," which he more accurately referred to as "variants," and which he pursued for decades, lack both the immediacy and the radical dynamism of his originals. In the second version of *The Cattle Dealer* (1912 and 1923–26), for example, Chagall's Cubist gestures are laid aside and the result is a shift from challenging to decorative. In Chagall's 1937 etching and aquatint reworking of his astonishing painting *The Apparition* (1924–25), it is the charged and ambiguous sexuality that is removed and flattened; in *Peasant Life* (1925), *I and the Village* is softened in the direction of the illustrative. The expressionless, masklike green face that dominates the right side of *I and the Village* has been transformed in the bottom right-hand corner into a happy peasant who has the look of a village idiot; the uncanny cow who carries her own cow

dreams has mutated into a happy, chomping, lovable horse. The effect in all cases is to placate rather than to startle.

Quite possibly, although it is a speculation that I would like to resist, it was the simple improvement in Chagall's standard of living that blunted the edge of his work. In 1924 he had moved with Bella and Ida into a spacious studio on the avenue d'Orléans that had once belonged to the painter Eugene Zak. Vollard was providing Chagall with a regular income, and for the first time in years, perhaps in his entire life, Chagall enjoyed more than a measure of comfort. An irresistible and much reproduced photograph from 1924 shows Marc, Bella, and Ida languorously posed against a backdrop of some of Chagall's great works, including *The Birthday* and *The Praying Jew*. Marc reclines on a chaise longue looking every inch the dandy-artist. He wears a vertically striped, open-necked painter's smock with what appears to be a silk scarf or cravat around his neck. Ida, at his feet, clutches a doll. Bella is placid and beautiful in her signature dark top with white collar. The wall hangings and pillows in the room are in the orientalist mode of the day, and the family as a whole appears altogether content.

How slippery was Chagall's identity? He appears often as a chameleon figure, fiercely protective of his artistic independence and yet eager to please. His work and his life both reveal a reactive desire to be a Russian to Russians, a Jew to Jews, and a Frenchman to the French: at the same time, Chagall resisted a fixed identity whenever one seemed to be on the point of closing around him. His work for Vollard, for example, throws into relief the shifting tides of Chagall's

national and religious identity. The 107 engravings that he executed over a four-year period for *Dead Souls* were clearly a labor of love, and when, in 1927, he was done with his witty and sometimes lyrical expressions—one plate is uniquely committed to the rustling foliage in the character Pliushkin's garden—he sent 96 of his etchings off to the State Tretiakov Gallery in Moscow with, as he wrote in his accompanying letter, "all the love of a Russian painter for his homeland."

His next commission challenged and tested his love for his new homeland. Vollard, with the unexpected notion in his head that "an artist whose birth made him familiar with the magic of the Orient" would be the perfect foil for La Fontaine, whose stories were "at once sound and delicate, realistic and fantastic," asked Chagall to produce a series of gouaches to illustrate the *Fables.* Neither Vollard nor Chagall, who quickly accepted the commission, anticipated the furor that would erupt when it became widely known that a foreign Jew had been given the opportunity to go to work on a French classic, and a children's favorite to boot. While it was not exactly the Dreyfus affair, the controversy did find its way from assaults by xenophobic and nationalistic critics like Adolphe Basler ("What next? Soutine on Racine?"), through a venomous and barely concealed anti-Semitic attack by Arsène Alexandre in *Le Figaro*, all the way into the French Chamber of Deputies, where Chagall was belittlingly described by one hostile politician as a "Vitebsk sign painter."

But not to worry, the circus was in town, both figura-

tively and literally. The end of the party in Paris that been predicted by many in the local bohemian set when Modigliani had died on a cold January morning in 1920, and his coffin had been borne through the streets in a grand farewell to a prince of Montmartre and Montparnasse, turned out to be only a hiatus. The American postwar boom—Hemingway and his wife lived comfortably in Paris on five dollars a day—and the general cancan elation of young men who were no longer destined to die in the fetid trenches of the Somme, and young women no longer haunted by dreams of impending widowhood, turned the city of love into a boho paradise.

Chagall at thirty-six, with a stable marriage and an eight-year-old child, had no cravings for the dark alcoves of the various *bals*. He was not out on the town every night, neither drinking at Dingo's with everybody's favorite model Kiki or with Lady Duff Twysden, the model for Hemingway's Brett Ashley, nor attending sexually fired-up extravaganzas such as the Maison Watteau ball, where the painter Moïse Kisling strutted in a red wig, posing, under decorations provided by Pascin, as a whore from Marseilles. But Vollard did offer Chagall use of his box at the Cirque d'Hiver, and the artist, who had developed an early love for the circus and the traveling mountebanks who passed through Vitebsk, repaired to the ringside with his family as often as he could.

In much of Chagall's work in the 1920s Paris is embraced as a romance of acrobats and roses. His vision is irresistible, as it confirms an illusion of the city that Western culture has emphatically endorsed at least since the time of the troubadours. Chagall's lovely oversize bouquets of lilac, lilies, and

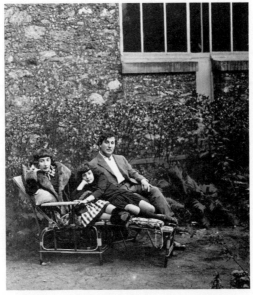

Marc, Bella, and Ida Chagall, Boulougne-sur-Seine, 1925.
(© *Archives Marc et Ida Chagall, Paris*)

blown roses that either dwarf or provide a bed for his kissing, fondling, frequently semi-naked couples at once buy into and contribute to the mythos of Paris as the beating heart of love's body.

Chagall had lots of good reasons to feel bountiful and expansive. He had "come through," as D. H. Lawrence joyously declared of himself and his wife, Frieda, toward the end of the war, and even if, as Lawrence insisted, the "old stable ego" was gone after World War I, Chagall's unstable ego and deracinated personality seemed perfectly attuned to the new times. In Paris, while the twenties roared around him,

Chagall had both love and fame. He owned a firm contract with the Bernheim-Jeune gallery and his reputation was honed and advanced by influential critics, including André Salmon and Philippe Soupault, in an expanding series of monographs and articles. While Chagall's paintings did not quite command the already considerable prices of Picasso and Braque, he was by no means uncomfortable.

For any artist the creative activity is "about looking," and while Chagall almost always worked indoors, his various peregrinations may have as much to do with the eruption of flowers and light onto his canvases as the upsurge of his spirits. Toward the end of 1925 the Chagalls had moved to a small house at 3 Allée-des-Pins, near the Bois de Boulogne, where Chagall walked daily, and close to the Jardin Fleuriste, where, come spring, its flowers were in abundant bloom. Bella, with money in her pocket, was not about to resist the cut flowers in the local markets. Compared to the starkness of Berlin and the deprivations of postrevolutionary Russia, Paris was a cornucopia of visual delights.

In 1926 Chagall worked on the gouaches for the *Fables* in Mourillon, a fishing village near Toulon. He also visited Nice for the first time, and then passed a few months in the Auvergne, occupying a house opposite a picturesque church in a village square near Lake Chambon.

In addition, throughout the second half of the decade the family traveled extensively in the French countryside, visiting Normandy and Brittany and spending time with Robert and Sonia Delaunay at their country home in L'Isle-Adam

near Pontoise, a favorite plein-air location for both Pissarro and Cézanne. Chagall's paintings in these years are suffused with a blossomy lightness, his colors, always ecstatic, are drenched in Mediterranean radiance. Now, for the first time, he began to mix gouache, quick to dry and useful for an outdoor impression, with oil paint that could be layered on back in the studio, a technique devised to match the increasing balance of his outdoor/indoor activity.

A book marking the vast contribution of Jews to the history of sentimentality, from the novelist Grace Aguilar through Al Jolson and Irving Berlin and on, let us say, to Barbra Streisand and Neil Diamond, has yet to be written. But in it Chagall would surely have his own chapter, not because his paintings are desperately mawkish (and after all, sentimentality is not the attribute only of weaker artists—think of Dickens or Renoir) but because he walked the tightrope that separates sentimentality from deeper, more authentic feeling better than anyone, except perhaps the great Israeli poet Yehuda Amichai.

Chagall's paintings have, despite his higher reach, frequently become the stuff of chocolate box or pop love. It is not, for example, an accident that in the movie *Ferris Bueller's Day Off*, Ferris, after thoughtfully pondering Picasso and Braque in the Art Institute of Chicago, is inspired to kiss his girlfriend in front of Chagall's stained-glass windows. And this requires some pondering. *Ida at Her Window* (1924) is a lovely example of Chagall's new French lyricism. His eight-year-old daughter, tanned and barefoot, sits on a windowsill

in a green summer dress framed by a turquoise blue shutter. Her right hand touches a glass vase that holds orange, yellow, and purple flowers. Ida's expressionless gaze is set past an expanse of green toward the sea. The colors in the painting appear to have been drawn up from the water. No wonder that Chagall had recently declined André Breton's invitation to join the Surrealists, for his own dreams transmitted to canvas were not spontaneous "automatist" projections, or ideological assaults on bourgeois morality, but rather, and increasingly, idiosyncratic representations of real or powerfully imagined love and serenity.

Chagall's girls, women, and flowers, almost always drawn from studies of his daughter and wife, could not be more different from his near contemporary Pascin, who is the bad Jewish boy to Chagall's good one. Pascin's little girls, in dresses and holding bouquets in their laps, are painted in cool, faded blues, greens, and grays, and what clearly interests their painter is his models' inner psychology and burgeoning sexuality as it is expressed in their plump or winsome bodies. Moving up in age, where Chagall's Bella appears chastely in white with a bunch of roses (*Double Portrait* [1924]) or in a strangely Hamlet-like pose and garb (*Bella with Carnation* [1925]) or, as is frequently the case, with an approving angel hovering nearby, Pascin's women are almost without fail highly eroticized ladies of the night.

And yet, perhaps as one might expect, those paintings by Chagall that *are* sexually charged, because they appear to arise out of repression, are more powerful and disturbing than almost any work by Pascin, Modigliani, or even, and

perhaps especially, Picasso. In *The Dream* (1927), for example, a semi-naked woman arches back along the length of a creature with a horse's body and a rabbit's head. Possibly the woman is strapped down; perhaps she has been ravished already or is on her way to a ravishing. Either way, she is borne though a whirling, dark blue sky in an inverted landscape in which a tree squiggles spermlike toward her. In *The Rooster* (1929), a female figure rides and embraces around the neck a brightly colored and rather happy-looking giant cock while in the background two lovers row on a placid lake. Whatever the mythical or fabulous origins of these images—*The Dream* resembles a cross between Lewis Carroll and Leda and the Swan—these paintings provide a startling corrective, or at least a disquieting alternative, to "soft" Chagall. There is no doubt that Chagall discovered in the 1920s that he could sell his hanging bouquets and Parisian lovers with relative ease, and it is possible to argue that he stopped challenging himself as an artist in this happy, productive, and rewarding period of his life. But in his art, as in his life, he always spoke more than one language.

Similarly, it is always dangerously tempting to disparage the family man and embrace the lone-wolf Don Juan rebel artist, but Chagall's domestic setup was hardly bourgeois and even though his credentials as a partygoer and wild man did not approach Modigliani's, Pascin's, or those of any of the numerous other artists, Jewish and Gentile, on the loose in pre- and postwar Paris, Chagall was certainly in demand in his own stimulating and intellectually challenging social circuit. In Paris, as elsewhere, he befriended writers before

artists, forging friendships with, among others, the French novelists André Malraux and Henri Michaux and the Yiddish poet Peretz Markish. And there were always the Delaunays, who hosted Sunday gatherings attended by Dadaists, Surrealists, and other cutting-edge artists. There is a lovely extant photograph of Bella wearing one of Sonia Delaunay's extraordinary "simultaneous design" dresses (Gloria Swanson, the reigning star of Hollywood, had purchased one in 1923), and we can credit Robert, by daring to out-lyricize Chagall in his own portrait of Bella, with inspiring Chagall, who was not immune to jealous provocation, to paint the strange and uncanny *Bella with a Carnation*. In a brief memoir of her Paris love affair with Modigliani, the Russian poet Anna Akhmatova describes how she once walked to Modigliani's studio intending to give him a bunch of roses. The painter was not at home, so Akhmatova threw the bouquet through an open window of his studio. Later in the day the two met up. Modigliani couldn't figure out how Akhmatova had got in without a key. The poet explained what she had done. "That's impossible," Modigliani said. "The roses were in a perfect circle." This anecdote, describing the arc of a romantic gesture falling as art, usefully characterizes the zeitgeist of Paris in the 1920s. Chagall threw a thousand flowers and tumbling figures into the surreal air that hung above the city's rooftops, and as if by magic they landed perfectly on his canvases, caught in flight, lovers free-falling under a half-moon or a clown riding a hoop on the back of a rainbow horse.

9

Palestine

In the autumn of 1930 Chagall received an invitation from Meir Dizengoff, the seventy-year-old mayor of Tel Aviv, to visit Palestine. At this time Chagall had already been commissioned by Vollard to illustrate an edition of the Hebrew Bible, but, as Benjamin Harshav has confirmed, while Chagall used this "Vollard excuse" to explain the motivation for his trip to Gentile friends and acquaintances who might suspect him of "emotional 'Zionist' attraction," his real reasons for going were more practical. Dizengoff was interested in establishing a museum of Jewish art in Tel Aviv. The project was something close to Chagall's heart, and he had already endorsed a similar plan for a museum in Vilna. Dizengoff, treating Chagall with deference and the necessary flattery—the first letter from the old man to the forty-three-year-old begins and ends with "Cher Maître"—had offered Chagall chairmanship of the sole advisory committee. Chagall's sense of himself certainly comported with that projected by Dizengoff, as is clear from an interview that he gave in Jerusalem two weeks after his arrival in Palestine: "As Herzl came to Baron Rothschild, asking for help to

build the Land of Israel, so Mr. Dizengoff came to me in Paris, asking for help in building a museum" (he was probably joking).

At the end of February 1931 the Chagalls sailed from Marseilles on the steamship *Champollion.* As luck would have it, they found onboard not only an old friend from their Berlin days, the great Hebrew poet Chaim Nachman Bialik, but also the French Jewish poet and philosopher Edmund Fleg. A charming photograph shows Chagall and Bialik on deck, hats in hand so as not to lose them over the rail; standing next to them, fifteen-year-old Ida tries hard to keep her skirt from flapping above her knees. Chagall is in a fashionable double-breasted suit with a jaunty bow tie. His hair is mussed by the wind, and he looks altogether cheerful. Bialik, in a three-piece suit with a visible pocket watch and with his shiny bald head, presents the more severe appearance of a European bureaucrat.

At this time, in transit on the high seas between Marseilles and Alexandria (they would travel overland to Palestine), the lives of the two men offer an interesting contrast. Bialik, fourteen years Chagall's senior but with a similar town-shtetl-cheder background and childhood, had been an early beneficiary of the emergence of a secular Hebrew culture from the ruins of Jewish life in Russia, and quickly became a force within that culture. Largely through the electric effect on a mass audience of a few of his most stirring poems, he had been obliged to live most of his adult life as the "Jewish national poet," a role that, even if he had once weakly sought it, stayed with him as an intolerable burden.

Like an aging rock star, Bialik was a prisoner of his old hits. On his first visit to Palestine in 1909 (a year before Chagall's arrival in Paris—the choice of destination is of course significant), he tried to read from a short story but had been shouted down by his audience, which wanted to hear his familiar poems of national revival.

By 1931 Bialik had been living in Tel Aviv for six years— on a street that during his own lifetime was named after him and where, the victim of an unhappy private life and terrible self-doubt as a writer, he had more or less given up poetry altogether. Crossing to Palestine, Bialik was returning home, the ardent Zionist at the very end of his career, confined more or less to an audience of Hebrew speakers; Chagall, a tourist, was already launched onto the world's stage, with a burgeoning international career.

For any immigrant, to choose Palestine as home meant to relinquish it as a dream. The shift over to reality was frequently, for any number of reasons, a jolt. The country, replete with national Jewish aspirations, was, as yet, under the rule of the British mandate, in place since the end of World War I and the collapse of the Ottoman Empire. It was a society of manifest conflict and contradiction. The British had begun their occupation of Palestine with high hopes that a part of their geopolitical vision could be realized. A solid, stable presence in the Middle East would guarantee the safety of maritime routes to India and other imperial possessions. And with confidence born of imperial experience in other parts of the globe, they felt they could both handle and enlighten the local populace, whether Jewish or

Arab. Well, good luck, guys: the irrepressible conflict soon surfaced, and, caught in the double bind of their conflicting promises to preserve the status quo for the Arabs while simultaneously implementing the 1917 Balfour Declaration's policy favoring "the establishment in Palestine of a National Home for the Jewish people," the British found themselves perplexed, frustrated, angry, and ultimately impotent. To make matters worse, the British did not like the Jews of Palestine very much and were ambivalent about the Arabs, sometimes romanticizing and sometimes despising them.

To compound the situation there were Jews, both Zionist and indifferent to Zionism, in high positions of the British governing authority, and Jews, secular and religious, Zionist and sometimes virulently anti-Zionist, among the local population. The Palestinian Arabs, affiliated at this time more by tribal than by national identity, may have looked appealingly picturesque to colonial visitors, but only a few months before Chagall's arrival their own seething animosities to the expanding Jewish population, inflamed by the mufti of Jerusalem, had exploded in Hebron, where sixty-seven Jews had been massacred in three days of rioting. The British relocated the remainder of the Jewish population of Hebron to Jerusalem.

British culture in Palestine, where Jews and Arabs served side by side in the mandate police force, reflected in microcosm that of the larger British Empire. As in India, an incongruous English world of teatime, gymkhanas, foxhunting—although the British were obliged to chase jackal

among the cacti as, pace the Song of Songs, there were no foxes in Palestine—duck shooting (on the Sea of Galilee), and marching bands was grafted onto a resistant environment.

Bialik, wandering undisturbed, except by his internal demons, through the streets of Tel Aviv in the dusk of British-run Palestine, found no further need to excoriate Jewish passivity or to idealize *aliyah*, or indeed to translate his private imaginings into literature. To be sure, his fall into silence preceded his move to Tel Aviv, but one wonders if Chagall took Bialik's fate as a warning, or a confirmation, that it was better to keep Palestine in the realm of the imagination, and preferably linked to the distant biblical past; the decline in Bialik's literary output must have suggested that there was a high price to pay for cleaving too closely to the quotidian exigencies of the promised land.

S. Y. Agnon once told Saul Bellow that his novels would have an insecure future until they were translated into Hebrew, but the world has tended to think differently. Certainly something has to explain the banal and utterly unconvincing paintings and drawings that Chagall produced during his visit to Palestine. One glance at his conventional and tedious rendition of *The Wailing Wall* (1932), with its huge brown stones dwarfing a few praying figures, is enough to reveal how in Jerusalem Chagall jettisoned everything that made his painting alive and enchanting: all bright color is drained from the canvas, while the figures are dutifully earthbound. It is as if life in the *Yishuv*, that is, the life of the

Jews in mandate Palestine before the establishment of the state of Israel, represented a dangerous provinciality to Chagall, one that he had only recently escaped and to which he did not wish to return. This being so, rather than embrace in his defining style the transforming secular world around him, in the manner, say, of the Romanian-born painter Reuven Rubin, who had immigrated to Palestine in 1922, Chagall oddly chose to represent postcard "sites"—the wall, a synagogue interior in Safed, Rachel's tomb—in a conservative manner guaranteed neither to challenge nor to offend, but with the devastating effect of blocking what should have been his natural subject matter.

Reuven Rubin's self-portraits, portraits, and landscapes executed around the same time as Chagall's visit have an exuberant color-filled lyricism reminiscent of Chagall's—especially in a painting like *Les fiancés*, where a sheep (a Jewish unicorn?) has unexpectedly made its way onto a Tel Aviv balcony to lay its head in the lap of Rubin's fiancée, Esther, who holds a large bouquet, while Rubin, palette and brushes in hand, surveys the waves kissing the port of Jaffa. If only Chagall had felt in Palestine the freedom and passion of the immigrant instead of the loyal compliance of the Jewish tourist, he might have produced wonderful work there. But Chagall's Mediterranean broke on French shores.

As for the British in Palestine, Chagall hardly seems to have noticed them, and vice versa. One of Chagall's letters notes that Edwin Samuel, the son of Sir Herbert Samuel, the first British high commissioner to Palestine, urged him to visit the "Omar Mosque," a site that left Chagall unmoved

and unimpressed, but I can find no corresponding reference to Chagall in Edwin's memoir *A Lifetime in Jerusalem*, although the book does contain an arresting photograph of George Bernard Shaw toweling off his feet on the shore of the Sea of Galilee in 1930.

Accounts of Chagall's visit to Palestine vary greatly. On his return to Paris Chagall gave an interview in which he talked of his particular affection and admiration for the kibbutz ("I even wanted to live among them"), the sunny atmosphere of youthful Tel Aviv, and the spiritual charge of Jerusalem, where, once again, "Christ as a poet and a prophetic figure" rose up to fill his imagination. In Jerusalem, as earlier in Vitebsk, Chagall lamented the schism that detached Jesus from the Jewish family. Other friends reported Chagall's comfort among Palestine's large Yiddish-speaking population while hinting at his discomfort among the Hebrew speakers. Chagall is frequently described as having been deeply moved by his visit, but in her memoir *Bouquet of Memories*, Esther Rubin, who took a trip around the country with her husband, Reuven, and Chagall, recalls that "Chagall did not seem particularly interested in Eretz Yisrael." Significantly, before Chagall left for Paris Reuven Rubin suggested that they exchange paintings, "as is customary among painters," but Chagall declined. At the time Tel Aviv had a population of 50,000. Was Reuven Rubin's work tainted for Chagall with the stain of provinciality? Or perhaps Rubin's superb paintings had thrown Chagall's own Palestine efforts into uncomfortable relief.

Chagall's involvement in planning the Tel Aviv museum

ran into trouble early on. Dizengoff's aesthetic was not exactly sophisticated. At one point he returned from a trip to Europe with plaster copies of Michelangelo's *David* and *Moses.* "They had these in all sizes and I picked the biggest," he told Reuven Rubin. Chagall's response when he heard the story was a curt "Who needs it?" He had, rightfully, envisioned a home for great works by, among others, Pissarro, Modigliani, Pascin, and even Soutine, whose personality disgusted Chagall. Dizengoff was disappointed but not exactly humbled by the response to his purchases. He set the statue of Moses on the roof of his house, where, on a moonlit night some months later, an alert Tel Aviv police officer confused it with a sniper (Moses' horn for the rifle), climbed onto the roof, and bashed Moses on the head from behind. Dizengoff is reported to have rushed out yelling, "What have you done? You've just destroyed a Michelangelo sculpture." The pieces are kept to this day in the basement of the Tel Aviv museum. Chagall was not an ideological Zionist, but undoubtedly he had deep Zionist sympathies. At this point in his life these sentiments were not enough, however, to eradicate entirely his equally deep suspicion, engendered by his experiences in Russia, of bureaucratic interference in the world of art. A dispute over a purchase of statues from Chagall's friend, the sculptor Chana Orloff, led to a break with Dizengoff. While friendly relations were eventually restored, Chagall greatly reduced his level of involvement in the museum project. When the building opened to the public on April 2, 1932, Chagall sent Dizengoff a one-line congratulatory telegram.

10

Vilna

B ack in Paris Chagall dedicated himself to his etchings for Vollard's Bible. By 1932 he had finished 32 of the anticipated 105 plates. Chagall was by now a consummate master of graphic technique. His early etchings, painterly renditions of Sarah, Rachel, Ruth, and Esther, are both delicate and powerful. However, if he had been influenced by his trip to the Holy Land, that impact can only be detected in the brilliant and intense light that saturates the images. Chagall's figures are for the most part drawn from the shtetl world, for he suspected Palestinian Jewish orientalism (Rubin darkened his skin in his self-portraits in order to make himself look "Canaanite") of tending to the merely picturesque. As was generally the case for Chagall, whenever he painted from Jewish history or legend, Vitebsk and its environs remained his touchstone of Jewish authenticity. Vollard's death in 1939, the outbreak of war, and Chagall's subsequent exile in America all combined to prevent him from completing his etchings in timely fashion. In 1956, Edition Tériade finally published the illustrated text. Chagall's

lithographs and etchings were widely praised, and celebratory exhibitions were held in Basel, Bern, and Brussels.

Like F. Scott Fitzgerald's, Chagall's career, mood, and subject matter paralleled to an extent the shifting political and economic fortunes of Europe and America. The New York Stock Exchange crashed on the same day in 1929 that Chagall moved into his beautiful new house on the avenue des Sycamores in the Villa Montmorency, only to learn first that his architect had absconded without paying his workers, and, moreover, that the Bernheim-Jeune gallery had canceled his contract.

The Paris party of the 1920s, a distinctly well-attended and high-end affair, was about to be replaced by the Depression and a whole new set of less fortunate guests. Most Americans in Paris by and large rushed home, to be replaced by writers and artists with an agenda quite different from attending the movable feast. George Orwell swapped down-and-out in London for down-and-out in Paris, and walked along the rue du Coq d'Or at seven in the morning, while his concierge busied herself squashing bugs on the wallpaper of her rooms. Henry Miller, penniless lone wolf and sexual adventurer, begged meals from friends and when he didn't get them stood ravenous and hallucinating in front of Matisse's paintings in a gallery on the Rue de Sèze, hoping to find sustenance there.

Chagall was certainly not going hungry like Miller and Orwell, but dark history was about to grab him by the throat and he felt the hands reaching out. In 1933 Hitler came

to power in Germany, prompting an immediate increase there in hostile activity toward Jews. In Mannheim, Nazis burned three of Chagall's paintings and displayed *The Pinch of Snuff*, his 1912 portrait of a rabbi enjoying a recreational sniff while studying Talmud, in the window of an art gallery with the caption "Taxpayer you should know how your money was spent." In the same year Chagall applied unsuccessfully for French citizenship, his years as a Soviet commissar coming back to haunt him.

Throughout the early 1930s Chagall traveled extensively in Europe, visiting Spain, England, and Holland. The joyous inspiration that he took from his first direct encounters with El Greco, Goya, and Rembrandt in their countries of origin was undoubtedly tempered by his increasing awareness of looming danger. A darker magic invaded his canvases: the flowers and acrobats were gone or confined to the margins, and haunting, premonitory visions replaced them. The Nazi threat to Jews returned Vitebsk to the forefront of Chagall's imagination. He produced two magnificent paintings, the bleak and austere *Nude over Vitebsk* (1933) and the melancholy *Solitude* (1933–34). In the first a nude woman, her back to us, lies on her side sleeping, a white fan open next to her upper arm, her long chestnut braid running down her spine. Her bed is the gray sky above an almost empty Vitebsk street, also painted in shades of gray. A vase with red flowers has been summarily placed in the bottom left-hand corner, but its blooms are lifeless. The overall effect is both uncanny and disturbing. Chagall's sleeping nude is not one of the antic

levitating creatures of his earlier works, but a foreboding figure, at once beautiful and terribly vulnerable. *Solitude* is less mysterious but no less powerful. A bearded Jew shrouded in his tallith sits clutching a *sefer torah* in one arm while resting his weary head on the other. His facial expression is gloomy. Next to him a white cow plays a yellow violin. In the background an angel hovers over what might be a burning town, or at least houses enveloped in black smoke.

Not long after he completed *Solitude* Chagall experienced what should have been a joyous occasion, the wedding of his eighteen-year-old daughter, Ida (the model for *Nude over Vitebsk*), to Michel Rapaport, a young lawyer from a Russian

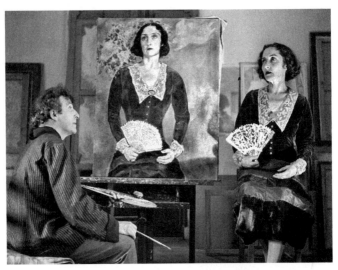

Chagall and his first wife, Bella, August 1934.
(Courtesy Roger-Viollet)

Jewish background. Chagall's relationship to Ida, loving and characterized by one observer as one of "mutual admiration," had been unusually open. As a fifteen-year-old Ida had frequently posed nude for her father, and a small scandal had erupted when Chagall allowed a photograph of one such occasion to appear in *Cahiers d'Art*. The Spanish poet Rafael Alberti has described his first visit to Chagall's home in July 1931, when he discovered "Chagall painting his beautiful daughter Ida completely nude in the woods under a tree." Alberti was overcome by the scene. "Oh, that girl was so beautiful it was a spectacle to see her under the trees that way. Certainly there was nothing erotic about it, nothing improper . . . her father had no false shame about it and neither did she . . . He was a bit pagan, you know, a bit of a faun, a satyr. He certainly wasn't religious in any sectarian sense. No, he was a man truly open, free." Elsewhere Alberti, committed to his pagan vision, insisted that there was "nothing Jewish" about Chagall.

Even with Eros absented, it is possible that Ida's wedding was a blow to Chagall, an intrusion on a relationship of profound intimacy. Certainly, without such an understanding it is difficult to explain the strangely desolate and empty wedding painting *The Bride's Chair* (1934), which Chagall produced to mark the day. The occupant of the bride's chair, shrouded in a white shawl, is not Ida but a spray of white flowers. The "groom" is a large bouquet of white roses. On a nearby table a three-pronged candelabra stands on a white tablecloth alongside a single lit candle (a *yahrzeit*?). On the

wall above hangs Chagall's own gorgeously ecstatic painting *The Birthday.* The contrast between Chagall's apprehension of his own courtship of and marriage to Bella with that of Ida and Michel's nuptials could not be any clearer. Oddly, among art historians only Franz Meyer, Ida's second husband, has read *The Bride's Chair* as a "tender subject" where "the full, pure resonance of the white is magically intensified by the pale tobacco brown, the green, and the delicate colors of the flowers."

How was it possible for an undoubtedly perspicacious poet like Rafael Alberti to declare that he found "nothing Jewish" in Chagall? It seems that Chagall exhibited a dual consciousness. In Paris he was a bohemian, on the surface not the most outrageous, but nonetheless, as Ida's modeling and the public displays of her nudity confirm, quite willing to defy convention along with the best of his peers. In contrast, he was also a man who read the Yiddish papers daily in Paris, and who could tell Edmund Fleg, apparently without irony, "I am a little Jew of Vitebsk. All that I paint, all that I do, all that I am, is just the little Jew of Vitebsk." There is, of course, no reason why Chagall should have had more success than anyone else in negotiating the rapidity with which the Jewish world had expanded in his lifetime. All his links to the past pressed daily upon his attachment to and enthusiasm for the liberating present. Meanwhile, the future stood gravely in waiting for all the Jews who had turned the corner into the modern world.

In August 1935 Chagall and Bella traveled to Vilna, which

at the time was still inside Poland's borders, to attend the opening of the new Museum of Jewish Art there and an exhibition of 116 of Chagall's graphic works, both timed to coincide with a conference to celebrate the tenth anniversary of the founding of YIVO (the Jewish Scientific Institute). Vilna was a city with 100,000 Jews (twice the Jewish population of Tel Aviv).

The summer of 1935 was a turning point toward misery for the Jewish population of Poland and its territories. The death of Marshal Pilsudski in May, and the immediate collapse of his authoritarian but not vindictively anti-Semitic administration, led to the rise of the Saracja regime. This government, inspired by the success of the Nazi party in Germany, openly espoused a policy of economic anti-Semitism. Under Saracja Jews were publicly encouraged to emigrate, and "ghetto benches," separate seats painted yellow, were set aside for Jewish students at the back of classes. The Vilna that Chagall visited was already a place where street beatings and other assaults on Jews were increasingly common. Although Chagall's letters and postcards from Vilna reflect his appreciation for the beauty of the city and the way its streets and buildings took him back to Vitebsk, he could not fail to have sensed the local atmosphere of foreboding and distress.

In Vilna Chagall met a number of local Yiddish writers, including the poet Abraham Sutzkever, who at the age of twenty-two had already secured a solid reputation. Chagall, twenty-six years Sutzkever's senior, took to the young man

and formed a bond with him that was to last until Chagall's death.

In September, while Chagall was still in Vilna, Nazi Germany adopted the Nuremberg Laws, which officially disenfranchised Jews and made them noncitizens. Jews could no longer vote, hold government jobs, serve in the army, marry non-Jews, engage in extramarital sexual relations with Aryans, or hire female non-Jewish domestic workers. The London *Times* commented, "Nothing like the complete disinheritance and segregation of Jewish citizens, now announced, has been heard since medieval times." In Vilna, as he had done in Safed, Chagall painted the interior of a local synagogue as an act of homage to a city that was a vital Jewish cultural center.

Back in Paris, Chagall moved to a new studio near the Trocadero and recommenced his European travels, this time taking Bella to Florence and Venice. The journey proved to be a brief respite, for as the world opened for Chagall it simultaneously threatened to close. In 1937, three of Chagall's canvases were permanently removed from German museums and displayed in the infamous exhibition of "degenerate art" held by the Nazis in Munich. He had been marked by the Reich. Shortly after, through the intervention of a powerful group of French intellectuals, Chagall was finally granted French citizenship; it must have seemed to him not a moment too soon, although within four years his citizenship was to be revoked by the Vichy government.

Artists responded on their canvases to the rise of fascism

and Nazism, although their forms of resistance and opposition wildly diverged. Matisse, for example, continued to search after beauty and to paint in the belief that to champion an autonomous French aesthetic was the most vital response that he could make. Picasso produced *Guernica*, his monumental reaction to one of the worst atrocities of the Spanish Civil War, the bombing by German pilots at Franco's behest of the Basque city of Guernica on March 30, 1937, a crowded market day on which 1,660 Spaniards lost their lives.

Meanwhile, Chagall, for what appear to be complex and not entirely discernible reasons, rode the dangerous swell and surge of European history and politics back in time to the Russian Revolution and the cataclysm of October 1917. His huge 1937 painting *The Revolution* (which six years later he cut up into three sections and reworked) features Lenin as its central figure, performing a one-armed handstand on a table where a meditative rabbinical figure is seated with Torah in hand and tefillin in place. The rabbi and the revolutionary leader are depicted praying and performing outdoors on snowy ground, with a samovar and a seated anthropomorphic goat for nearby company. The French tricolor flies behind Lenin's right leg, while his free hand appears to have lost hold of a red flag whose hammer and sickle have been transformed into an aleph. To the left of these figures the canvas is occupied by the destructive and violent turmoil of a vast and well-armed revolutionary crowd whose men and women wave swords, guns, and red flags. By con-

trast, to the right, Chagall represents the lyric world of the shtetl and its dreaming artists. A painter (young Chagall?) sits at his easel, a man plays the cello, a small child colors on a slanting rooftop by the light of an oil lamp while his parents, the mother with a bouquet in her hand (Chagall, Bella, and Ida?), lie nearby looking anxiously toward the crowd; elsewhere, a musical parade drums and pipes its way around town. The aggressive, angry, and potentially murderous crowd on the left is painted in a somber, muted spread of blue, green, purple, brown, and red, with a splash of yellow on a woman's coat; the expressive, inspired Jews on the right are drawn from the same palette, but in lighter, fresher tones, and with less pigment.

The painting supports a number of interpretations: Chagall's warning to his contemporaries not to be seduced by the justness of the Communist cause in the Spanish Civil War into overlooking the short- and long-term dangers of a country turned upside down by Communism; a belated revision of his own brief attachment to the Revolution; an elegy for the peaceable kingdom of the shtetl; a representation of the clashes within Chagall's personal history, in which the flags that dominate the composition, Soviet reds, the French tricolor, and the strangely adjusted red flag with aleph represent different stages of his journey. From another perspective *The Revolution* is a self-portrait of Chagall's mind, with the Dionysian, chaotic, revolutionary, id-like elements on the left, the Apollonian, bucolic, balanced products of the ego on the right, and the two looming, authoritarian, super-

ego elements in the middle—the Hebrew Bible father and the father of Communism, the new religion, both of which Chagall embraced and rejected. Beyond all speculation, however, the painting has an undoubted and lasting strangeness. One wants to ask of Chagall in 1937, Why now?

After Vilna, after the exhibition of "degenerate art" and the removal of his works from German museums, Chagall was certainly aware that European Jewish culture was, in Lucy Davidowicz's haunting phrase, "a feverish flowering in the shadow of death." And yet it seems that he had his own Soviet demons to exorcize before he could turn his attention head-on to the new enemy.

In 1938, while the Nazis stole the summer to burn synagogues in Munich and Nuremberg, mark Jewish businesses, and force all German Jews without recognizably "Jewish" first names to take the middle names of "Israel" for the men and "Sarah" for the women, Chagall conceived in the black milk of daybreak what is perhaps his most remarkable and controversial painting, *White Crucifixion.* In all likelihood he finished the work after the letter *J* had been stamped on all the passports belonging to German Jews, after the Italian government had imposed its own version of the Nuremberg Laws, and after Kristallnacht, the night of the broken glass in Germany on November 9, when 191 synagogues were burned, Jewish tombstones were overturned and desecrated, and Jewish residents of Leipzig (Wagner's birthplace) were hurled into a small stream in the local zoo, spat at, and pelted with mud, while in other cities and towns across the

country ninety-one Jews were brutally murdered and thirty thousand were rounded up and sent to concentration camps.

White Crucifixion is Chagall's *Guernica*, a painting that responds to immediate and terrible atrocity. In it a fire set by a Nazi brownshirt rages through a synagogue; a desperate bearded old Jew wears a humiliating placard around his neck that in the painting's early versions, until Chagall decided to erase the words as unnecessarily explicit, clearly read *Ich Bin Jude*; a boatload of exhausted, supplicating Jewish refugees flee from a burning inverted shtetl where a corpse lies spread-eagled on the ground; Soviet peasant forces, sabers raised, rush in from the margin of the canvas, but their intent seems murderous rather than salvatory; floating rabbinical figures cover their eyes or crumple in lamentation; and at the still center of this devastation and misery, dominating the canvas, is Jesus on the cross, his loincloth striped and fringed like a tallith, his head bowed beneath Hebrew lettering that spells out Jesus of Nazareth, King of the Jews, and above that the more traditional Latin acronym for the same, INRI, which Chagall must have seen on El Greco's formidable *Christ on the Cross* as well as in numerous other Christian representations of the Crucifixion.

Picasso, who by 1937 had long since shrugged off his country's Catholic tradition, chose its secular, ritualistic symbols of the bull and the horse to convey the horror of German/Spanish fascist bombing. Chagall, in what was perhaps an even more radical gesture, appeared to reach back to a pre-Christian Jesus, a man who has not yet been granted

the powers of miracle and redemption, and is rather an ancient Jewish martyr presented as a symbol of contemporary Jewish martyrs. In so doing Chagall risked alienating those members of his Jewish audience for whom the simple presence of Jesus Christ in a painting signaled betrayal and oppression rather than their opposite.

Chagall's appropriation of the Crucifixion of Jesus as an icon of *Jewish* suffering is not entirely uncommon among Jewish writers and artists in the twentieth century. It occurs, for example, in the work of the Yiddish novelist Pinchas Kahanovich (known as Der Nister, The Hidden One), in Scholem Asch, to chilling effect in Elie Wiesel's *Night*, and in Yehuda Amichai's remarkable poem "The Jewish Time Bomb." Whatever its degree of surprise to a Jewish audience, Chagall's decision to paint a Crucifixion scene in 1938 is hardly out of keeping with his own obsessions, for, as has already been noted, his relationship with "Christ as a poet and prophetic figure" was deep and long-lasting.

Was Chagall ahead of his time in insisting on wresting free a Jesus unadulterated by late-coming Christianity? The plethora of books issued recently on the subject of the early resonance between Judaism and Christianity suggest that he probably was. And yet there is something not altogether persuasive in the litany of critical approval in biographies and works of art history for Chagall's autonomously Jewish Jesus. For, while there are certainly a number of works like *White Crucifixion* in which Christ's Jewishness is crucial, there are many others, like the 1950 ceramic platter *Christ on*

the Cross, where it cannot be extrapolated without a great deal of wishful thinking. But Chagall's "Christian" Jesus is equally problematic. Since the mid-1920s and the beginnings of his friendship in Paris with the brilliant and charismatic French Catholic philosopher Jacques Maritain and his wife, the poet Raissa Maritain, a Russian-born convert from Judaism, Chagall had been aware of their interpretations of his paintings: essays and poems that characterized Chagall's renditions of Jesus as the work of a Jew moving toward Christ *perhaps without even knowing it*. ("Despite itself," Jacques Maritain wrote in a 1941 essay excoriating anti-Semitism and evoking *White Crucifixion*, "Israel is climbing Calvary side by side with Christians . . . As in Marc Chagall's beautiful painting, the poor Jews, without understanding it, are swept along in the great tempest of the Crucifixion.") A work like *Christ on the Cross* seems to lend credence to the Maritains' view. And yet, despite the luminous intellectual gestures and poetic flourishes of both Maritains—who had successfully proselytized a number of Jewish artists and writers in postwar Paris—Chagall powerfully resisted their attempts to Christianize both him and his work.

Chagall's relationship to the figure of Jesus Christ is ultimately mysterious, overdetermined, unclassifiable, and contradictory. It is the Jesus of a Jewish child who grew up in an environment of churches and Russian Orthodox icons; of a Jewish painter both attuned to and rebelling against a two-thousand-year tradition of Christian iconography in

art; of a Jew in love with the stories of the Hebrew Bible and yet well versed in the parables of the New Testament, drawn to the poetry of that book and excited by its gaunt philosophy; of a Jew who wants to argue Christ with the Lubavitcher rebbe but must decry religion as a Soviet revolutionary; of a pagan illustrating the Hebrew Bible; and of a Jew painting, obsessively it sometimes seems, Jesus on the cross.

11

Villentroy, Gordes, Marseilles

War on the horizon always draws people out of cities, away from threatened borders, and into the heart of the countryside, where the illusion of safety can be temporarily sustained. In the summer of 1939 Chagall took his family back to the farmhouse in Villentroy on the Loire, where they had passed a peaceable, pleasant summer a year earlier. But, as if the diabolic forces massing in the external world had unhinged a little of Chagall's internal world, instead of breathing out Chagall experienced an episode of high paranoia. Toward the end of August Chagall convinced himself that the farmer with whom the family shared their cottage was eyeing him with murderous intent, so he barricaded himself in his living quarters. As soon as the imagined imminent danger was past, the Chagalls moved to a nearby town on the left bank of the river, Saint-Dye-sur-Loire.

The outbreak of war on September 1 did not immediately affect the family's daily life in France (the "Phony War" that ran from October 1939 through May 1940 aroused a false sense of security in many French and British residents), but

it did persuade Chagall speedily to move all his paintings out of Paris and down to Saint-Dye-sur-Loire. The future was sufficiently ambiguous to allow Chagall to return briefly to Paris in January 1940 for an exhibition at Galerie Mai of paintings that he had executed in the previous two years. By spring, the situation had deteriorated and speculation was rife that the lovely hamlets of the Loire Valley were about to form a holding line for the French army. Chagall and Bella scouted farther south for a new home. They landed in Provence, in Gordes, a "tumbled down old town on the edge of a vast and peaceful valley," as Varian Fry, the man who later came to rescue him, described it, and there they discovered a long-empty building that had once been a Catholic girls' school. The high ceilings, long windows, and spacious rooms offered a perfectly seductive studio space, and Chagall bought the place.

Here, for almost a year in the relative sanctity of unoccupied France, while the German army overwhelmed and quickly forced the surrender of Belgian, Dutch, and French forces, marched into Paris, and began to tighten its grip on continental Europe's Jews, Chagall painted his usual circus groups but also produced a series of extraordinarily beautiful country still lifes. "Perhaps," Rilke says in his ninth Duino elegy, "we are *here* in order to say: house, bridge, fountain, gate, pitcher, fruit-tree, window . . . But to *say* them . . . *more* intensely than the Things themselves ever dreamed of existing." There is precisely this heightened (and for that reason, poignant) intensity in Chagall's grapes

and peaches, baskets of fruit, vases of flowers, and pheasants and rabbits laid out for cooking, which equals if not surpasses the effect of his *The Painter and the Christ* from the same year. In that painting a weary Chagall, palette in hand, sits before his own giant canvas showing a Hebraic crucified Jesus. The self-identification is unambiguous and reinforced by a poem Chagall wrote, most likely while at Gordes:

> Nuit et jour je porte une croix
> On me pousse, on me train par la main
> Deja, la nuit autour de moi
> Toi t'éloignes, mon Dieux. Pourquoi?

> (Night and day I carry a cross
> I am pushed, tugged by the hand
> Already, night is all around me
> My God, why hast thou abandoned me?)

Too much time has been spent by art historians on pondering Chagall's assumed stubbornness in refusing to leave Gordes until it was almost too late. The truth, as Benjamin Harshav's research has made clear, is that, while indeed ambivalent about leaving France, Chagall was asking for help from abroad, albeit covertly, as early as September 1, 1940. Certainly, as a newly minted French citizen, an established internationally famous artist, and a man who had already moved too many times at the behest of others while losing a lot of paintings along the way, Chagall was understandably anxious about the necessity to flee, and he had responded negatively to Varian Fry's first letter urging him

to do so. And yet he was not a fool: as soon as Vichy adopted anti-Jewish laws in October 1940, Chagall understood what had to happen.

Since June 1940 an Emergency Rescue Committee made up of concerned private individuals had been at work in the United States with the express mission of bringing political and intellectual refugees out of France before the Gestapo or their French collaborators could get hold of them. Varian Fry was chosen by the committee to become its agent in France and play Scarlet Pimpernel.

Fry, at first glance, seems an unlikely hero. Conservative in both manner and appearance, he was a Harvard classics major who enjoyed bird-watching and wine tasting. But he was also the editor of a prestigious journal of foreign press reprints, *The Living Age*, and the author of position papers for the Foreign Policy Association. Most urgently, Fry, then in his mid-twenties, had traveled in Germany in 1935 and been a horrified eyewitness to the early pogroms effectuated by Hitler's thugs on the streets of Berlin.

Fry arrived in Marseilles in August 1940. There he set up the American Relief Center, ostensibly to provide financial support for stranded refugees, but the office was in fact a front for his human smuggling operation. Fry took on not only the French police and the security services in Vichy, both under ever-increasing pressure from their Nazi over-lords in occupied France to make arrests, but also the slow-footed, bureaucratically entangled, and frequently indifferent if not outright hostile U.S. State Department.

After the fall of France the American Federation of Labor

had succeeded in persuading the State Department to grant emergency visas to a number of prominent European labor leaders, including Modigliani's younger brother Giuseppe, who was the head of the Italian Socialist Party. But transit visas out of France were still required. The AFL's representative, Frank Bohn, worked in Marseilles to provide them by any means, including forgery, but he was soon forced to flee. Fry took over the operation, adding his own list of prominent writers, artists, musicians, and scientists to those desperate to escape.

Fry's rescue mission was supposed to be limited to big names, writers like Lion Feuchtwanger and Franz Werfel and Thomas Mann's son Golo, but he found ways to circumvent the restriction and include lesser celebrities and sometimes simply people with very little to no talent on the listed requests for visas that he cabled daily to New York. As the noose tightened, Fry and a small staff, at great personal risk to themselves, delved deep into the underground world of false passports and other documents, money laundering, bribery, and the illegal purchase or rental of small fishing vessels. Even Fry himself took groups of refugees over the hills and into Spain. All in all he managed to spirit more than 1,500 people out of France before the authorities there closed down his operations and expelled him in September 1941.

Efforts to bring Chagall and his family to America had been under way for a few months when in March 1941 Fry and Harry Bingham, the American consul general, drove

into Gordes, their high-end car causing a quiet sensation in the village. To this point funds to help pay Chagall's passage had been raised from such Jewish luminaries in America as Helena Rubinstein and Edward G. Robinson, although the former, beset by requests for aid, had balked at providing additional monies for Ida and her husband, Michel.

Chagall's name had appeared on a list drawn up by Alfred Barr, Jr., the director of the Museum of Modern Art in New York, alongside those of Picasso, Ernst, Matisse, Man Ray, Kandinsky, Rouault, Dufy, Masson, Klee, Lipchitz, and others. All were to receive official "invitations" to show their work at MoMA.

On their drive up to Gordes from Marseilles, Fry and Bingham had passed two trucks full of German soldiers on the road to Aix. Fry's account of the early March weekend that he and Bingham spent at Gordes discussing arrangements for Chagall's urgent departure from French soil contains Chagall's much quoted question, which he apparently repeated anxiously at intervals over both days, "Are there cows in America?" This line has received extensive parsing; the repetition suggests to me that the question nagging at Chagall (via Fry) was "Will I have a subject in America?" or "Will I be able to paint?" Chagall, it should not be forgotten, did not speak English.

Fry admired Chagall, although he did describe him, with perhaps more disapprobation than intended, as "a nice child, vain and simple." One night in Marseilles the two men had experienced an RAF bombing raid together, sitting it

out in the darkness of the Gare Noailles, listening to the dull thud of British bombs and the antiaircraft guns of L'État Français. Chagall and Fry peeked out of the station entrance at a sky crisscrossed with yellow searchlights, only to be ignominiously shooed back by an air-raid warden. A few weeks later Chagall told Fry that when he and his family had left for America Fry could use his home to hide other refugees.

The anti-Jewish laws promulgated in October 1940 by Marshal Pétain, the head of the puppet state of Vichy France, were a last warning that Chagall was quick to heed. To begin with, foreign Jews could be interned in camps and Algerian Jews immediately lost their French citizenship; many were shipped to concentration camps in the Sahara. Chagall, a French Jew, was exempt for a short period, but eventually his citizenship was stripped. Two weeks after Fry and Bingham's visit the Vichy government set up its Commissariat for Jewish Affairs under the direction of the notorious anti-Semite Xavier Vallat. All Jews were required to register. Jewish property, like the Chagalls' home, was to be "Aryanized," that is, handed over to non-Jews. Within days Chagall was in Marseilles. There, either from foresight or a willful refusal to give up entirely on the country in which he had been happiest, Chagall took up precious time by insisting on acquiring a reentry visa in addition to an exit visa. All procrastination was cut short in mid-April 1941, when he was arrested in a police raid at the Hotel Moderne in a sweep of individuals who "seemed likely to be Jewish."

Bella, luckily, was passed over. She immediately called Fry, who came expeditiously to the rescue. He telephoned a police official at the Bishopric, launched a full-blooded protest, and threatened to call the *New York Times*. Vichy, it should be remembered, had been granted full diplomatic recognition by the U.S. government, and at this point in its short history American opinion still counted for something. Chagall's Carnegie diploma (*The Betrothed* had won third prize at the Carnegie International exhibition in Pittsburgh in 1939) produced at the police station had apparently impressed his captors to some degree, but it was Fry's suggestion of worldwide embarrassment for Vichy that apparently did the trick. Chagall was speedily returned to his hotel. A few weeks longer and the painter would probably have been on his way to Drancy, the French transit point for Auschwitz.

On May 7, 1941, Chagall and Bella crossed into Spain. Four days later they were in Lisbon and ready to set sail. Through the extraordinary efforts of Ida and an international group of Chagall's supporters, all his paintings and drawings had been packed for shipment to New York. The work would not arrive as quickly as Chagall himself, as the German embassy in Spain made a greedy and criminal attempt to impound the crates, but the intervention of a sympathetic administrator from the Prado sent the art on its way. Bella, roiled by the past and deeply upset to leave France, had the premonition that she would never see the country again. Days after Chagall's ship left the port of Lis-

bon for New York, German consulates were informed that Hermann Göring had banned the emigration of Jews from all occupied territories, including France, in view of the "doubtless imminent final solution."

Chagall, then, like so many others, owed his and his family's lives to the astonishing courage, tenacity, and resourcefulness of Varian Fry, who is recognized among the Righteous Gentiles at Yad Vashem, Israel's Holocaust memorial. It is all the sadder in this regard that when, in the mid-1960s, Fry came to ask a favor of Chagall, he was rebuffed. Fry, who had been living a quiet life in Connecticut, had been recruited by the International Rescue Committee to raise funds for world refugees. His assignment was to compile a portfolio of prints to be created by artists who were themselves former refugees "marking the 25th anniversary of their flight from Hitler." Chagall balked at handing over anything: his refusal to help preoccupied Fry for three years. Perhaps it was some solace that Fry had Ida on his side; she wrote to him that her father's behavior was "a disgrace." Eventually Chagall relented, but too late for Varian Fry, who died in September 1967, three years before the collected lithographs finally appeared.

12

New York

Chagall, like many others before and after him, thought New York City was "Babylon." He was fifty-three years old when he first set foot on its teeming streets, about twice the age appropriate for craning your neck back, swallowing the skyline, taking a deep breath, and plunging in.

There were advantages to arriving with a reputation and a sack of paintings. Pierre Matisse, Henri's son, who had established a successful Madison Avenue gallery in Manhattan in 1931, met the family at the dock and drove them to their hotel. He quickly signed Chagall to a contract that guaranteed the artist $350 a month and arranged for a November show of some of Chagall's early work. Even with the stability of a fixed income, Marc and Bella were, not surprisingly, unsettled to begin with. They moved into three different hotels before renting an apartment at 4 East Seventy-fourth Street.

Babel, perhaps, more than Babylon, was the loud, hammering city in Chagall's ears. He was happiest among the Yiddish speakers of the Lower East Side and picked up his

news from the *Forward* and other Yiddish publications. He was also able to relax into French or Russian among the numerous émigré artists who used Matisse's gallery as a home base. Thanks largely to the efforts of Varian Fry, New York was now home to any number of European artists, including Fernand Léger, Jean Hélion, Ossip Zadkine, Piet Mondrian, Marcel Duchamp, Jacques Lipchitz, and André Breton, the surrealist Chagall had once spurned. Chagall met them all on his rounds of Manhattan's galleries and studios. The Maritains were also in New York; they, along with the poets Claire and Ivan Goll, were probably closest to Chagall and Bella.

There were new faces too, most prominently those of the sculptor Alexander Calder and the art historian Meyer Schapiro. Calder, a bear of a man with a childlike personality that matched Chagall's, owned a studio in New Preston, Connecticut, where the Chagalls rented a summer home. Schapiro, who at thirty-seven was already a full professor at Columbia and a widely revered and respected critic, came to admire Chagall's art for what were, from Chagall's point of view, entirely the wrong reasons: Schapiro emphasized the inescapable literary and illustrative aspects of Chagall's work, characterizations that enraged and offended Chagall because they seemed flat-footed and contradicted Chagall's own sense of his work as mystical and autonomously inspired. But in 1941 this crack in their relationship was years away, and Schapiro, who had been born in Lithuania and had come to the United States at the age of three, was a sympathetic conduit for Chagall into American life.

Chagall in his New York studio during World War II.
(*Courtesy Roger-Viollet*)

By and large Chagall's critical reputation in New York did not equal what it had been in Paris. He was not a "hot" artist for American collectors outside of the Jewish community, and, while he certainly had cachet with the establishment—in 1946 the Museum of Modern Art would give him a major retrospective—New York was on the cusp of what was to be, via Pollock, Rauschenberg, de Kooning, and Rothko, the most extraordinary breakthrough in modern painting since Cubism. In the context of cutting-edge American art, fired

as it was by the abstract genius of Hans Hofmann, Chagall's quirky work could not help but come across as slightly dated, as it had before in the days of Russian Constructivist and Suprematist preeminence. When the painter Ted Fried tried to secure membership for Chagall in the Federation of Painters and Sculptors, he was rudely rebuffed on the grounds that Chagall was not "a modern artist." No invitation to the American dance.

In Europe, of course, there was that "other dancing," as Gerald Stern calls it in his extraordinary poem "The Dancing," which contrasts American innocence with Nazi murder. Chagall responded to the exponentially bad news from France, Germany, and Poland like a man unhinged, by spreading the martyred figure of a Jewish Christ across his canvases. He was not alone. Something peculiar happened to an entire group of Jewish artists in America as they struggled to find some appropriate way in which to respond to the suffering of those left behind in Europe: they found Jesus.

In 1942 the Puma Gallery in New York promoted an exhibition entitled *Modern Christs*. Twenty-six artists, of whom seventeen were Jewish, including Adolph Gottlieb and Louise Nevelson, showed their work. And yet Chagall's Christs are different. No one personalized the image to the extent that he did, going so far in *Descent from the Cross* (1941) as to paint the initials MARC CH on the cross where you would expect to find INRI. Christ/Marc Ch is lowered to the ground by a figure with the head of a bird; a shtetl Jew

with a three-branched candelabra in his hand waits at the foot of the cross, while behind the figures a village is in flames. *Resurrection, The Painter Crucified, Yellow Christ, Yellow Crucifixion, Obsession, Descent from the Cross, Persecution, Crucifixion and Candles, Winter, Mexican Crucifixion, The Crucified,* all Crucifixion scenes, were executed or completed by Chagall between 1941 and 1944. Jesus is the Christ of old, or he has a palette in his hand, or he is a shtetl Jew hung with a placard while two other Jews are crucified behind him like the thieves who accompanied Jesus, or he wears tefillin and his crucified left arm stretches toward an open Torah scroll, but almost without exception there is murderous chaos nearby.

In keeping with the ever present conflict in Chagall's life between the forces that brought him joy and those that reduced him to despair, he continued to paint circus animals and performers in New York, just as he had done in Gordes when the Nazi net was closing around him. But his clowns, acrobats, and ethereal equestrians have a rote quality to them when compared with the uncanny histrionics of the Christ paintings. "For me," Chagall said in an interview he gave to *Partisan Review* in 1944, "Christ is a great poet, the teaching of whose poetry has been forgotten by the modern world," but in his identification of Nazi victims with Jesus, all mixed and merged with confusions about the sufferings of others and his own suffering, Chagall transcended the world of poets and poetry in a manner that is both disturbing and profound. In 1947, with the war over for two years, Chagall had this to say about those Jews who were slaughtered in his

hometown and in the ghettos where they had been herded: "their crucifixion in the streets of Vitebsk and other places took on the tragic appearance of the crucified Christ Himself." Given the inflamed rhetoric that had issued from more than a few Catholic priests in Nazi-occupied Poland during the war, this was hardly a comparison likely to endear Chagall to his Jewish audience.

By and large, Jewish artists, whether European or American, knew no better than anyone else what to do with the unprecedented and indigestible information bleeding out of Germany and Nazi-occupied countries. It is hardly surprising that they reached back to what was known and familiar—the catastrophic history of martyrdom and murder, whether by Roman crucifixion or the fires of a shtetl pogrom—in order to get their heads around a genocide that, ultimately, *no one* would be able to grasp except in parts that never quite add up. Perhaps the Crucifixion of Jesus leaped to mind because no other "Jewish" historical event appeared "big enough" in its ramifications to compare to what was going on.

It was to be many years before the bone-chilling eyewitness accounts of survivors and the first detailed histories of the Holocaust became widely available to the general public, and many more until the Eichmann trial in Jerusalem in 1961, a media spectacle at once cathartic and extraordinary, somehow threw open the door to a wide variety of Holocaust representations in fiction, film, music, and art.

We could hardly expect Chagall, schooled in an old-style

Russian anti-Semitism that was brutal but restricted, imme-
diately to find an appropriate form in which to represent the
boundless destruction of European Jewry. In the 1980s, with
thirty years of historical evidence available to him in pic-
tures and words, the German artist Anselm Kiefer ran iron
tracks off his monumental paintings of Auschwitz and onto
the floor of the galleries in which they were shown—as if
the represented event, the arrival of Jews in the death camp
and their subsequent murder, could not be contained within
any frame. ("I never thought a German artist would make
me cry," wrote Leon Wieseltier in *The New Republic*.) Simi-
larly, Primo Levi wrote memoir, essays, fiction, poetry, and
memoir mixed with fiction about his Holocaust experiences,
as if no single genre could possibly hold material that always
overflowed its generic banks. In addition to Kiefer and Levi,
numerous creative figures, including the French novelist
Georges Perec, in his memoir/novel *W, or The Memory of
Childhood*, and the filmmaker Claude Lanzmann, whose docu-
mentary *Shoah* ran for nine hours, have, in one way or
another, "broken the frame" in an attempt to approximate
the unassimilable events of the Holocaust.

However disturbing its use of Jesus as a symbolic image of
contemporary Jewish martyrdom might have been, the work
of Chagall and his contemporaries keeps faith with the
world of the frame and all that it implies about the artist's
potential to master experience. They were familiar, of course,
with Dada, but while that movement's anarchy, expressed,
for example, in Duchamp's infamous urinal, might have been

appropriate to prick the vanities and conventions of the art world and tweak the governing boards of museums, it did not seem capable of taking on a cataclysmic historical event like the destruction of European Jewry. No, painting was the serious way to go, although painting hardly went anywhere where the Holocaust was concerned. Toward the end of the war, Chagall appeared to acknowledge the general hopelessness of the task: "We, the Jewish artists today, are like grass, maybe nice grass, but grass on a cemetery."

For local American artists on the rise, the European influx to New York City was a double-edged sword. On the one hand Paris had lost its hold as capital of the world art scene, but on the other the new arrivals frequently acted like elitist snobs toward their new hosts and fellow painters. In this regard the French Surrealists had the worst reputation, and the crowd that gathered around Max Ernst and his lover Peggy Guggenheim, who was perhaps the single most influential figure in establishing reputations and fostering commercial success, was characterized by its exclusivity. For his part, Chagall, distanced by language from the marrow of American life, probably came across as more cliquish than he actually was. Chagall's narcissism (coupled with his self-effacement as the unworthy "little Jew") was always in the ascendancy. He showed admirable skepticism in disdaining all groups, but belonging to a club of one produced a vanity in him that grew increasingly disconcerting as the painter aged. Sidney Alexander, one of Chagall's liveliest biographers, reports that when the American Jewish sculp-

tor Chaim Gross visited Chagall at his home in Saint-Paul-de-Vence in 1971 (the two had met in New York in 1943 and liked to chat in Yiddish), Gross drew a sketch of Chagall only to have his subject take a pencil to the work in order to cover bald spots with hair, shorten the nose, and slant the eyes into a seductive geisha look.

In March 1942 Pierre Matisse showed an impressive array of works by Europeans in New York under the heading Artists in Exile. The group photograph taken for the catalogue shows a conservatively dressed and coiffed all-male cast that looks more like a corporate board than a gathering of radical painters. Only Chagall, in a loud tartan necktie, and Léger, who chose to go tieless, hint at the bohemian world left behind in Paris. The bland harmony of the group, as suggested by the photograph, was utterly illusory. According to Matisse, as soon as the camera had clicked there was a speedy return to general backbiting and envy.

In New York Chagall felt more Russian than French, and at times perhaps more Russian than Jewish. Such identity shifts are not uncommon. By the time that the Chagalls had settled in New York the Hitler-Stalin pact was broken and the Soviets were back on the right side of the stockade. This freed Chagall and Bella to direct their sympathetic attention to the fate of their homeland, and Vitebsk in particular. As a result their concentration on events in France lessened.

In 1943 the Soviet Cultural Commission sent the poet Itzhik Feffer and the actor Solomon Mikhoels on a propa-

ganda mission to New York. Their purpose was to encourage American Jews to get behind the Soviet war effort. Chagall had been friends with both men in Russia, and in New York he vouched for their authenticity in the face of suspicion that they were merely Stalin's puppets and probably spies (which of course, by this time, and having no option in the matter, they were). As a member of the recently formed Committee of Jewish Writers, Artists, and Scientists, which was of course antifascist, Chagall quickly attracted the attention of the supposedly equally antifascist FBI. Chagall's FBI files, recently unearthed by Benjamin Harshav, would read like comic, bumbling, and absurd bureaucratic fiction were it not for the fact that we know how many people's lives were ruined by similar reports. The Committee of Jewish Writers, Artists, and Scientists, headed by Albert Einstein, is designated a "Communist front for racial agitation," while Chagall's own dubious Red activities included exhibiting at a Riverside Museum show partially sponsored by the Committee for the Negro in the Arts. Chagall was at times naïve about both the reactionary ferocity of the American far right and the murderous manipulations of Stalin's NKVD. When Mikhoels and Feffer returned to Moscow, they took with them two paintings donated by Chagall for display in Soviet museums along with one of his ever hopeful but in the end inexplicably sentimental and irrational paeans to Russia: "To my fatherland, to which I owe all I have done in the last thirty-five years and shall do in the future." The paintings were not shown, and like Rosencrantz and

Guildenstern, the two men who carried the message were murdered.

By the spring of 1942 the Nazi extermination of the Jews of Europe had begun in earnest. At the death camp in Sobibor 36,000 Jews were gassed in the month of May alone. A month earlier an Einsatzkommando unit had reported the results of its previous four months' labor in the Crimea: 91,678 Jews murdered. The scale of the killing was not yet common knowledge. Jews in unoccupied Europe and in America went to work or pursued their leisure activities under a black cloud but without full information of the unprecedented range and thoroughness of Nazi murder.

Chagall, already a kind of survivor, found himself in Mexico. He had been commissioned to create the sets and costumes for the New York City Ballet's forthcoming production of *Aleko*, but as the former Soviet plenipotentiary was not affiliated with any union that worked in American theater, the entire company had decamped over the border in order to accommodate him. In Mexico Chagall fell in love with the exotic light and color that might have seduced him in Palestine if the complex relationship between his Jewish imagination and Jewish reality had not intervened to drain all passion from his painting. His vast sets for *Aleko* (libretto by Pushkin, music by Tchaikovsky, choreography by the Russian Léonide Massine), which included a stunning orange and red-gold backdrop of a smudged, burning sunset over a wheat field, stole the show. At the premiere in Mexico City's Bellas Artes Theater on September 8, Chagall himself

received numerous curtain calls from a wildly enthusiastic audience that included the great Mexican muralists Diego Rivera and José Clemente Orozco.

A month later *Aleko* opened at the Metropolitan Opera in New York, and once again Chagall was the hero of the night. At the Yiddish theater in Moscow Chagall had daubed even the actors' faces in order to subsume them to his vision. Chagall's set and costumes for his first ballet were only marginally less overwhelming. It was hardly the fault of the artist. You cannot hire a truly great painter whose work is theatrical to begin with and expect to rein him or her in: David Hockney's remarkable 1981 sets for the Metropolitan Opera productions of *Le sacre du printemps*, *Le rossignol*, and *Oedipus Rex* are another case in point.

For two more years Chagall and Bella led a life unthreatened but not untroubled. The duality is manifest in Chagall's work as he continued to produce both delightful circus etchings and grim paintings of crucified figures or of Vitebsk in flames. If, for Chagall, Jesus was a symbol of Jewish martyrdom in Europe, Vitebsk was a synecdoche for all the Jewish towns and villages destroyed in the German advance. In *The War* (1943), flames engulf the city and the sky above it, and rise terrifyingly from the burning red hair of a nursing mother; a corpse, strangely reminiscent of the figure in Chagall's 1908 painting *The Dead Man*, lies in the otherwise deserted street, arms outstretched. Elsewhere, soldiers march, a Jewish refugee flees, and a struggling horse with a rooster on his back tries to lift an earthbound, red-

wheeled cart and transform it by a dream of escape into Elijah's flaming chariot heading skyward.

The Chagalls summered now at placid Cranberry Lake in upstate New York, experiencing there the pleasures of the countryside, even though it was unfamiliar territory. There were certainly cows. Chagall produced a few bucolic oils and gouaches of the area, including one work, *Cranberry Lake* (1943), which makes the village look as if it were the near neighbor of a Russian shtetl. Upstate New York had its Jewish enclaves, particularly in the Catskills, but Cranberry Lake, a secluded spot farther north in the Adirondacks, was not one of them. The Chagalls certainly did not travel to the Catskills for square dancing at Camp Woodland or to hear Red Buttons at one of the Borscht Belt hotels. They did, however, become unhappily aware that anti-Semitism was not exclusive to Europe when Bella spotted a carefully worded but unmistakable "No Jews Allowed" sign in a Beaver Lake hotel, where, on account of Chagall's celebrity, an exception had apparently been made to permit their stay.

On August 25, 1944, Paris was liberated by Allied troops. Chagall heard the news from his son-in-law, Michel Gordey (Michel had changed his last name from Rapoport to Gordey in late 1940 or early 1941, as he was involved in work for the French Resistance and did not want to jeopardize the safety of his parents), who at the time was working in Washington, D.C., for Voice of America. Bella's first impulse was to return to France as soon as possible. She had felt isolated and homesick in America. Indeed, it was in anticipation of her

exile there that she had begun to write her memoirs. When she sat down to write, it was Yiddish, her "faltering mother tongue," rather than Russian (which she spoke much more than her husband) that spilled onto the page, as if the world that she and Marc had known in their youth could only be authentically represented in that language. As *Cranberry Lake* suggests, we might also want to say that Chagall, although he would powerfully resist the notion, continued to paint in Yiddish.

The Chagalls gave themselves a week to pack up for New York. After that, Paris beckoned, but almost as soon as their decision to move had been taken, tragedy struck. Bella was taken ill with what turned out to be a streptococcus infection. There was no penicillin easily available—except for extreme emergencies, the antibiotic was exclusively for military use—and, after a few days' illness, on September 2 Bella died. The circumstances surrounding her death are not entirely clear, but a number of accounts offered by her friends, acquaintances, and Chagall himself contain disturbing anti-Semitic elements. In one version Bella was refused admittance to a local hospital on dubious grounds, while in another it was Bella's own delirious anxieties, a resurgence of childhood fears brought on by the exclusionary sign in the Beaver Lake hotel, that prevented her from entering a Catholic hospital. Bella was forty-nine.

"Everything has become a shadow," Chagall told his friends, and he turned his pictures to the wall. He was expressive in his grief, and sobbed uncontrollably at Bella's

funeral. For thirty-five years Bella had been his consummate companion and constant muse. With the occasional exception of Ida, she had also been his only model. Bella, as her beautifully evocative memoir *Burning Lights* reveals, was a woman of passion and refined sensibility. If in her life her talent was inevitably eclipsed by the vast output and fame of her husband, there is no doubting that Bella, better educated and a better writer than her husband, whose poems exhibit precisely the sentimental affliction that her own strong, surreal prose avoids, carried her own gift. She did so with remarkable reserve and aplomb and was rewarded for that suppression with what is perhaps the most remarkable series of paintings as love poems that exists in twentieth-century art.

It is both poignant and fitting that Chagall, after eleven years of work, completed his rapturous *To My Wife* (1933–44) shortly before Bella died. Much of the story of how he liked to imagine her is told there: in the subdued eroticism of Bella naked on a red couch, in the painting's floral extravaganzas, in its musicians, angels, anthropomorphic fish and animals, in its youthful bride and groom and topsy-turvy shtetl, and in the strong reds, shaded blues and purples, and muted browns and grays that converge around the three words etched in black on the canopy above Bella's head: À MA FEMME. Surely Bella loved this story, even though in her own version, as parsed in her chapter "A Wedding," marriage is stranger and far more ambiguous, a bittersweet event, light haunted by shadows, in which a Jewish

bride frequently passes from one set of limitations to another. And yet, whatever the idealized ground of their conception, Chagall's paintings of embracing couples, all valentines to Bella, have been adored by crowds of young lovers and those yearning for love, who have taken to them as lasting images of romantic persistence in the face of a world gone mad.

13

Virginia

Chagall spent the next several months in mourning for Bella. He didn't work and he mooned about in a state of unrelieved loneliness. Ida and Michel looked after him in the Riverside Drive apartment that they all shared, but their own relationship was on the rocks and by the time that summer drew near Ida needed a break. To make matters worse, Chagall's housekeeper quit: it seems that everyone's nerves were frayed. Into the breach stepped Virginia Haggard. At twenty-nine she was a year older than Ida; she possessed a patrician English background—her great-uncle was H. Rider Haggard, author of the stirring adventure tale *King Solomon's Mines*—and was, on the surface, an unlikely replacement for Bella. But Virginia spoke fluent French; her father, Sir Godfrey Haggard, had been the British consul general in Paris; and Virginia, at the time a young art student, had once met Chagall at an embassy function. Moreover, she too was desperately lonely and hungry for love. Her own marriage to the Scottish painter John McNeil was miserable, largely on account of his frequent bouts of heavy

depression, which may or may not have had their origins in his abject career and impecunious state. The family income all came from Virginia, who, without parental assistance (there was bad blood between her father and her husband) cleaned and sewed for a living: a chance meeting with a friend of Ida's in Central Park had brought Virginia's sock-darning talents to the attention of the Chagall household. Virginia and John had a five-year-old daughter, Jean, who generally accompanied her mother when she went out to work.

On their first visit to Riverside Drive, Ida, a budding artist herself, made a quick sketch of the mother and child. It wasn't long before the two were regulars in the Riverside Drive apartment. Virginia took over as housekeeper, which allowed Ida to go off on vacation. Michel Gordey stayed more or less invisible in his half of the apartment, Jean found things to occupy her, one thing led to another, and soon enough Virginia and Marc were lovers.

Virginia Haggard's account of her relationship with Chagall, *My Life with Chagall: Seven Years of Plenty with the Master as Told by the Woman Who Shared Them*, belies its rather unfortunate title, with its overt but hard-to-unravel biblical allusion to Joseph in Egypt. It is a narrative of impressive intelligence and integrity. Kept secret from the world, if not Chagall's circle of friends, Virginia Haggard was first mentioned by a Chagall biographer in 1977, twenty-five years after the end of their relationship. Virginia indeed lived with Chagall for seven years and they had a son together, David,

but she was not allowed to attend the opening of Chagall's 1946 Museum of Modern Art retrospective (Ida went), and she frequently found herself in what, from the outside, appear to be untenable and humiliating situations. For example, two weeks after David's birth, an event that Chagall characteristically and intentionally avoided by taking off for Paris a month before Virginia's due date, she was obliged to write to Chagall's friends Joseph and Adele Opatoshu asking for a loan of one hundred dollars in order to pay her laundry, phone, and electric bills. And yet Virginia reports every mortifying episode without resentment, and with a degree of consideration and understanding unusual even for someone who grants the usual "genius" exemptions. Like Bob Dylan's forward-looking artist in "She Belongs to Me," she seems to know too much to argue or to judge.

Chagall's relationship with Virginia frequently highlights the painter's confused and sometimes guilt-ridden association to his own Jewishness and the complexities that attended his sense of himself as an emblematic artist for the Jewish community, a position that he both embraced and rejected. For example, Chagall was mortified when, despite precautions, Virginia became pregnant within a year of Bella's death. His inner disturbance stemmed neither from impending fatherhood nor from the fact that Virginia was his mistress, but from anxiety over his contravention of Jewish law. According to Virginia, Chagall did not want it to get out that he had sired a child during the yearlong mourning period for Bella. He took steps to keep Virginia's pregnancy

hidden, including a move to the secluded countryside, High Falls in the Catskill Mountains, where he bought a modest clapboard house.

Like so many secular Jews of his generation and beyond, Chagall maintained a nostalgic, superstitious, and undoubtedly conflicted relationship to the strictures of observant Judaism. Virginia was probably his first Gentile lover; Chagall felt guilty enough about that to suggest from time to time that she consider conversion. However, he also seemed to enjoy her "otherness" and by no means insisted that she embrace his faith. He tolerated, and even encouraged, Virginia's burgeoning relationship with Quest Brown, an English clairvoyant and palmist. Indeed, Chagall was happy to have his own palm read and generally pleased with the results. There is an inked imprint of Chagall's hand made by Quest Brown. In her memoir Virginia reports that Chagall attended synagogue only once in all the years that she knew him. He was brought by some Orthodox neighbors in High Falls to services on the first Yom Kippur after Bella's death, presumably to participate in Yizkor, the memorial service.

While Virginia was Chagall's lover, her non-Jewishness was largely treated, both by Chagall and by his Jewish friends, as a pleasant affectation to be tolerated and lightly mocked. When they were in a "teasing mood," the Opatoshus (Joseph was a well-known Yiddish writer) liked to refer to Virginia (affectionately, as she imagined) as *shiksele* and "goy." When, after seven years, things turned sour in her relationship with Chagall, he began to attribute everything

that he disapproved of in Virginia to her previously trifling goyishness.

As long as Virginia accepted without challenge the role of hidden companion that had been assigned to her, and while she allowed Ida more or less to run both her father's business *and* social affairs, things were rosy. Ida, a go-getter and general busybody, mothered both Chagall and Virginia, while the lovers seemed to relish their roles as largely obedient but occasionally miscreant children. The thing that could generally be guaranteed to enrage Chagall (who had a notoriously short temper) was money. Ida, who wanted a bigger piece of the action, once roused her father to lift a chair over her head with intent to smash it down. The painter of *Jeune mariée aux roses* (Young Bride with Roses) had to be restrained. With Virginia he was horribly controlling, allocating a meager allowance and, when angry, reminding her of the debt that she owed him for bringing her out of her indigent state and into the high life.

Throughout his New York years Chagall remained resistant to English and was happiest when, on visits to New York City, he found someone like the journalist Max Lerner with whom he could talk Yiddish. For this reason, and because of its familiar milieu, Chagall loved the Lower East Side. He wandered anonymously there, reveling in his purchases of gefilte fish and "Jewish" bread. Virginia describes him reading a Yiddish newspaper, most likely the *Forverts* (the *Forward*), the large-circulation daily founded in 1897 by Abraham Cahan, as he walked, munching strudel and letting

the pages drop to the sidewalk after he had perused them. He was clearly abiding by Vitebsk's litter laws. On one such trip Chagall bought a silver Magen David for Virginia and strung the Jewish star happily around her neck.

Virginia was well aware that she lived in the shadow of Bella, and Chagall would occasionally let her know that in her own life she needed to be "worthy" of Bella's inviolate memory. In a fascinating way, Chagall's paintings from this period frequently enact his shifting and conflicting allegiances. In *Lovers on the Bridge* (1946), for example, a split composition features Chagall at his easel consoled and embraced by Bella while his right hand stretches out to create a portrait of Virginia. Four years later *Nude with Two Faces* (1950), which features a horned (and horny?) goat in the nude's lap, appears to merge a smiling Virginia with a downcast Bella.

Chagall and Virginia's son was born on June 22, 1946, in the Bronx. He was named David in memory of Chagall's brother, but carried the last name McNeil, as Virginia was not yet divorced from her husband. David was circumcised on June 29 in a ceremonial bris presided over by Joseph Opatoshu. Chagall did not return to the United States until August.

The biographies of male artists, writers, and composers are replete with tales of inflated creative egos challenged by some version or other of the crying baby. As the English novelist and critic Cyril Connolly wrote, "The artist's wife will know that there is no more somber enemy of good art

than the pram in the hall." Joseph Conrad, at work in his garden, famously responded to the birth of one of his sons by demanding that the noise be stopped immediately. Chagall was a warmer personality than the author of *Lord Jim*, at times brimming over with passion and joy, but he was no less dedicated to his art and no less determined to secure undisturbed space in which to work.

In October 1947 Chagall retuned to Paris for the opening of his retrospective at the Musée National d'Art Moderne. Retrospectives, magnificent in their breadth and the torrent of admiration that they generally inspire, also carry a whiff of closure that is threatening to any artist, and Chagall was no exception. The exhibition gave him "the painful feeling that people consider my work finished. I want to cry out like a man condemned to death 'Let me live a little longer, I shall do better.' "

Back in High Falls, the cheers (and the anxieties) from Paris ringing in his ears, Chagall worked long days in his studio on paintings that he had begun on his Paris sojourn a year earlier. Virginia describes a brief idyll, both seductive and compelling: the artist at work through the heat of the day and on into the firefly cool of the evening; the lover arriving in his studio with bouquets of gathered wildflowers which in turn inspire and find their way into paintings. Later, Chagall sketches mother and child in a bedroom permeated by the smells of linseed oil and turpentine from the studio below. The couple is blissfully happy. Like most idylls, Chagall and Virginia's leaned upon someone else's misery; in

this case the sufferer was Virginia's daughter, Jean. Chagall wanted to pack her off to boarding school and, in a move that she later regretted considerably, Virginia complied.

Meanwhile, Ida remained in Paris preparing the ground for her father's return. She energetically campaigned on his behalf with dealers and buyers, and seemed to enjoy basking in his fame. She was more than eager for her father to resettle in France, and her letters to him and to Virginia from this period are seductive both in their evocation of bittersweet bohemian life in postwar Paris and in their depiction of an art world desperate for the return of one of its exiled heroes. "People are waiting for him," she wrote to Virginia. "Their expectation is something to be treasured, not despised." But Chagall procrastinated. Winter had come to High Falls, and like Solzhenitsyn years later in Vermont, Chagall found the deep snow and woods of the American Northeast to be a forceful reminder of his Russian home. According to Virginia, Chagall felt "more of a Jew" in upstate New York than at any time since he had left Vitebsk: the proximity of farm animals and country folk and the still-vibrant Yiddish culture in New York City had stirred up dormant memories and associations.

Another year passed with Chagall working in happy seclusion, but with Ida increasingly insistent that he return to Paris. One by one the artists forced into exile by Hitler's war, including Léger, Breton, Tanguy, and Ernst, had returned to their studios in France. For Jewish artists like Chagall the situation was qualitatively different. He would

not be returning "home" to France but to a place that he had made home and which was now haunted, no less than Russia, by murderous anti-Semitism and the additional ghost of collaboration. As he later wrote, "I am too much the Jew from the ghetto . . . and I am always haunted by the sense that I live in somebody else's country. True, I did not have that feeling in Vitebsk, in America and in Israel." As it turned out, the house that Chagall eventually bought in Orgeval, on the outskirts of Paris, had been requisitioned by the German army during the occupation, and the stables-cum-garage where Chagall parked his car had creepily been a place of imprisonment and possibly execution for Resistance fighters. Chagall, perhaps more familiar from his Soviet days with adapting to radical shifts of ownership, was unfazed by the house's history, but Virginia never felt altogether comfortable in it.

For more than two years Chagall had successfully kept his relationship with Virginia and their son out of the public eye. His zealotry in this regard had backfired in one important regard: David's legal status. His desire for secrecy above all had prevented Chagall from consulting lawyers when it would have been beneficial to do so. Now, with a move to France imminent, Chagall discovered that French law forbade adoption by a man who was already a parent, while American law required David's legal father to have denied his paternity within two months of the child's birth. For the foreseeable future David would remain a McNeil.

In the spring of 1948, shortly before Chagall finalized his

plans to return to Paris, the Belgian photographer Charles
Leirens visited High Falls. Leirens had photographed Cha-
gall on Riverside Drive while Bella was still alive. Now he
came to him for a second time with plans for a new portfolio.
Leirens, a musicologist as well as a photographer, was close
to Chagall in age and sensibility, and the two men enjoyed
each other's company. Unfortunately for Chagall, Leirens
also fell in love with Virginia, and she with him, and eventu-
ally he would steal her away from Chagall.

Chagall admired America's energy and dynamism, but in
the end he could not rid himself of the notion that for an
artist of his stature France, despite the scars of recent his-
tory that disfigured its face, was the distinguished and
sophisticated place to be. In truth, Chagall's "home" was in
the forefront of a movement, modernism, which happened
to continue to reveal itself most powerfully in France: in
America it had already morphed into Abstract Expression-
ism. "The man in the air in my paintings . . . is me," Cha-
gall told an interviewer in 1950. "It used to be partially me.
Now it is entirely me. I'm not fixed anyplace. I have no place
of my own . . . I have to live someplace."

World War II sent the wrong people wandering. God's
curse on Cain was intended for murderers and not their vic-
tims. Chagall was a refugee twice over, from Lenin and from
Hitler, but he was also a gypsy fiddler wanderer, a boho with
a palette, whose art brought him from place to place to sell
his wares. Western culture has been happy with those sexy
guys for quite a while now (for a recent incarnation, see Tony
Goldwyn's movie *A Walk on the Moon*, in which a troubadour

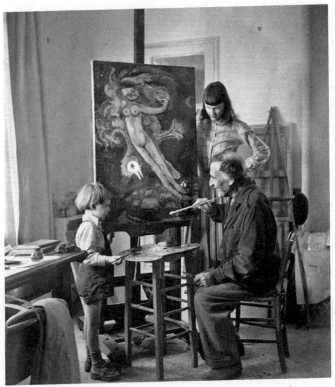

Chagall with Virginia Haggard and their son, David,
in Cannes, April 1951. (*Courtesy Roger-Viollet*)

traveling blouse salesman disrupts life at a Catskills Jewish
resort in the summer of 1969), as long as they stay more or
less alone and don't, like the hippies in the 1960s, rock the
boat too much. Chagall, ever facing in opposite directions,
had both the refugee's gravitas and the rambler's insou-
ciance.

On his last day in High Falls, August 16, 1948, Chagall

wrote a poem in Yiddish to Bella, "On the Fourth Anniversary of Her Death." The poem, both maudlin and poignant, reads like a plan for a painting. Here are Bella's white dress and the red chuppah from their wedding; here are flowers and stars and green fields; an expressed hope for the future of the Jewish people, and a dream of Bella's return to Chagall. Was Chagall, like Keats, "half in love with easeful death"? A better antecedent is probably S. Y. Ansky, with whose 1919 play *The Dybbuk*, the ur-drama of both Yiddish and Hebrew theater, Chagall was thoroughly familiar. Like Chagall in his paintings, Ansky yoked together the natural and the supernatural in his Yiddish *Romeo and Juliet* (or *Romeo and Juliet* meets *The Exorcist*, as one wag has described it), incorporating the folk culture of the Eastern European Hasidic shtetl world—myths, folktales, songs, and legends—that he had recorded as the head of an ethnographic expedition traveling through Volhynia and Podolia from 1911 to 1914. Ansky's doomed lovers, Khonnon and his *bashert* Leah, kept apart by a materialistic father, represent all manner of separation and merging: between the demonic and the angelic, Old World superstition and modern love (Why should Dad get his way?), magic and mysticism, the Jewish past and the burgeoning Jewish present. Ansky's working title was "Between Two Worlds," which is where Chagall must have felt himself (if not between three) after Bella's death.

The romance of *The Dybbuk*, in which, after his death, Khonnon's spirit inhabits Leah's body in an attempt to secure her love for eternity, rounds on Leah's passionate

death wish: her great and true love, her absent love, overwhelms anything that life has to offer. Try as they might, the rabbis cannot get that demon out. Such also is the romance of Chagall's poem, which, like the play, concludes with a vision of a couple, in this case Chagall and Bella, reunited in death-as-life. However, the poem contains the possibility that Chagall has performed his own partial exorcism. For, significantly, Bella is dispatched in the poem to redeem the land of Israel: "As red as our Chuppah, / so is our love for our people and our homeland, / Go and wake them with our dream." Meanwhile, beyond the border of the poem, as he waits for his death and the moment when Bella will return to him, Chagall must head in a different direction, to France.

Virginia and Chagall closed up their house in High Falls, leaving a great many of their belongings inside as hostages to ensure their return. But they never came back. Soon after they left, the FBI showed up to search the house for "incriminating documents." Chagall's antifascism—at the time of his departure he was honorary president of the Committee for the Suppression of Anti-Semitism and the Promotion of Peace—continued to be a thorn in Mr. Hoover's side.

14

Orgeval

In August 1948 Chagall and Virginia sailed on the ocean liner *De Grasse* for Le Havre, France. The years in America had certainly consolidated his status as one of the world's most renowned and admired artists. His retrospective at the Museum of Modern Art had moved on to the Art Institute of Chicago in September 1946 (Chagall's first flight, the great levitator levitated, occurred when he flew out for the opening), and the following year the show traveled to the Tate Gallery in London and museums in Amsterdam, Zurich, and Bern. In addition, he had continued to illustrate books, producing, while on his visit to Paris, a series of gouaches for *The Thousand and One Nights* and his first color lithographs.

Virginia held genuine love for Chagall, but this did not prevent her from casting a critical eye over his work. It was Virginia Haggard's belief that fame and financial success had a deleterious effect on Chagall's art (she wisely neglected to tell him as much) and that his finest work had been produced in the time of his greatest "material insecurity." Many art historians and critics have tended to agree, seeing in much of

his work after his return to France an endless bouquet thrown to an audience eager for whimsical beauty. To be sure, there is a great deal in many of Chagall's post-1948 paintings to delight the eye and hurt not, but the old strangeness was not entirely gone, and it resurfaced periodically in works that are both uncanny and challenging. *Christ in a Blue Sky* (1949–50), for example, is a breathtakingly erotic rendition of a slim semi-naked woman with full, round breasts wildly embracing Christ on the cross while closely observed by Chagall's ubiquitous red goat, fired up against the background of a blood-red sun descending over Vitebsk. At times he could be as passionate an old goat as Picasso.

Chagall was sixty-one when he and Virginia moved to the house with a large overgrown garden that Ida had found for them in Orgeval, Seine-et-Oise, about a hundred kilometers from Paris. There, Chagall had two studios, proximity to a forest, and lush neighboring fields, one of which was home to the inevitable Chagallian cow. At first the move ruffled him. "My art demands extreme solitude and forgetting oneself," he wrote to Pierre Matisse in New York; "one cannot move from one place to another all the time." But he settled in quickly, aided by a stream of admiring visitors: art critics and art historians, poets including the Surrealist Paul Éluard, gallery directors, and old friends. Jacques and Raissa Maritain had also returned from New York, and Raissa had begun work on *L'orage enchanté*, a book about Chagall's painting.

The Maritains had been involved in the conversion to

Catholicism of a number of Jewish artists and intellectuals; with Chagall, however, they trod carefully. "Marc," writes Virginia Haggard, "was one of the rare artists the Maritains didn't try to convert to Catholicism." Chagall, by all accounts, tiptoed around them. What accounts for this polite minuet? In his essay "On Anti-Semitism," published in the journal *Christianity and Crisis* in 1941, Maritain notes the "growing solicitude in Israel's heart for the Just Man crucified," and cites a number of Jewish writers, including Sholem Asch and Waldo Frank, who have tried to "reintegrate the Gospel into the brotherhood of Israel while not yet recognizing Jesus as the Messiah." In the face of the Nazi horror, Maritain courageously, if controversially, insists that "to persecute the House of Israel is to persecute Christ . . . in his fleshly lineage and in his forgetful people whom he ceaselessly loves and calls." Freud, from a different perspective, also held that German hatred of Jews was "fundamentally hatred of Christians," pagan revenge "against the new religion [Christianity] that was forced on them." For Maritain, Chagall's paintings must have appeared to be the work of someone tantalizingly close to hearing Jesus' call. Indeed, he found his own philosophy powerfully expressed on his friend's canvases, where "poor Jews, without understanding it, are swept along in the great tempest of the Crucifixion." Raissa wrote a poem, "Chagall," to the same effect. One can hardly fault the Maritains for making the connection. After all, it was Chagall who, via his own singular Christology, had yoked the Crucifixion to the Ho-

locaust, although Chagall's own effort, it seems, was to re-absorb Christianity into Judaism, and not the other way around.

As we have seen, the temptations of Christ, consciously or unconsciously, were too much for any number of Jewish artists and writers. In literary works we might think of Primo Levi's use of Dante's *Inferno* in *Survival in Auschwitz* or Elie Wiesel's memoir *Night*, in which a Jewish child and the two adults who flank him are hanged in Auschwitz while an onlooker describes the boy as "God"—a scene that inspired the French Catholic writer François Mauriac to a Christological interpretation of the death camp.

Chagall was a big fish to reel in. Perhaps Maritain believed that the best way to do so was to let the artist take the hook himself without offering a bait: Chagall's obsession with Christ on the cross certainly had to transcend an irresistible way to divide up a canvas, or a "sharp division of pictorial space," as Chagall sometimes claimed. Chagall's caution with Maritain seems less puzzling. He tended to define himself in opposition, and whether the seductive opponent was Schneerson the Lubavitcher rebbe or Maritain the Catholic intellectual, the result was the same: tentative approach and speedy withdrawal.

On weekends Ida, separated from Michel Gordey, came down to Orgeval with her new love, the Swiss artist Gea Augsbourg. In typical fashion Chagall saw no contradiction between his own life and his disapproval of Gea as a future husband for Ida because he was not Jewish. Ida also brought

along her own troupe of friends: Paris intellectuals, writers, and artists, and even the odd tennis champion.

Chagall did not rule the French art world—he was not Picasso or Matisse—and indeed, the family liked to make fun of his third-place status and irrepressible envy of Picasso (in contrast, Picasso tended to be generous in his assessments of Chagall). But a bronze medal in the European art Olympics is really nothing to scoff at. "The Jew from the ghetto" had triumphed.

In September 1948 a room at the Venice Biennale was devoted to Chagall's work, and he received the prize for engraving. He and Virginia traveled to Venice for the award ceremony. It was his first visit to the city. He stood in ecstasy and awe before the Tintorettos in the Doge's Palace and the Giottos in nearby Padua. He made the acquaintance of the Italian painter Giorgio Morandi, whose modest personality and quiet, unchallenging addiction to the shifting light on a row of bottles in his studio both appealed to Chagall. In Morandi's company he could breathe, free from envy and status anxiety.

Chagall fell in love with Italy, and it's not hard to see why. He was feted, and Venice's singular beauty grabbed him by the throat. He took breakfast in a hotel overlooking the Grand Canal and was punted around in Peggy Guggenheim's private gondola. One night the art-loving millionairess took him to the Fenice Theater to hear Mozart's *Don Giovanni*: Peggy's gold lamé dress was so tight that she had to be lifted aboard by the gondolier. Chagall moved through moonlit

waters past palazzos that reflected a centuries-old collision of art, money, and fame. He was very much part of it now, and he forgot about High Falls.

Chagall's sense of his own worth was in the ascendancy when he traveled in the spring of 1949 to the south of France. He was there, at Tériade's house in Saint-Jean-Cap-Ferrat, to work on a set of illustrations for Boccaccio's *Decameron* that would appear in the Greek-born art publisher's magazine *Verve*. Like so many other painters before and after him, Chagall was taken with the Mediterranean light and the profusion of colors that it presented. As was the case in almost every new environment that he experienced (with the telling exception of New York City), he was immediately inspired. As spring moved toward summer his paintings, mainly gouaches, picked up the seasonal changes in a shift from bright yellows, pinks, and whites, as in *Lovers with Daisies* (1949), to the intense anemone blues and reds of a painting like *Blue Landscape* (1949). As ever in his supra-real portraits since Bella's death and the arrival on the scene of Virginia, a youthful Chagall lookalike (there are sometimes almost indecipherable gray lines in the male figure's hair) is present in embrace or proximity with one or the other or both women, while the painter, in joy or sadness or some combination of the two, conjures flowers, birds, fish, fruit, animals, instruments, and planets to circle around them: indigo violins, almond cows, emerald cocks, reseda moons.

Chagall and Virginia searched for a house. Picasso lived in nearby Vallauris and Matisse in Cimiez in the hills overlook-

ing Nice. In this company he didn't feel much like playing the country boy, and he went in search of grand accommodations. "Chagall can't live in a house that has cow dung on the driveway," he told Virginia, who tartly notes in her memoir that cows were few and far between in Saint-Jean and those that were in the vicinity were kept in "dark and cruel sheds." The couple impulsively put a down payment on a "tall dignified" house of which Ida massively disapproved. Nevertheless, they moved in. Picasso came to visit, driven by his liveried chauffeur, and Chagall felt the bite: his own car was a modest Peugeot 201. According to Virginia, the two great painters "enjoyed tormenting one another," and most accounts of their meetings report a plethora of sly digs and nasty asides.

Back in Orgeval for the late summer of 1949, Chagall returned to work with a passion. Ida was laid up in the house, recuperating from serious stomach surgery, but by Virginia's own admission, neither she nor the artist turned out to be very good nurses. Virginia had responsibilities toward her own children to explain her unresponsiveness, and Chagall was, well, Chagall.

It is probably no accident that Chagall painted more self-portraits than almost any painter before him with the possible exception of Rembrandt. He was fascinated by his own face as both subject and canvas. After Virginia had read his memoir she asked, with less anxiety than Bella's mother, why he had applied home-made lipstick and mascara before heading off for a night out in Vitebsk. He replied, "Some-

how painting my face was not so very different from paint-
ing a picture of my face in the mirror." The artist as termi-
nal narcissist is hardly an endangered species, but Chagall
seems to offer a variation on the type, for he is also the artist
as sad or happy clown, a theatrical figure, like the living
actors whose faces he daubed along with their costumes in
Moscow's Yiddish theater. The surfaces of the world are
seamless to Chagall; there is almost nothing receptive on
which he would not paint.

Nevertheless, as the years passed his narcissism some-
times trumped his artistic integrity. He began to speak
about himself in the third person, and his self-portraits took
on the appearance of what Virginia accurately called "ro-
mantic self-fantasies."

Within a year Chagall and Virginia had made a decisive
move to the south of France, closing up and selling their
home in Orgeval and moving from Saint-Jean to Les Collines,
a house in Vence with a Mediterranean view that had once
been the secret love nest of the French poet Paul Valéry and
the writer Catherine Pozzi.

Les Collines would be Chagall's permanent home for
many years. Here, with a studio on its grounds that over-
looked the date palms and orange groves that led down to
the sea and a house set among eucalyptus trees, tall cy-
presses, and terraces shaded by vines and roses, he worked,
when in residence, almost daily.

Back in Saint-Jean two English ladies had turned up one
day, like Coleridge's Man from Porlock, and interrupted

Chagall with an offer. They wanted to "commission" him to make two large paintings for London's Watergate Theatre. The money was negligible—in fact it was zero. What they proposed was a free loan of the paintings for one year. No doubt to the chagrin of his gallery, Chagall generously agreed, his sympathies awakened, perhaps, by an association to his exciting but financially stretched days with Moscow's Yiddish theater. At Les Collines the first task that he set himself was to produce the promised paintings for the Watergate. The result was two large pieces, *The Blue Circus* (now in London's Tate Gallery) and *The Dance*. Virginia was dispatched to deliver the completed paintings and had to suffer the disdain of a British customs official who unrolled the canvases only to deliver a tried-and-true "You call this art?"

Chagall certainly did, although faced with the work of his contemporaries he frequently responded like the customs official. In a manner unusual among even the greatest painters, he is frequently reported to have owned only two small works by other artists: a small bronze nude by Rodin and a sculpted figure by Laurens. Although, on a visit to Chagall's home in Saint-Paul-de-Vence in the summer of 1973, the English writer Anthony Rudolf noticed a small painting by Bonnard to the right of the door: "I lingered in front of it but he gently moved me on." At David's birth Calder had given Chagall one of his mobiles, but for some reason Chagall had resented the gift and didn't display it. As with Reuven Rubin, he refused all offers to trade. Perhaps the anxiety of influence was great in Chagall, and he protected himself

not out of pride but fragility: the shakiness of a man who comes from little and knows how easy it is to lose everything, including confidence in your own ability.

In the 1950s Chagall's paintings began to sell for large sums. In the face of his blue-chip standing, criticism in the art world dwindled, although Ida remained a stern judge of his work and he was generally receptive to her comments. Friends came in numbers to the new house as they had to the old, among them the poet Jacques Prévert and the art dealer Aimé Maeght, who was to represent Chagall for many years.

Sometimes Chagall would take the short journey to Cimiez to visit Matisse. The great master, now in his early eighties, was bedridden but had adapted to his confinement by using charcoal attached to a bamboo pole to draw on the ceiling of his bedroom. Chagall brought books for Matisse to pore over, including his own illustrated *Decameron*.

France was hospitable to Chagall now. At no time did he seem to feel, as Yeats had of Ireland at precisely the same age, that it was "no country for old men." He settled into a happy routine: work, including his first foray into ceramics at Serge Ramel's pottery in Vence; trips to Paris to visit Ida and to experiment in lithography in the studio of Ferdinand Mourlot on the rue de Chabrol; and a harmonious domestic life at home with Virginia and David. Jean, at boarding school in England, visited only for the summer holidays. One of Chagall's earliest ceramics, dedicated on its reverse to Ida, is a small white enamel tile, *Les fiancés* (1950), on which a

coy (but half-naked) female figure with a yellow necklace casts her eyes down, while her fiancé, head and hand garlanded in turquoise flowers, is about to caress her. This simple, charming piece, so different in its effect from the deathly emptiness of *The Betrothed's Chair* (1934), holds much of the love and lightness that Chagall could bestow when the mood took him.

Chagall's vision of love, so appealing to the human soul, frequently involves a merging of two faces, or bodies, into one. In this regard he is Platonic, as his figures pursue their other halves in an apparent longing to become whole again. Over and again he paints the myth that Aristophanes recounts in *The Symposium*.

"He painted love but he didn't practice it," Virginia Haggard remarks of Chagall in her memoir, more in sorrow than in anger. It is a devastating comment but of the moment, one surmises, rather than a general truth. After being chased out of Russia and France, after the Holocaust, after the death of Bella and the birth of David, Chagall might be forgiven some temporary, or even long-term, exhaustion of emotion.

In early 1950 Abraham Sutzkever, the Yiddish poet whom Chagall had first befriended in Vilna, came to visit him in Vence. During the war Sutzkever had spent six weeks in a crawl space beneath a tin roof in the Vilna ghetto before finding his way to the partisans in the forests around the city. There he had been captured and forced to dig his own grave. Miraculously, he survived when the bullets intended to kill him passed over his head. Sutzkever escaped to Russia

and spent the rest of the war in Moscow, immigrating to Palestine in 1947 but not before serving as a witness at the Nuremberg trials. In Israel in 1949 he founded the Yiddish quarterly *Di Goldene Keyt* (The Golden Chain). He and Chagall corresponded extensively. Chagall sent poems to the magazine, never asking for payment, while Sutzkever remained an appreciative and loyal friend who, as time passed, stood up for Chagall against his emergent critics in Israel. Their esteem was mutual; Chagall admired Sutzkever's warrior past and his efforts to preserve Yiddish culture against all odds in an inhospitable environment. "Sutzkever's friendship," Virginia once wrote, "is like an oasis to Marc." In Vence the two men took long walks together. Sutzkever, only two years older than Virginia, treated her coldly.

Sutzkever's poems, with their "fiddle roses" and "cello girls," enact, like Chagall's paintings, a form of synesthesia, and even if they had not been friends it is easy to see why Chagall agreed to illustrate his books. Moreover, they both shared and held on to a form of pre-Holocaust consciousness in which the world of "before," the world of the shtetl and of Yiddish city life and language to which they were nostalgically attached, remained vital in their art. For example, Sutzkever's 1944 poem "Written on the Slat of a Railway Car," takes the form of a note that accompanies a string of pearls thrown from an Auschwitz-bound train by Marie, a Paris dancing girl. But despite the fact that his subject is murder, the poet cannot quite subdue the lyric voice that he honed as an aesthetically inclined young man in Vilna:

> If some time someone should find pearls
> threaded on a blood red string of silk
> which, near the throat, runs all the thinner
> like life's own path until it's gone
> somewhere in a fog and can't be seen . . .

This poem reaches its apotheosis in "Written in Pencil in the Sealed Railway Car," a quite different poem composed some twenty years later by Dan Pagis, a child survivor of the camps. Pagis's poem, in contrast to Sutzkever's, is utterly stark, spare, and impossibly dark. It is the most chilling poem that I know of, and offers no way out through restorative language:

> Here in this boxcar
> I am eve with abel my son,
> If you see my other son, cain, son of man
> Tell him i

The relation between Sutzkever and Pagis might be compared to that between Chagall and an artist like the abstract Israeli painter Moshe Kupferman, whose gray marks and lines allow no escape from their tragic import. In Pagis and Kupferman the past is simply not there; it has been obliterated: no dancing girls, no shtetl (even if in flames), no rabbis clutching Torahs, no donkeys loaded with poems. Neither Pagis nor Kupferman has chosen the Holocaust as a theme: it has chosen them. They cannot do anything of weight and value without its being there.

With Sutzkever in her home and Yiddish in the air, Virginia felt like an intruder. Sutzkever had met Bella and his loyalties clearly lay with her. Virginia felt that Chagall tacitly approved of Sutzkever's keeping his distance from her. "He squared Marc's conscience with regard to Bella," she wrote. It was not a good sign.

15

A Problem of Conscience

The seductions of a large empty wall are almost irresistible to an ambitious artist. When that wall (or window) is in a church and the artist is Jewish, certain anxieties might be imagined to arise, and that was the case with Chagall. In the spring of 1950 Chagall received a request from Father Couturier, a Dominican monk, to decorate the baptistery of his newly built church on the Plateau d'Assy in the Haute-Savoie region of France. Couturier, a sophisticated and highly cultured man, had already secured and set in place works by Léger, Matisse, Rouault, Bonnard, and the Jewish sculptor Jacques Lipchitz, whose bronze Virgin bore the hopeful if confusingly expansive inscription "Jacob Lipchitz, a Jew faithful to the religion of his ancestors, made this Virgin for the good understanding of mankind upon earth, as long as the Spirit reigns."

Chagall had been flirting with the idea of decorating a small church for some time, probably inspired by Matisse's chapel in Vence, which he passed daily on his morning walks, and where the agnostic master had designed everything down to the priestly vestments. Thus, even before hearing

from Father Couturier, Chagall had twice approached the local diocese in Vence with proposals to execute murals in two more or less abandoned chapels: the Chapelle des Pénitents Blancs and the Chapelle du Calvaire. Chagall had turned to the church after his friend Arkady Leokum had tried, at Chagall's behest, to interest Temple Emanu-El on Fifth Avenue in New York City in providing a space for his work, but the wealthy temple's board of directors had issued an instant rebuff. The Vence diocese was equally uncooperative.

An embittered Chagall set off with Virginia to view Couturier's Notre Dame de Toute Grâce and liked what he saw. The chapel, with its extravagant Léger mosaic and yellow-tiled Matisse altarpiece, had a theatrical appeal. One can imagine Chagall contemplating with pleasure a public space without pesky actors and a director to get in the way. And yet his ambition to become a Jewish Giotto was laced with guilt and confusion. Indeed, the indecision and commotion that thinking about the baptistery immediately generated in him lay bare the perplexity of his life as a Jewish artist like almost nothing else.

In what was an astonishing display of self-doubt, he procrastinated for months, going so far as to set up a meeting with the chief rabbi of France and a number of the country's prominent Jews in order to discuss the matter. He listened to both Jewish and Christian opinion, sought the advice of friends, including Sutzkever, who had no objections, and finally turned to the president of Israel, Chaim Weizmann.

Chagall's letter to Weizmann, written in Yiddish and

translated into English by Ida, is neurotically endearing. "I write to you," the artist begins, "as our fathers in Russia used to write to their Rabbis for help in solving problems of conscience." What follows is an utterly recognizable tour de force of Jewish bewilderment from a man whose life had taken him from the medieval world of the Orthodox East through war, revolution, and the Holocaust to the pinnacle of a secular career in the vastly modern West.

Chagall worries that if he accepts the commission it will be bad for the Jews (an appeasement of the Roman Catholic Church at a time when its policy toward Israel is unfavorable), but on the other hand it might be good for the Jews ("the presence of a Jewish painting in a church might be good propaganda for our people"). On the third hand he doesn't want Israelis to think that he has "anything in common with non-Judaism," but then again what he plans to paint for the Christian worshippers to look at are biblical scenes "symbolizing the suffering of the martyred Jewish people." Weizmann replied, as had more or less everybody else, that Chagall should be guided by the dictates of his own conscience. One can imagine that the first president of the nascent and threatened state of Israel had other things on his mind.

When asked about his Jewish affiliation, Sir Isaiah Berlin once replied, "The Orthodox synagogue is the synagogue that I am not attending," which could be a neat summary of Chagall's plight. It took a properly biblical seven years before Chagall, at the age of seventy, arrived at a decision to donate to the church a ceramic mural showing the parting of

the Red Sea, two stained-glass windows, and two marble bas-reliefs.

While Chagall procrastinated, an official invitation to visit Israel arrived from the country's new president, Zalman Shazar. Shazar wrote in Hebrew, which led Chagall to describe himself as a "Goy" because he needed a translation. Israel planned a major retrospective for Chagall in three cities: Tel Aviv, Jerusalem, and Haifa. "What do they need me as a 'guest,' " he wrote to Sutzkever, "me, the weak, pale, too quiet Jew . . . our government has and must have *many other worries.*" Did Chagall really consider the Israeli government to be "his"? In the intimate world of Yiddish exchanges, Chagall's affiliations are deeply Jewish and his concerns both emblematic and exemplary. "Every man feels meanly of himself for not having been a soldier," wrote Dr. Johnson, and every Diaspora Jew who feels the draw of Israel may well be similarly afflicted. Chagall's self-characterization as the useless Jew in the corner speaks to a dialectic in evidence since the founding of the state.

In the late spring of 1951 Chagall and Virginia boarded an Israeli liner in Marseilles for the six-day trip to Haifa. His reputation and status in the art world were equivalent to the two solid gold bars that he had recently deposited, along with a few favorite canvases, in the vaults of a Paris Credit Lyonnais (in the same bank that Picasso used to store his valuables). Chagall was living in the maw of great commercial success. On board ship he and Virginia occupied a VIP suite and ate at the captain's table.

Despite outward appearances, however, the couple's rela-

tionship was in flux. In the previous months Virginia had connected with a group of alternative neobohemian types living in Roquefort-les-Pins, not far from Vence. Her new friends were antimaterialist, vegetarian, and into both homeopathy and skinny-dipping. Chagall had nothing against this bunch, although he was unaware of the skinny-dipping, but his and Ida's trajectories were quite different from Virginia's. The painter and his daughter were now fully accredited members of the establishment. Virginia remained shadowy.

In Israel Virginia felt distanced and out of it, while Chagall was overwhelmed by his exuberant reception. Israel wanted to make him its own, and Moshe Sharett, then foreign minister, offered a beautiful home and living expenses if the artist would agree to make Haifa his regular winter studio. Chagall responded graciously but without a committal.

At the Habimah Theater Chagall sat next to Golda Meir, chatted in Yiddish, and watched a performance of *The Dybbuk* performed in Bialik's Hebrew translation. In her memoir Virginia recalls how in High Falls days, after a good meal and a few glasses of wine, Chagall would sometimes perform the bride's dance (did she mean the beggar's dance?) from the play's wedding scene while "twirling a table napkin over his head."

The spirit of Yiddish culture indeed danced in Chagall and only needed a small spark to ignite it. Clearly, the Yiddish world as it had been exported to Israel touched and seduced him more than any other aspect of the country. But

how much? Certainly, he had no wish for Israelis to think badly of him, and perhaps for this reason from time to time he would take a familiar Diasporist "I would if only I could" line with regard to *aliyah*. To Sutzkever Chagall once wrote: "More than once I thought to myself: if only I could run off to my small but deeply loved land to live out my years near you and breathe the air of real people . . . The older one gets, the more one is drawn to the source. I am envious of you—you are in the land." But Virginia Haggard's commentary on this letter is merciless: "Needless to say Marc had no desire whatsoever to go and live in Israel."

Well, maybe and maybe not. Unlike Sutzkever, who lived Jewish history from the inside out, Chagall assumed different personalities in Yiddish and French, often revealing his Jewish self in the former language while concealing it in the latter. Moreover, it is more than understandable that Chagall would be ambivalent about a move to Israel. The country, in 1951, was provincial; despite the presence of some wonderful artists such as Mordecai Ardon, it was still regarded as something of a cultural backwater. There were no painters of international stature living there. Perhaps most important, Yiddish culture, under assault from Hebrew culture, had the appearance of a dying animal (Isaac Bashevis Singer was a long way from the Nobel Prize). Even though Chagall was broadly welcomed in Israel, he was respected in most quarters as "an old master," someone affiliated with the Jewish world of the shtetl that the new Zionists were working hard to erase.

Chagall continued to contribute poems to *Di Goldene Keyt* (which ran under Sutzkever's editorship until 1996), but he must have understood that Yiddish writing was faltering not only on the international scene but also in the local arena (even if the Histadrut, Israel's trade union movement, funded *Di Goldene Keyt*), whereas, despite its reception among critics in Israel, his own "Yiddish" painting (although Chagall, who resented being pigeonholed as a "Jewish" painter, would never have called it that) had remarkably triumphed and was on display in the great museums of the world. The author of the little poem "My Land"—a reflection on the melancholy of homeless postwar wandering written in 1946 on the occasion of Chagall's return to Paris after the war—which appeared in the first issue of *Di Goldene Keyt*, would, in just over a decade, be decorating the ceiling of the Paris Opéra with the raiments of his shtetl-born dreams.

Chagall, with Virginia in tow, did the VIP rounds in Israel. He chatted with Moshe Dayan at army headquarters and dined with Ben-Gurion, who played the philistine and described his early days hewing stone for Palestine's roads. They chatted in Yiddish and traded barbs about the relative incomprehensibility of art and politics. Photographs from the trip show Chagall in plaid shirt and tie, dark trousers, and a Parisian beret, holding hands with lanky Virginia in front of stone Jerusalem arches ("Virginia is still tall," he once wrote to the Opatoshus). He appears posed and uncomfortable, Virginia seems distracted. Finally, he met with Weizmann, who reiterated his "it's between you and

Chagall with Reuven Rubin and his wife, Esther, at a
reception in his honor at the Milo club in Tel Aviv in 1951.
(Courtesy Rubin Museum, Tel Aviv)

your conscience" stance on Chagall and churches. Chagall
took the opportunity to hint that a few nice mural commis-
sions from the state of Israel might go a long way to obliter-
ate his desire to embellish and beautify a French baptistery,
but he got no response.

On his first trip to Palestine Chagall had found time to
work, but this time around in Israel he produced only a few
sketches from his trips to kibbutzim, Nazareth, Acco, and
Galilee. The heat of the day was oppressive: friends recom-
mended salty cheese and salt herring to stimulate thirst,
which Chagall happily consumed in the breakfast room of
the King David Hotel. It had been only five years since the

bombing of the hotel by the Irgun in which more than ninety British soldiers and Arab workers were killed. Virginia's brother Stephen had spent many nights in the hotel as a member of the British armed forces during World War II, and indeed had set out on his last journey from the King David before he was killed in 1943. In Jerusalem memories of her brother haunted Virginia, increased her detachment, and perhaps contributed to the increasing tension between her and Chagall, which sometimes flickered around his Russo-Jewish and her Anglo-Christian agnosticism. Meanwhile, the artist climbed the Tower of David, from which vantage point he could see Jordanian soldiers on the parapets of the Old City, rifles at the ready, pointing across no-man's-land. He sketched the war-ravaged arena.

He would return to Israel several more times—in 1957, 1962, 1969, and 1978. Eventually a commission came in, for the synagogue of the Hadassah hospital in Jerusalem, a building that turned out to be a successful tourist trap but an aesthetic disaster. In addition he donated a vast tapestry and a mosaic to the Knesset, Israel's parliament building.

"Art lives in France," he wrote to Joseph Opatoshu on his return to Vence. In Jerusalem, in the burning white light of summer, he had wondered how it could be possible for "the poetry of color [to] radiate here." The five-day journey home on the *Kedma* had taken him on rough seas. "My head is spinning like the beautiful Jewish ship *Kedma*," he wrote to his friend, the artist Moshe Mokady, in Tel Aviv. It is a lovely image of Jewish perplexity.

But "Art lives in France," he also told the French newspaper *Artes*, quashing a rumor that he was contemplating *aliyah*. "My whole being lives in France, where I came in my youth to live and work."

Throughout his life Chagall puzzled over the enigma of arrival. For all his insistence that France was home—he told *Artes*, "My garden is waiting for me," which always suggests "my roots are in that place"—all too often, and poignantly, he seems to be trying to convince himself that such is the case. The Hebrew word *makom* holds the literal meaning of "place," but it is also, as in *Ha-Makom*, God. *Makom* is both anywhere and the sublime itself. As an artist whose religion was art, but whose text was frequently the Hebrew Bible; as a refugee whose refuge was Yiddish culture as much as it was an apartment or house in France or North America; and as a Jew in any of the numerous ways that the word held meaning for him, it appears that Chagall's true home was the *makom* of his studio, in whatever country that happened to be, where the mundane earth, squeezed paint tubes, brushes, turpentine, and his yearning for being in an ultimate sacred space were one.

16

Vava

On their return to France Chagall and Virginia's relationship slowly unraveled. The immediate catalyst was another visit from the photographer Charles Leirens, but things had been on a downward slope for a while. "You don't like Jews," Chagall told Virginia, who felt that she had no religion. It wasn't a fair jibe. Virginia's divorce finally came through, but too late to have any impact on her deteriorating relationship with Chagall. Leirens was a year older than Chagall, and in poor health, but this was no barrier to Virginia, who seemed to find vulnerability attractive in a much older man. Ida had a new love too, Franz Meyer, a Swiss art historian and curator. They married in Chagall's studio under one of his glorious paintings, *The Blue Circus*.

Virginia's affair with Leirens and her subsequent departure from Vence temporarily unhinged Chagall. He gloomily rounded the circle of his friends in search of solace. Virginia later claimed that he experienced "a sort of pleasure in his sadness," but whether playing a part or not, Chagall's ego was bruised, and he was devastated enough to sever all ties

not only with Virginia but also with his son, David, whom he refused to see for two years after the breakup.

Chagall's grief at losing Virginia was, however, short-lived. Ida, ever mindful of her father's horror of being alone (he also had a horror of contagion and refused either to visit or to receive sick friends) and perhaps of his need for a muse, got in touch with Ida Bourdet, who had sold her Vence house to Chagall, and the two women put their heads together to come up with a suitable replacement for Virginia.

Ida Bourdet had a friend whom she thought would be perfect for the bachelor artist: Valentina Brodsky, a forty-year-old woman of Russian Jewish origin, originally from Kiev but presently running a milliner's shop in London. The two Idas played *schadhanim* (matchmakers) and soon enough Vava, as she was known, was ensconced in Chagall's Vence home. After a few weeks as "housekeeper" she agreed to stay on, but only if that insipid title was converted to the more robust "wife." Chagall agreed, and the two were married in Clairefontaine on July 12, 1952, a brief four months after Virginia's departure from the scene.

In Virginia's memoir she reports that Claude Bourdet, Ida's husband, "published the bans" on Chagall's behalf. It is an odd phrase to describe the announcement of forthcoming nuptials for a Jewish couple. However, while Chagall told friends that he was both delighted and relieved to have a Jewish wife back in the fold, it seems likely that Vava had in fact converted to Christianity in London years before meeting Chagall. Michel Gordey, Ida Chagall's first husband, insisted

as much in a conversation with Benjamin Harshav. He had, he told Harshav, got the news from relatives who had known Vava in London. Harshav in turn claims that Vava must have hidden this information from Chagall, although Virginia Haggard's description of Vava's "Russian-Jewish origin," when set alongside those dubious bans, seem to indicate that Vava's conversion was certainly known to her.

Harshav fascinatingly suggests that Vava's secret affiliation with Christianity led to obstructive behavior that undermined Chagall's relationships with his Yiddish-speaking Jewish friends and associates. According to Harshav, Vava intercepted correspondence in Yiddish and hid Yiddish newspapers from Chagall, ostensibly to prevent "upsetting" news about Israel from getting through. She also may have been behind the artist's refusal, via the Maeght Foundation, of a commission to illustrate a Haggadah on the unconvincing grounds that he did not want to be known as a Jewish painter. Certainly, Vava was responsible for burying her husband in a Christian cemetery, something rarely contemplated, let alone enacted, by even the most resentful and vengeful of Jewish wives. My guess is that Chagall knew very well that Vava had converted—and didn't care. He was a major fan of Jesus himself, and what he appeared to want in a good companion at this stage of his life was ur-Jewishness; in this regard Vava's credentials were perfectly in order—and better: "She's got *yiches*" (family status or prestige), Chagall told the New York art critic Emily Genauer in a private conversation. "When my father was

hauling herrings, the Brodskys of Kiev were buying Tintorettos!" Well, not exactly, but the point is clear.

Ida Chagall could not have known it at the time, but with the appearance of Vava her days as the prime mover of her father's business affairs were drawing to a close. Vava, in addition to being attractive and intelligent, turned out to be a formidable woman with ideas of her own. According to some sources, she even negotiated a speedy divorce and remarriage to Chagall on terms more favorable to herself. Vava quickly chose Galerie Maeght to be Chagall's sole representative, and Ida's influence on her father immediately waned. Vava, levelheaded and practical, organized her husband's life in order to

Chagall and his second wife, Valentina Brodsky, in June 1962. (*Courtesy Roger-Viollet*)

Marc Chagall and Pablo Picasso, Madoura, Vallauris,
ca. 1952. (© *Archives Marc et Ida Chagall, Paris*)

give him the time and space that he needed to work, and he
settled into a happy and productive period.

New forms, in particular lithography and ceramics, con-
tinued to challenge and intrigue Chagall. Sometimes he
worked alongside Picasso in the Madoura ceramics studio in
Vallauris. A photograph from 1951 shows the two great
artists, Picasso bare-chested, Chagall in his signature
checked shirt, apparently quite enjoying each other's com-
pany. Compared to Picasso, Chagall was a beginner in the
medium. His early plates and pots appear decorated with
"Chagalls" rather than being artworks that fully embrace
the medium. By contrast, Picasso's ceramics are antic in
their use of the raw material: handles, spouts, and flat sur-
faces are incorporated as ears, noses, and faces. Picasso, it

seems, was not overly impressed by Chagall's efforts and on one occasion played a practical joke on Chagall by completing one of his unfinished plates à la Chagall.

Inevitably a rift developed in the two men's relationship. Françoise Gilot, Picasso's mistress at the time, records in *Life with Picasso* the unpleasant lunch hosted by Tériade that put the final nail in the coffin. Picasso, in a bad mood because there were too many skinny women around, began to tease Chagall about his long absence from Russia. The undercurrent seems to have been "Why don't you go back to your own country?" Chagall responded with a jibe about the naïveté of Picasso's communism. Picasso's retort was unpleasant and unmistakably anti-Semitic: "With you I suppose it's a question of business. There's no money to be made there."

Modernism and its hot baby, Cubism, had been a great international leveler. Paris before World War I had been home to all manner of foreign artists: Picasso and Juan Gris from Spain, Aleksandr Archipenko and Natalya Goncharova from Russia, Diego Rivera from Mexico, and Jews from all over Europe. In the great shuffle of perception that took art into the mind's eye, where it could see quite clearly the invisible fourth leg of a chair, the raiments of religion, previously responsible for what could not be seen, were generally discarded. Add a dose of romantic lefty politics and you had the recipe for a happy universalism. Two wars later, isms in general weren't looking so good—especially to Jews, who had received a solid reminder that how they saw themselves mattered little, in terms of survival, when compared to how

others saw them. Chagall kept dreaming universally right through the inauguration of his secularly oriented National Museum of the Biblical Message, near Nice, but Picasso's nasty comment must have sent Old World shivers down his spine.

Indeed, Picasso's record with Jewish friends has highs and lows. His most egregious behavior undoubtedly occurred after the Nazis arrested one of his oldest and closest friends, the French poet, painter, writer, and critic Max Jacob, whom Picasso had known since 1901, when the two men had shared lodgings in Paris.

Jacob was a vastly influential figure and a fixture on the Paris art scene. An unabashed homosexual, he had nonetheless converted to Catholicism in 1909 at the age of thirty-three after seeing a vision of Christ, but his second religious affiliation did not spare him from Nazi persecution. After his arrest in February 1944 at Saint-Benôit-sur-Loire, his friends mobilized in an effort to free him. Jacob was taken to Drancy, the French point of departure for Auschwitz. From Saint-Benôit-sur-Loire he had managed to get a letter out to Jean Cocteau asking for help, particularly from Picasso, who carried some influence with the German authorities. Cocteau drew up an appeal, collected signatures, and delivered the petition by hand to von Rose, the counselor in charge of pardons and reprieves at the German embassy. Picasso, astonishingly, had refused to sign. Von Rose was known to be an admirer of Jacob's work, but this was no guarantee of clemency. Pierre Colle, Jacob's literary executor, went to Picasso's home on the rue des Grands-Augustins and begged

him to intervene on Jacob's behalf. Once again Picasso refused, turning Colle away with his infamous quip: "It is not worth doing anything at all. Max is a little devil. He doesn't need our help to escape from prison."

Jacob died of pneumonia in a filthy, freezing cell at Drancy. His brother, his sister Mirthe-Lea, and her husband were all murdered at Auschwitz.

Chagall too had known Jacob in Paris, but they had never become close friends. Jacob, as he himself frequently admitted, had gone to Paris as a young man in order to "sin disgracefully." In *My Life* Chagall describes a visit to Jacob's cramped apartment in Montmartre, where Jacob's seductive moves both appealed to and terrified Chagall. "His eyes glistened and rolled constantly. He stretched his body, moved about restlessly. Suddenly he was quiet. Moving his half opened mouth, he whistled. Then he laughed and his eyes, his chin, his arms, called to me, captivated me. I said to myself: 'If I follow him, he will devour me whole and throw my bones out of the window.' "

In the first years of his marriage to Vava, Chagall worked on his "Paris Series," a group of paintings, some begun years earlier, with the city as background to a parade of floating lovers. Sometimes images of Vitebsk intrude behind familiar Parisian landmarks, while the lovers themselves frequently appear to be representations of the artist with one or another of his past or present loves: Bella, Virginia, or Vava. The paintings, from a man approaching seventy, are vigor-

ous and youthful. Chagall was master of color: "when Matisse dies," Picasso once said, "Chagall will be the only painter left who understands what color really is." It was this mastery that enabled him to create the vivid exuberance associated with young love. Where Picasso, for example, fell into the erotic grotesque in old age, Chagall, for the most part, retained an unsullied romanticism. *Bouquet of Flowers* (1956) and *Sunday* (1952–54) both have an early morning, springlike air: Paris with froth on the daydream. One has to harden the heart to resist them.

Vava encouraged Chagall to take on large projects. When they met he had already accepted a commission from Tériade for a series of lithographs on the theme of *Daphnis and Chloë* (they were published in 1961). But his horizons expanded now, and within a few years he was designing the sets and costumes for the Paris Opéra's own *Daphnis and Chloë*. He also made his first foray into the world of stained glass when he agreed to produce twelve windows for the synagogue of the Hadassah Medical Center in Jerusalem: the synagogue would be built specifically to frame the windows, rather than the windows to adorn the building. On the plans, with an admirable slip of the brush, Chagall inked in the ancient tribal names in Yiddish. Vava could not repress everything from the Old Country.

With his characteristic ecumenical elasticity Chagall also agreed to design stained-glass windows for the thirteenth-century cathedral of Saint Étienne in Metz. The two projects, synagogue and cathedral, progressed side by side. For Hadassah, he took inspiration from Genesis 49 and Deuter-

onomy 33. He carefully avoided human representation (although there are beseeching, disembodied hands in *The Tribe of Judah*), choosing to integrate text, floating Hebrew letters spelling out the names of the twelve tribes and fragments of biblical verse, with a stunning array of birds, fish, animals, stone tablets of the law, candelabra, Stars of David, and crowns, all realized in vivid red, yellow, green, purple, and Chagall's trademark blue. For the cathedral he concentrated on biblical stories; the windows include *Abraham's Sacrifice*, *King David*, and *Adam and Eve's Expulsion from Paradise*. For both commissions Chagall worked at the Simon workshops in Reims with the master stained-glass craftsman Charles Marq, and, as with all his glasswork for places of worship, Chagall refused to take payment.

"Whether it is in a cathedral or a synagogue," Chagall once said, "it is all the same—something mystical passes through the window." He added, in a conversation with the critic André Verdet, "For me a stained-glass window represents the transparent partition between my heart and the heart of the world." In later commissions for churches, he frequently abandoned his devotion to the Hebrew Bible and produced images of the Crucifixion and allegorical Christian figures like the Good Samaritan.

As Chagall grew older he became increasingly committed to a universalist and utopian religious philosophy and aesthetic. The museum named and established for him in the hills above Nice is not "the Chagall Museum" but the National Museum of the Biblical Message Marc Chagall. To this unusual institution, planned and funded, like the Ma-

tisse Museum, by the French government, Chagall donated in 1966 seventeen monumental paintings illustrating scenes from Genesis, Exodus, and the Song of Songs. The museum itself, opened in July 1973, in addition to the paintings holds and displays thirty-nine gouaches originally painted in 1931 and 1932 as preparatory sketches for the Bible illustrations commissioned by Vollard.

The National Museum of the Biblical Message is not a house of worship. In his comments at the inauguration, Chagall made clear that his interest lay in a spirituality that transcended the borders of any particular religion. "Perhaps young and not-so-young people searching for an ideal of brotherhood and love, such as my colors and lines have dreamed it, will come into this house." And yet seventeen of the Biblical Message paintings were designed specifically for the Calvary chapel in Vence. Twelve were intended to adorn the walls of the church, whose floor plan was in the shape of a Latin cross, while the additional five were to be placed in the adjoining sacristy. It was only humidity seeping into the chapel's stones that put paid to the plan.

There is no doubt that Chagall never quite came to terms with the anxieties that beset him as a Jewish artist taking on commissions to adorn Christian edifices. On the other hand, it is clear that he never felt quite free enough (or in enough demand!) in his dealings with Jewish institutions and organizations. The Museum of the Biblical Message is in some ways a perfect compromise for Chagall between his artistic yearnings and his agonistic beliefs: it is, in contemporary

terms, and as Chagall made quite clear, a painterly version of the Bible as Literature. "The Bible has captured my imagination ever since I was a very young child. To me, it has always seemed the greatest source of poetry the world has ever known. Since then, I have sought its reflection in life and in art. The Bible is like a resonance of nature, and that secret is what I have tried to transmit." Chagall's Bible here is the Hebrew Bible, to which all the works in the museum refer. But, as we have seen, he initially conceived twelve of the Genesis and Exodus paintings as decoration for the Calvary chapel in Vence. Chagall's childhood imagination was happily filled with Hebrew Bible stories, but his visual imagination was also replete with images of the churches that surrounded him in Vitebsk. In adulthood, by bringing his renderings of Hebrew Bible stories into French churches, he found a way to merge the disparate and frequently conflicted Jewish/Christian world of his childhood in a manner that was both seamless and unthreatening. Chagall, we might want to say, looked to tame Christian houses of worship by filling their windows and covering their walls with Jewish visions, while simultaneously attempting to broaden Jewish history to accommodate his favorite poet-philosopher, Jesus.

Ironically, while Chagall moved ever deeper into a kind of no-man's-land between Judaism and Christianity, his reputation, especially in the United States, as the Jewish painter supreme was cemented by the remarkable success of a 1964 Broadway musical: *Fiddler on the Roof.*

Fiddler on the Roof (music by Jerry Bock, lyrics by Sheldon

Harnick, and libretto by Joseph Stein) was based on the Tevye stories of Sholem Aleichem, but its actual title is a reference to *Music*, one of the wall panels that Chagall created for the Moscow state Yiddish theater in 1920 and which indeed features an outsized shtetl fiddler wearing a green cap and tallith and dancing on the roofs of two little houses with an even tinier domed church between them. Chagall was deeply attached to this piece, and after he left Russia he reconstituted the lost image as *The Green Violinist* (1923–24). The set designer for the original Broadway production of *Fiddler on the Roof* was Boris Aronson, a Russian Jewish artist who, like Chagall, had once studied in Berlin with the graphic artist Hermann Struck, and who was the author of a short monograph on Chagall written in Yiddish in 1923 that was apparently too intimate for the taste of its subject and caused offense. More important, Aronson had begun his career in theater work at the Moscow state Yiddish theater in 1920, at a time when Chagall was its principal artist. Aronson had seen *Music*.

As the theater critic Jan Lisa Huttner has perceptively noted, Aronson's backdrop surrounds Tevye's family with neighbors in little houses that "echo the borders" of Chagall's *I and the Village*. In addition, Aronson seems to have taken Chagall's palette and dipped into it for his color-drenched set. Aronson offered an *hommage* to Chagall in his work for *Fiddler on the Roof*, and there can be no doubt that in the American imagination Chagall, like it or not, and for better or worse, has been inextricably linked with the sentimental musical ever since.

In the 1950s and 1960s, when Broadway or Hollywood focused on Jewish themes, in the interests of pursuing the larger market it attempted to bridge Jewish and Gentile culture by effectively de-Judaizing the content of musicals, plays, and screenplays. The most egregious case is Frances Goodrich and Albert Hackett's multiple-prize-winning 1955 play *The Diary of Anne Frank* (Goodrich and Hackett were the screenwriters of *It's a Wonderful Life*), which traduced an earlier version by the American novelist Meyer Levin, eliminating scenes that were "too Jewish," like a Hannukah ceremony, and generally doing its best to attenuate Anne into a figure with nice (and dubiously decontextualized) American values ("I still believe that people are really good at heart"), with whom as large an audience as possible could closely identify. Certainly, Anne's death in Bergen-Belsen from typhoid in 1945 wasn't going to get a mention. To a degree *Fiddler on the Roof* also inhabits the safe, commercial box office no-man's-land between Judaism and Christianity, with its sentimental softening of Sholem Aleichem's original stories and its sliding of Jewish sensibility into a neat conservative American philosophy that can be summed up in a single word: "Tradition!" But this is not the same no-man's-land that Chagall inhabited. The difference between *Fiddler on the Roof* and Chagall's *Music* matches that between Irving Berlin's "White Christmas" and Chagall's *White Crucifixion*. Berlin appeased the Gentiles, but also gave the Jews something they could hum along to; Chagall appeased no one, and clung to his strong, singular vision to exhibit both Jewish joy and Jewish suffering.

In the mid-1970s the Yiddish journalist S. L. Schneiderman wrote a series of articles for the *Jewish Daily Forward*, some of which were excerpted in English in *Midstream*, excoriating Chagall for his persistent and unrepentant Christian image making. For Schneiderman, Chagall threw a smoke screen around his church work by claiming that it had something to do with Jewish martyrology, when in fact it was unmistakable and unmediated Christian illustration. But Schneiderman's was a small voice amid the great hullabaloo of Jewish praise that burst out in the 1960s and 1970s for the painter who, through his imaginative efforts, had opened the gates for 3,242 performances of "If I Were a Rich Man" at the Imperial Theater. The art critic Robert Hughes once called Chagall "the Fiddler on the Roof of Modernism," and perhaps he did bring whimsy and sentiment to the cold theory of the twentieth century's most urgent art movement. But the association with the musical has probably done more harm than good to Chagall's reputation by preserving it in schmaltz. It would be nice to know what Chagall made of *Un violon sur le toit* when it opened in Paris to great acclaim (one of the few foreign musicals ever to do so), but unfortunately, although it ran for years with Ivan Rebroff as Tevye, there is no record of Chagall's ever having attended a performance.

In representing Jewish love, nothing could be further from the melodic flirtatiousness of *Fiddler* than the strange liaisons that Chagall imagined when he came, around the same time that Tevye's daughters were begging the matchmaker to make them a match, to paint the *Song of Songs* (1958–60). In the foreground of *Song of Songs I* (1960), for

example, a semi-naked woman with the body of a rooster with deep-red incandescent feathers appears about to perform fellatio on her lover; elsewhere a clothed crowned figure (King David?) lies clasping a naked woman (Bathsheba?) from behind, while other naked and eroticized women wander a deep-red garden beyond the city walls lit by yellow Stars of David and serenaded by a Pan-like figure with a pipe. In *Song of Songs III* (1960), the color field is a woman's breasts and abdomen. All five paintings show clothed men and naked or semi-naked women (a recurrent voyeuristic gesture in Chagall's work): sometimes the men fondle their lovers' breasts, sometimes they appear to be making love to them from behind; one of the female figures, half-asleep on a bed of pinkish blossom, appears to be masturbating. The paintings are dedicated to "Vava, my joy and my happiness," and undoubtedly reflect the inspirational delight, erotic and ecstatic in paint and, one also hopes, in practice, that Chagall discovered in his new marriage. But the past is in these paintings too: Bella and Virginia, Vitebsk and Vence, and further, all the way back to the profane love songs of the fifth or fourth century B.C.E. that are collected in the Songs of Songs that is the Song of Solomon. Rabbi Akiba (second century C.E.) cursed those who sang passages from the Song of Songs in the wineshops—the fools who continued to understand the erotic passages in their literal sense rather than accept the allegorical meaning that the rabbis insisted upon. Chagall, we can imagine, would have been among the drinkers and singers.

17

Blessings

The ineluctable rollout of great fame produced an abundance of opportunity, both secular and religious, for Chagall in his late years. He painted the ceiling of the Paris Opéra, and, perhaps in response to the little outburst of conservative French anti-Semitism that had greeted Minister of Culture André Malraux's announcement of the commission—Chagall was called the "Bernardin de St. Pierre of the Ghetto"—puckishly featured a Jewish wedding scene among his tributes to composers, actors, and dancers. He designed sets and costumes for the New York Metropolitan Opera's production of Mozart's *The Magic Flute* (1967) and two vast murals for the new building itself, and he executed a window, *Peace* (1964), for the United Nations building in New York in which he characteristically, if irrationally, given the multicultural spirit of the site, included a Christ figure.

Chagall's experience with the Paris Opéra had reminded him that for a Jew in France complete assimilation was always something of an illusion. He told the Paris-based American art critic Carlton Lake, "It is amazing the way the

French resent foreigners. You live here most of your life. You become a naturalized French citizen, give them twenty paintings for their museum of modern art, work for nothing decorating their cathedrals, and they still despise you. You are not one of them. It was always like that." And yet this awareness did not prevent Chagall from continuing to take on commissions for stained-glass windows for churches all over France. For example, in the 1970s, when he was over eighty, he produced a triptych for the choir of the Cathedral of Notre-Dame in Reims. Again, it is hard to determine whether Chagall was Judaizing churches and cathedrals and assimilating them into himself or if the Christian world was absorbing him: in all likelihood, these contradictory processes occurred simultaneously.

Elsewhere Chagall implemented a window for Chichester Cathedral in England, mosaics for the University of Nice and the First National City Bank of Chicago, and yet more windows for the Art Institute of Chicago. He also accepted, apparently with some discomfort, a commission to make paintings for the foyer of a theater in Frankfurt. Much traveled in the world, he refused to visit Germany, the country that had murdered his past, and in this regard there is an uncomfortable irony in the fact that the very last stained-glass windows that he produced, between 1977 and 1984, were for the transept of St. Stephan's church in Mainz. Apparently, Vava twisted his arm.

Did Chagall, as Picasso certainly did, spread himself too thin in his later years? The influential critic Robert Hughes,

waxing a little more nasty than nice, certainly thought so: "Chagall's quasi-religious imagery, modular and diffuse at the same time, would serve (with adjustments: drop the flying cow, put in a menorah) to commemorate nearly anything, from the Holocaust to the self-celebration of a bank." Hughes has a point, but one cannot help but admire the fecundity of Chagall's imagination and the energy of his creative spirit. Let's see what Robert Hughes is up to when he's ninety.

In the mid-1960s the steep flight of stairs that brought the artist to the studio on the grounds of his Vence home became too taxing for him, and he and Vava searched for and found a new home in nearby Saint-Paul-de-Vence. There, Chagall constructed a studio in which he was to work for the last nineteen years of his long life. He became reclusive in the home, receiving food while he was at work through a small opening in the wall. He wrote that Vava had "imprisoned" him, but if so, he was a happy prisoner. He also took long furloughs in their Paris apartment on the quai d'Anjou, overlooking the Seine.

The consensus, even among Chagall's staunchest supporters, has been that much of the work that he produced in the last twenty years of his life is predictable and sentimental, a kaleidoscope of soft pastels, as tame and unthreatening as the unhurried pastoral that unfurled down the terraces outside his studio. But history and politics were outside Chagall's windows too, and he was neither immune nor indifferent to their presence. The outbreak of the Six-Day

Ida Chagall and her father, ca. 1952.
(*Courtesy Rue des Archives*)

War in June 1967, for example, sparked an emotional re-
sponse in Chagall, who immediately wrote in Yiddish both
to Kadish Luz, the speaker of the Knesset in Israel, with
whom he had formed a friendship, and to *Die Goldene Keyt*,
expressing his anxiety and offering his blessings "embossed
in my windows of the Twelve Tribes." (Five years earlier
Chagall had been so enraged by the in situ presentation of
the windows that he had chucked and broken a few
Jerusalem chairs.) Again, in his letters Chagall refers to "our
government." The hospital was certainly in the line of fire:
four of the Hadassah windows suffered damage during the

Six-Day War, and Chagall installed replacements two years later in 1969. Three windows are marked to this day by bullet holes. Unfortunately, Chagall's Hadassah windows are a sorry sight, or better, a sorry site. Teddy Kollek, mayor of Jerusalem when the windows were installed, acknowledged that the building "was a disgrace, and a terrible, demeaning setting for those stunning windows," but he blamed Chagall for not paying closer attention to the plans. Today the little synagogue is barely noticeable in the great throng of hospital activity that surrounds it. It is perhaps the most disappointing staple tourist must-see in Israel.

Chagall's deep connection to Israel did not, however, prevent him from visiting the Soviet Union in 1973, at a time when that country's Jews were essentially held hostage and Moscow supported and armed Israel's enemies. Undoubtedly, Chagall was naïve in agreeing to make the trip. His visit was a coup for the Soviet authorities, who disingenuously retrieved Chagall's works, including the "lost" panels from his Yiddish theater murals, from the basements to which they had been confined for fifty years, and grandly offered them for Chagall to sign. As soon as Chagall had left the country, all his work went back underground. And yet it is certainly understandable that a man in his mid-eighties might want to see again the country of his birth, especially as an opportunity presented itself for Chagall to visit two of his sisters in Leningrad.

Chagall's paintings from old age are largely but not exclusively joyful. The circus is still in town; the lovers are in

flight. There is no rage against the dying of the light, but from time to time the tragic past comes and spreads its darkness over his canvases. When it does, as in the inferno of *War* (1964–66), it almost always takes the same shape: a shtetl in flames.

In one remarkable painting, *The Fall of Icarus* (1975), completed when Chagall was eighty-eight, the winged boy tumbles to earth above a heavily populated shtetl. The contrast with Pieter Brueghel's famous painting *Landscape with the Fall of Icarus* (1558) is striking. Brueghel's Icarus falls far off into the sea, unobserved by a world that moves on, indifferent to the tragedy. It was this painting which led W. H. Auden to the conclusion that the Old Masters always had it right about suffering. Chagall's Icarus appears to invoke a quite different and even more unsettling response. On the left side of the painting members of the crowd watch the fall in consternation, while on the right side, buoyed it might at first appear by the presence of a naked woman on one of their roofs, others gesture, smile, and cheer as if Icarus were performing a bungee jump. The painting reiterates the structure of *The Revolution* (1937), where the murderous Red Army is separated from a shtetl thronged with creative, peaceful Jews by a snowy field in which Lenin performs a handstand on a table. In *The Fall of Icarus* the dividing field is red; the two crowds, we might surmise, are once again Jew haters and Jews, and from this perspective the naked woman appears to be a ravaged creature. Chagall's vision, darker than Brueghel's or Auden's and fashioned by recent history,

is one in which a people must witness its own destruction while another celebrates it.

It is tempting to read the divisions in Chagall's canvases also as expressions of his divided psyche, his "crucifixion," as he frequently saw it. He too occupied a field between apparently irreconcilable worlds that could be unified only in his work. In his paintings, past and present, dream and reality, rabbi and clown, secular and observant, revolutionary and Jew, artist and Jew, Jesus and Elijah, man and beast, Vitebsk and Paris, all commingle and merge in a world where not only history and geography but also the laws of physics and nature have been suspended.

Perhaps, in this regard, nothing mattered so much to Chagall as the battles that he staged between what went on in the world and what happened on his canvases. In the astonishing late work *In Front of the Picture* (1968–71), an artist with the head of an ass is at work on a painting of a crucified figure that, with his tight curls and clean-shaven face, more closely resembles the Greek god Apollo than Jesus. The crucified figure has one arm free, which he uses to tenderly cover his heart with his hand. He does not appear to be in pain. He is observed by two shtetl Jews, a man and a woman, who could well be the victim's parents. Elsewhere a female figure holds a candelabra. The top of the easel on which the painting rests is an extension of the top of the wooden crucifix. There is a shtetl at the foot of the crucifix and what appears to be a French village in the border of the larger framing painting. A flying angel has her body in the

picture within the picture and her feet outside it. A young woman in the border looks straight ahead. The world of the painting on the easel, which incorporates the shtetl past, is dramatically dark, black and dark blue. The world of the border, light blue and green, is lyrical and whimsical: a midsummer day's dream. At the head of the crucifix is a name written in Hebrew letters: shin, aleph, gimmel, aleph, lamed; it spells "Chagall."

Old age bestowed a rich harvest: a huge retrospective of 474 works, *Hommage* to Marc Chagall, opened in December 1969 at the Grand Palais in Paris and ran for three months. It was followed in the next decade by numerous shows and awards in the world's most prestigious museums and galleries. On Chagall's ninetieth birthday, July 7, 1977, Pope Paul VI sent greetings from the Vatican, while France's art world pulled out all the stops for a nationwide carnival of Chagall's art. On January 1, 1977, he had been awarded the Grand Cross of the French Legion of Honor. Was he "one of them" now?

Israel claimed him too. Chagall took his last trip to Jerusalem in October 1977. There, Mayor Teddy Kollek awarded him the freedom of the city along with the title "Worthy of Jerusalem"; the Weizmann Institute of Science, in a wonderfully broad-minded gesture for an institution well known for its appreciation of gravity, conferred an honorary doctorate. To be both a French chevalier and a Jerusalem worthy was perhaps what Chagall had wanted ever since the steam train billowing smoke had deposited him on

the platform of the Gare du Nord in the summer of 1910. On the other hand, like Yehuda Halevi writing "My heart is in the East and I am in the West," Chagall at ninety-three wrote to Sutzkever: "Everything that comes from our Holy Land is dear to me. One thing causes me grief—that I cannot come again to the Land." But on the hand with seven fingers he also told Carlton Lake, "My wife [Vava] is against my concentrating too much on Palestine [*sic*]. Neither she nor I have nationalistic feelings regarding Israel. But I love the Bible and I love the race that created the Bible."

There were grown grandchildren now: Piet, Bella, and Meret, who belonged to Ida and Franz Meyer. And then there was Dylan, the son of David and his wife, Leslie Ben Said, who was the daughter of a Moroccan Jewish mother and a Belgian father. David had become a French pop singer and songwriter, and his music was recorded by, among others, Yves Montand and Julien Clerc. He also made albums of his own, and in the early 1970s, while putting in some studio time in Woodstock, New York, he drove to High Falls in what turned out to be a vain attempt to locate his parents' old home. In one of those peculiar historical intersections that seem too bizarre to be true, Chagall was able to brag about David to Bill Wyman, the Rolling Stones' guitarist, when the poet André Verdet brought the rock star over for a visit with the maestro.

In a poignant speech at the unveiling of his tapestries for Israel's Knesset in August 1969, Chagall offered hopes for peace, pity for Israel's enemies—"foes who are rather their

own foes," who "try to burst through closed doors which are actually open"—a paean to the Bible, and a reminder that "there is no art or creation without love." At eighty-two, Chagall exhibited the wisdom that removal from the fray confers. Like Mr. Stein at the end of Joseph Conrad's *Lord Jim*, who waves his hand sadly at his beautiful butterflies and is "preparing to leave all this," Chagall had seen too much fire and rain and now looked dispassionately on the tragedy of human conflict. "At my age," he told the audience at the Knesset, "I tend to look with some sadness at everything— friend and foe."

Cogent and exigent messages from the country of extreme old age are rare. It is remarkable that in the twentieth century great painting and longevity frequently went together, as if devotion to the task at hand bought time. Picasso, Joan Miró (about whose work Chagall was frequently scathing), and Chagall all lived and worked into their nineties. Matisse died at eighty-four. An unsparing critic once described Picasso's late work as "incoherent scrawls executed by a frenetic old man in the antechamber of death." No such decline is noticeable in Chagall's hand, although there is perhaps an emollient of feeling.

On the day before he died Chagall produced his last work, a lithograph entitled *Toward the Other Light* (1985). In it a young painter who strongly resembles young Chagall, winged as if ready for flight, is at work on a painting. An angel, arms outstretched toward the painter, descends from the sky, ready to carry him off. On the young artist's canvas

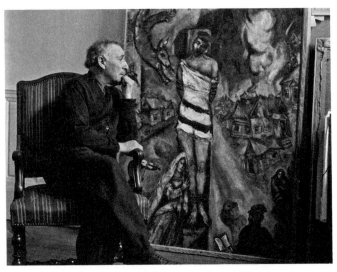

Chagall at home with his 1940 painting *The Martyr.*
(Courtesy Rue des Archives)

are two cartoonish figures, male and female. The male figure, in an inversion of Chagall's joyous *Double Portrait with Wineglass* (1917–18) (which also features an angel who is blessing the featured couple in a flyby) from almost seventy years earlier, seems to be carrying the woman. The young man in the painting extends a bouquet of flowers, breaking the frame of the canvas that holds him to do so. The painter extends his free hand to receive it. Chagall is giving himself a bunch of flowers. He had given his life to painting and now, at the very end, his painting was giving something back to him. The figures in the lithograph, Chagall painting Chagall and Bella, will linger in a wash of blue and green; the artist is already in the hands of the angel.

Chagall died on March 28, 1985. He was ninety-seven. There was a Jewish cemetery in nearby Nice, but Vava preferred to have Chagall laid to rest in Saint-Paul-de-Vence's terraced Catholic cemetery. The mayor of the town kindly donated an area of his own plot. A tall crucifix, later repositioned, shadowed the grave. Jack Lang, France's minister of culture, addressed the mourners, who stood among a profusion of flowers, as if Chagall's paintings had spilled out. Chagall's two children, Ida and David, were both in attendance. Chagall had requested a burial without religious rites, but as the coffin was lowered into the ground, a young man, not known to the other mourners, stepped forward from a background of cypress trees and recited Kaddish, the Jewish prayer for the dead.

CODA

When I was fifteen, my mother used to send me on mercy missions to our local tube station at Willesden Green. I carried an envelope with money to deliver to my impecunious Uncle Leslie. Leslie (it said Lazarus on his birth certificate) had fallen on hard times. He had once been a successful musical impresario, staging concerts at the Royal Albert Hall by, among others, the opera star Joan Sutherland. After the war he had fallen out with his partner over Leslie's refusal to bring to London the Vienna Boys' Choir. "They sang for Hitler," he would bitterly announce when the topic came up. Soon, Leslie was only the impresario of ice cream, reduced to selling advertisements for a tiny-circulation Yiddish newspaper.

Our meetings were moments of high embarrassment. Leslie swiftly pocketed the envelope (the money came via my mother from their wealthy brother Harold in Cape Town), then talked very fast to cover the awkwardness of the transaction. His topic was usually high art. As a young man he had met both D. H. Lawrence and H. G. Wells, and he claimed to have delivered a message from one to the other. My mother always described Leslie as a shining intellectual whose life had been scuppered by institutional prejudice. Leslie had

won a scholarship to attend a superior school in 1920, but because my grandfather was an alien from the Austro-Hungarian Empire, the money had been withdrawn. So Leslie made his own way in the world of the mind. He joined the New Left Book Club and in his thirties tried to run off to the Spanish Civil War. My grandmother fetched him back. She needed help. He stayed at home, and a bachelor.

At our biweekly meetings he urged me to read the greats: Dostoyevsky, Tolstoy, Chekhov, Lawrence, Joyce, and above all Shakespeare. And this led to his other topic: the lost Yiddish world. Leslie liked to describe to me performances that he had seen as a young man visiting the Pavilion, the Yiddish theater on the Whitechapel Road. What amused him in particular was *Hamelech Lear*. There, by the taxi stand at Willesden Green station, he would do Lear on the Heath or moaning about his daughters in Yiddish. He was laughing so much that tears ran down his face, or maybe he was crying. "Stay away from Yiddish," he told me. He wanted to save me not only from melodrama but also from everything else associated with that dying language, as if immersion in Yiddish's frayed and frozen culture could only lead to a hand outstretched at a railway station.

But he loved Chagall. In the language of Chagall's paintings the lost world and the high modern world converged to Leslie's satisfaction. As indeed they should have. Israel, with a set of different anxieties (although maybe not), banned Yiddish in the early days of the state (its two official languages were and remain Hebrew and Arabic), but the

country had no problem embracing Chagall's paintings. The tension in Chagall's life and work, richly productive, comes from the stress of Jewish absorption into the modern world. Hence a two-headed Cubist cockerel circa 1910 (*The Drunkard*).

In 1977 I lived in an apartment in Jerusalem at 3 Bezalel Street, on the second floor of a house walled in the grounds of the Bezalel art school. My landlord was Bezalel (Lilik) Schatz, whose father, the painter Boris Schatz, had founded the place. Lilik was a sculptor and his wife, Louise, a painter. Louise's sister Eve McClure had once been married to Henry Miller. For a while in the 1950s, the sisters and their husbands had led a bohemian life in Big Sur.

There was one other tenant on my floor, Max, a retired sailor from the U.S. Merchant Marine. Every morning Max watered the garden, as efficiently as he had once swabbed the decks, and released the scent of oleander and roses to my balcony. Some nights in summer I dragged my mattress out and slept under the bright stars and the overhanging branches of a gnarled olive tree: cyclamen grew in the crevices of the balcony's exterior walls, and thick-stemmed pink geraniums twisted their heads in my window boxes. On Fridays, before the Sabbath, the carpet beaters, wives and daughters, came out onto their balconies to spank the dust from household rugs in a last great crescendo of activity before the quiet of evening. Sometimes I would be invited down to Lilik and Louise's studio for coffee and conversation.

As a young man, Lilik had met Chagall in Paris in the late

1930s. Chagall had not responded well to Lilik's paintings, and Lilik in turn decided that the famous artist was a snob. Chagall warmed up to him only after Lilik had published a favorable review of Chagall's art in a Jewish magazine. There were other stories about Chagall, none of them particularly flattering, stories of put-downs, slights, and hurts, the common fare of personal transactions in the arts. Artists are not generally well known for their generosity of feeling toward other artists. The slant of Lilik's assessment of Chagall's personality was irrelevant to me. I was happy simply to be in the company of someone who knew Chagall. And, beyond everything, Lilik had no doubt at all that Chagall was a great artist.

In spring 2006, visiting Jerusalem for the first time in many years, I went to take a look at my old house. Next door, in The Artist's House exhibition space, was a retrospective of Lilik's work. I remembered the night before he died in 1978, when Max and I had gone to give blood in case he needed surgery. Then, standing before the one painting that had something of Chagall—an untitled work showing a couple with an inverted female figure that looked to me like an Expressionist version of Chagall's *The Promenade* (1929)— I remembered the conversations.

Ten years before he died Chagall wrote a letter to Thomas Messer at the Guggenheim Museum in New York requesting that he not lend any of his works to an exhibition called The

Jewish Experience in the Art of the Twentieth Century, planned for the Jewish Museum a few blocks uptown. Chagall hadn't been consulted in advance, but more important, he couldn't understand why anyone would want to include him in such a show. Our question must be, Why would they need to include anyone else?

ACKNOWLEDGMENTS

For assistance in the writing of this short book I have an embarrassingly large number of people to thank—and I'm not even counting shrinks. First among them must be Jonathan Rosen, who has been the most patient, good-natured, humorous, knowledgeable, and illuminating of editors. At Random House/Schocken I want to thank Dan Frank, Altie Karper, Janice Goldklang, Rahel Lerner for her acumen, and Fran Bigman, who has been enormously helpful with all the Minute Particulars, without which, as William Blake says, one cannot do good for another.

In Israel, Gabriel Levin, whose grandfather Marek Szwarc occupied the studio next to Chagall's in La Ruche, dug up all kinds of fascinating details for me, while Carmela Rubin, the director of the Reuven Rubin Museum in Tel Aviv, provided coffee and informed conversation. Dean Susan Ernst at Tufts University awarded me a travel and research grant that enabled me to study and write in France, and my colleagues from the Department of Art History, Andrew McClellan and Eric Rosenberg, were kind enough to tolerate my muddy trespass into their fields over numerous lunches. Thanks also are due to Bella Meyer, Anthony Rudolf, and Monica Bohm-Duchen.

Acknowledgments

I owe the greatest debt to my wife, Sharon Kaitz. She talked this book through with me for years, looked at pictures, adjusted my color blindness, and if you come across an idea in the book that really grabs you—it was probably hers. Her own studio was a source of inspiration to me as I contemplated Chagall's.

Adam Wilson cooked some spectacular family meals during the writing of this book. Gabriel Wilson more or less stopped playing the drums when I asked him to.

BIBLIOGRAPHIC NOTE

Anyone writing about Chagall today owes an enormous debt to Benjamin Harshav, whose superb scholarship has recently made available in English translation hundreds of Chagall's letters and other pertinent and revealing documents originally written in Yiddish, Russian, French, German, and Hebrew. *Marc Chagall and His Times: A Documentary Narrative* (Stanford University Press, 2004) is the sine qua non for an encounter with Chagall's life. Franz Meyer's massive *Marc Chagall: Life and Work* (Harry N. Abrams, 1964) remains a remarkable source of information, although the book was published twenty-one years before Chagall's death and, famously, or infamously, omits any mention of Chagall's seven-year relationship with Virginia Haggard. Franz Meyer was Chagall's son-in-law. Sidney Alexander was not so shy; his *Marc Chagall: A Biography* (G. P. Putnam's Sons, 1978) is wonderfully loose-lipped, both reverent and irreverent, and anecdotal. For a discerning reading of the paintings, it's hard to beat either Monica Bohm-Duchen's *Chagall* (Phaidon, 2001) or Jacob Baal-Teshuva's *Marc Chagall 1887–1985* (Taschen, 2003).

Chagall's own memoir, *My Life* (Da Capo Press, 1994), composed when he was in his early thirties, is a pleasure to read, poetical and evocative, but dubious as history.

Bibliographic Note

Of those who knew Chagall intimately, Bella Chagall's *Burning Lights* (Biblio Press, 1996) is a lovely memoir of a lost Jewish world, while Virginia Haggard's *My Life with Chagall: Seven Years of Plenty with the Master as Told by the Woman Who Shared Them* (Donald I. Fine, 1986) is a far more intelligent, observant, and insightful book than its title would suggest. *Quelques pas dans le pas d'un ange* (Gallimard, 2003), by Chagall and Virginia's son, David McNeil, is a tactful and good-natured memoir. Varian Fry's *Surrender on Demand* (Johnson Books, 1997) contains a brief but vital portrait of Chagall during World War II.

CHRONOLOGY

ca. 1735 Israel ben Eliezer, known as the Ba'al
 Shem Tov, founds the Hasidic move-
 ment, which stresses ecstatic prayer
 and mysticism over study. His influence
 soon spreads among the Jews of East-
 ern Europe.

1777 Rabbi Shneur Zalman of Lyady
 becomes leader of the Hasidim of
 Belarus. Led by generations of the
 Schneerson family, the dynasty, called
 Habad or Lubavich, eventually moves
 to the United States and establishes
 centers around the world.

1791 Catherine the Great of Russia restricts
 the Jews to residence in the Pale of
 Settlement, comprising modern-day
 Latvia, Lithuania, Ukraine, and
 Belarus.

1804 Napoleon's Civic Code grants religious
 autonomy to the Jews of Paris.

1881 The assassination of Czar Alexander II.

1882 The May Laws overturn privileges granted to the Jews of Russia in the 1860s and restrict them to urban areas of the Pale of Settlement. Major pogroms in the Pale in this year spark a tremendous wave of emigration, largely to the United States.

July 6, 1887 Moishe (Movcha) Shagal, later Marc Chagall, is born in Vitebsk, Belarus, to Sachar and Feiga-Ita Shagal.

1894 Sholem Aleichem, the Yiddish author and humorist, publishes the first of his many *Tevye der Milkhiger* (Tevye the Dairyman) monologues.

1897 Yehuda Pen opens School of Drawing and Painting in Vitebsk.

The Jewish daily *Forverts* is founded in New York by Abraham Cahan.

The First World Zionist Congress is held in Basel.

ca. 1900 Chagall begins to study at Yehuda Pen's school in Vitebsk.

1903 The Jews of Kishinev are attacked in a brutal pogrom. The Hebrew poet

Chaim Nachman Bialik, sent to Kishinev by the Jewish Historical Commission in Odessa to write a report on the atrocity, instead memorializes it in his epic poem *Be'Ir ha'Harega* (In the City of Slaughter).

1904 Picasso sets up his studio in Paris.

1905 The Jewish artists Jules Pascin (Julius Pincas) and Amedeo Modigliani arrive in Paris.

1906 The sculptor Boris Schatz, court sculptor to King Ferdinand of Bulgaria, founds the Bezalel Academy of Arts and Design in Jerusalem.

Chagall leaves Yehuda Pen's school.

spring 1907 Chagall moves to St. Petersburg, where he enrolls in the School of the Imperial Society for the Encouragement of the Fine Arts.

1908 Chagall apprentices to a sign painter to secure residency in St. Petersburg.

1909 Chagall, supported by a wealthy St. Petersburg woman, enrolls in Zvantseva Academy; he studies briefly with Leon Bakst.

summer 1910 Chagall arrives in Paris, with a stipend for one year of study provided by Maxim Vinaver, a wealthy St. Petersburg lawyer and member of parliament.

winter 1911– Chagall moves to La Ruche (the
spring 1912 Beehive), a building of artists' studios in Montparnasse, Paris.

1912 Chagall makes his first salon appearance at the Salon des Indépendants with *Dedicated to My Fiancée.*

The Romanian-born Jewish artist Reuven Rubin immigrates to Palestine. He studies at the Bezalel school and is a pioneer of the attempt to create a national style.

1913 The artist Chaim Soutine arrives in Paris.

September 1913 The German-Jewish art patron Herwarth Walden exhibits three of Chagall's works in his Berlin gallery.

June 1914 Walden features nearly two hundred works by Chagall in a two-man show with Alfred Kubin; Chagall attends the opening in Berlin and then returns to

Vitebsk for his sister's wedding and
a reunion with his fiancée, Bella
Rosenfeld.

July 28, 1914 Austria-Hungary invades Serbia,
starting World War I.

March 1915 Chagall shows twenty-five paintings in
Moscow at the Michailova salon.

July 25, 1915 Chagall marries Bella Rosenfeld.

1915 Chagall moves to Petrograd as clerk
in the Office of War Economy, first
visiting Rabbi Schneerson in Zaolshe
for guidance.

April 1916 Chagall shows sixty-three paintings at
the Dobitchina gallery in Petrograd.

May 18, 1916 Bella gives birth to a daughter, Ida.

November 1916 Forty-five of Chagall's paintings are
featured in the avant-garde Jack of
Diamonds group show in Moscow.

March 1917 The Russian Revolution results in the
abdication of Czar Nicholas.

October 26, 1917 The Bolsheviks take power in Russia,
later declaring the Soviet Union (1922).

November 2, 1917 The Balfour Declaration declares

British support for a Jewish national home in Palestine.

1918 Chagall is appointed commissar of art for the postrevolutionary government in Vitebsk.

January 1919 Chagall opens the People's Art College and Art Museum in Vitebsk.

1919 Chagall hires the avant-garde artists Kazimir Malevich and El Lissitzky to teach at his school.

autumn 1919 Chagall's father is killed by a truck in Vitebsk; his brother David is killed in Crimea shortly thereafter.

1920 S. Ansky's play *The Dybbuk* is first performed in Yiddish in Vilna; the Hebrew translation by Bialik is soon performed in Moscow, Tel Aviv, and New York.

May 1920 While Chagall is out of town fund-raising for the art school, Malevich stages a coup and declares it the Suprematist Academy, firing much of the faculty.

June 1920 Chagall and his family move to Moscow.

winter 1920 Chagall begins painting murals for the Moscow Yiddish State Theater.

Bella and Ida move to Malakhovka, a small town near Moscow.

Chagall joins Bella and Ida in Malakhovka and teaches art at a Jewish orphanage there; many Jewish writers and artists are also in residence.

early 1922 The Chagalls move back to Moscow.

summer 1922 Chagall arranges an exhibition in Lithuania, sending sixty-five pictures to Kaunas (Kovno) and taking the manuscript of his memoir. Bella and Ida follow.

1923 Paul Cassirer publishes Chagall's *Mein Leben*, the illustrations for Chagall's yet unfinished memoir.

September 1, 1923 The Chagall family arrives in Paris. All the work he has stored from his Paris period has disappeared.

1924 Chagall is employed by Vollard to illustrate Gogol's *Dead Souls*.

1924 Chagall's contract to illustrate La Fontaine's *Fables* causes an uproar in Paris because he is a Jew.

1930 Pascin, dying of cirrhosis, commits suicide in his Paris studio.

February 1931 The Chagalls visit Palestine by invitation of Meir Dizengoff.

1933 The Rise of Hitler in Germany. Nazis burn three of Chagall's paintings in Mannheim.

1934 Ida Chagall marries Michel Rapaport.

1935 The Yiddish writer Isaac Bashevis Singer immigrates to the United States.

August 1935 Bella and Marc Chagall travel to Vilna to attend the opening of the Museum of Jewish Art and an exhibit of 116 of Chagall's graphic works.

September 1935 Nazi Germany enacts the Nuremberg Laws, prohibiting marriage between Jews and non-Jews and stripping German Jews of their citizenship.

1937 The Yiddish poet Abraham Sutzkever, whom Chagall had met in Vilna in 1935,

publishes his first book, *Lider* (Songs), to great acclaim.

Yehuda Pen is murdered, probably by Stalin's NKVD.

Chagall is granted French citizenship.

November 9, 1938 Kristallnacht, the night of broken glass, on which Jewish businesses throughout Germany are looted, Jews attacked and killed, and synagogues burned.

September 1, 1939 Nazi Germany invades Poland, starting World War II.

January 1940 Chagall travels from the Loire Valley to Paris for an exhibition at Galerie Mai.

May 10, 1940 The German army invades France.

The Chagall family buys a house in Gordes, in Provence. They move in several weeks later.

June 14, 1940 Paris falls to the Germans. France is divided into occupied and unoccupied zones; in the occupied zones, the Nazis deport and exterminate large numbers of Jews; in the unoccupied zones, ruled by the Nazi-influenced Vichy

> government, anti-Jewish measures are
> enacted.

August 1940 Varian Fry arrives in Paris and sets up
> the American Relief Center, a front for
> his underground refugee-smuggling
> operations.

March 1941 Fry goes to Gordes to discuss the
> Chagalls' escape from Europe.

April 1941 Chagall, while in Marseilles arranging
> visas, is arrested in a sweep of Jews; he
> is released with Fry's help.

May 7, 1941 Marc and Bella Chagall cross into Spain
> and set sail from Lisbon to New York,
> where they are met by Henri Matisse's
> son Pierre. All of Chagall's work is sent
> on to New York.

September 1941 Fry is expelled by Vichy France.

July 16–17, 1942 Nearly thirteen thousand Jews in Paris
> and surrounding areas are taken in a
> roundup by Nazi authorities.

August 15, 1942 Vichy police arrest more than seven
> thousand foreign-born Jews in the
> unoccupied zone and turn them over to
> Germans.

1943 The Soviet Cultural Commission sends the poet Itzhik Feffer and the actor Solomon Mikhoels, whom Chagall had known in Russia, on a propaganda mission to New York to encourage support for the Russian war effort.

August 25, 1944 Paris is liberated by the Allies.

September 2, 1944 Bella Chagall dies of a streptococcus infection in New York as she and Marc are preparing to return to Paris.

Summer 1945 Virginia Haggard joins the Chagall household as housekeeper and soon after becomes Marc's lover.

1946 Chagall retrospective at MoMA.

June 22, 1946 The birth of Chagall's and Virginia's son, David.

October 1947 Chagall retrospective in Paris at Musée National d'Art Moderne.

November 29, 1947 The United Nations votes to approve the partition of Palestine.

January 13, 1948 Solomon Mikhoels is assassinated by Stalin.

May 14, 1948 The state of Israel is proclaimed.

Chronology

August 1948 Chagall and Virginia leave for France.

September 1948 Chagall is honored at Venice Biennale.

1949 Yiddish theater in Moscow is dissolved; Chagall's paintings are stored in the Tretiakov Gallery.

spring 1950 Chagall is invited to decorate the baptistery of Notre-Dame de Toute Grâce in the Haute Savoie region of France. He finally completes the work seven years later.

spring 1951 Chagall and Virginia travel to Israel at the invitation of President Salman Shazar.

April 16, 1952 Virginia Haggard leaves Chagall.

July 12, 1952 Chagall marries Valentina Brodsky.

August 12, 1952 Stalin secretly executes twenty-six leaders of Russian-Jewish cultural life.

March 5, 1953 Stalin dies.

1962 Chagall's stained-glass windows are dedicated at the synagogue of Hadassah hospital in Jerusalem.

1964 The musical *Fiddler on the Roof,* by Jerry Bock, Sheldon Harnick, and Joseph

Stein, opens on Broadway. Based on Sholem Aleichem's *Tevye* monologues, it draws its title from the murals Chagall painted for the Moscow Yiddish theater in 1920.

June 5, 1967 War breaks out between Israel and neighboring Egypt, Jordan, and Syria. The Six-Day War culminates in Israel's conquering East Jerusalem, the West Bank, the Sinai Peninsula, the Gaza Strip, and the Golan Heights.

September 1967 Varian Fry dies.

June 1973 Chagall visits Moscow as a guest of the Soviet government; he is permitted to view his paintings for the Moscow Yiddish theater and signs them.

July 1973 The opening of the National Museum of the Biblical Message Marc Chagall, near Nice.

October 1973 Egypt and Syria attack Israel on Yom Kippur.

1974 Chagall visits Chicago for the unveiling of his *Four Seasons* mosaic at the First National Plaza.

January 1, 1978 Chagall is decorated with the Grand Cross of the French Legion of Honor.

September 1978 President Anwar Sadat of Egypt and Prime Minister Menachem Begin of Israel meet with President Jimmy Carter at Camp David and sign the Camp David Accords, which put forth a framework for the Egyptian-Israeli peace treaty signed the following year.

March 28, 1985 Chagall dies at age ninety-seven and is buried, at his wife's insistence, in the Catholic cemetery in Saint-Paul-de-Vence.

Grateful acknowledgment is made to the following for permission to reprint previously published material:

New Directions Publishing Corp.: Excerpt from "Portrait" from *Selected Writings* by Blaise Cendrars. Copyright © 1962, 1966 by Walter Albert. Reprinted by permission of New Directions Publishing Corp.

Stanford University Press: Excerpts from *Marc Chagall and His Times: A Documentary Narrative* by Benjamin Harshav. Copyright © 2004 by Benjamin Harshav. All rights reserved. Reprinted by permission of Stanford University Press, www.sup.org.

Abraham Sutzkever and Jacqueline Osherow: Excerpt from "Written on the Slat of a Railway Car" by Abraham Sutzkever, translated by Jacqueline Osherow. First published in English in *Poetry: The Translation Issue*, vol. 188, April 2006. Reprinted by permission of Abraham Sutzkever, rights administered by Ruth Wisse and Jacqueline Osherow.

University of California Press: "Written in Pencil in the Sealed Railway Car" from *Selected Poems of Dan Pagis*, translated by Stephen Mitchell. Copyright © 1996 by The Regents of the University of California. Reprinted by permission of University of California Press.

ABOUT THE AUTHOR

Jonathan Wilson is the author of two novels, *A Palestine Affair* and *The Hiding Room*; two collections of stories, *Schoom* and *An Ambulance Is on the Way: Stories of Men in Trouble*; and two critical studies of the fiction of Saul Bellow. His work has appeared in *The New Yorker*, *The New York Times Magazine*, and *Best American Short Stories*, among other publications, and he is the recipient of a Guggenheim Fellowship. He is Fletcher Professor of Rhetoric and Debate, professor of English, and director of creative writing in the English department at Tufts University. He lives with his family in Newton, Massachusetts.